# Sculpture at the Corcoran: Photographs by David Finn

# Sculpture at the Corcoran: Photographs by David Finn

Text by David Finn with Susan Joy Slack

FOREWORD BY DAVID C. LEVY

RUDER FINN PRESS

in collaboration with the

## CORCORAN GALLERY OF ART

WASHINGTON, D.C.

COVER: *The Greek Slave* (Fig. 23)

All measurements are in inches.
Height precedes width precedes depth.

Designed by Lawrence Sunden, Inc.

First published in the United States in 2002 by
Ruder Finn Press, Inc.
301 East 57h Street
New York, NY 10022

PRINTED IN THE UNITED STATES OF AMERICA

ISBN NO. 0-9720119-1-9

# Table of Contents

ACKNOWLEDGMENTS   7

Foreword   9
DAVID LEVY

Introduction   10
DAVID FINN

The Sculpture   13
DAVID FINN WITH SUSAN SLACK

INDEX   190

DAVID FINN is internationally recognized as one of the world's finest photographers of sculpture. He has published more than eighty books on sculpture, devoted to works from different periods of history, ranging from ancient Egypt and classical Greece to western art form the 12th–20th centuries, including Michelangelo, Giambologna, Donatello, Cellini and Henry Moore, among others. His photographs have been shown in several one man and group exhibitions at museums and galleries worldwide.

SUSAN JOY SLACK is an art historian, with a degree from the Institute of Fine Arts, New York University. She has been a contributor to *Sculpture Review* magazine, and is Vice President of Ruder Finn Press, a New York-based publishing company.

## ACKNOWLEDGMENTS

The authors would like to acknowledge the invaluable assistance of the many staff members of the Corcoran Gallery of Art who made it possible to photograph and research the sculptures from the gallery's collection included in this book and the accompanying exhibition. Chief among them are Sarah Cash, Bechhoefer Curator of American Art, who tirelessly coordinated the Corcoran's role in fact-checking and editing the manscript and who managed all details of the exhibition. In the latter capacity she received expert collaboration from Paul Roth, Assistant Curator of Photography and Media Arts.

The authors are also indebted to David C. Levy, President and Director, for his enthusiasm for this project and to Jacquelyn Days Serwer, Chief Curator, for her scholarly suggestions and additions. The authors also wish to thank all of the following for their individual contributions: Jack Cowart, formerly Deputy Director and Chief Curator; Jonathan Binstock, Curator of Contemporary Art; Philip Brookman, Senior Curator of Photography and Media Arts; Laura Coyle, Curator of European Art; and Terrie Sultan, formerly Curator of Contemporary Art. Former Assistant Curator of American Art Dorothy Moss ably assisted in managing details of the project. Other staff members played important roles as well: Ken Ashton, Museum Technician; Yvonne P. Dailey, Assistant to the Director; Kimberly Davis, Registrar; Victoria Fisher, formerly Assistant Registrar and Registrar; Cathy Frankel, formerly Exhibitions Coordinator; Abby Frankson, Lighting Specialist; Lauren Harry, Assistant to the Chief Curator; Guy Jordan, Graduate Intern in American Art, spring 2002; Dave Jung, Assistant Preparator; Quint Marshall, formerly Assistant Preparator; Elizabeth Parr, Exhibitions Director; Clyde Paton, Preparator; Stacey Schmidt, Assistant Curator of Contemporary Art; Cristina Segovia, formerly Rights and Reproductions Coordinator; Zahava Shaffer, Graduate Intern in American Art, summer 2002; Ellen Tozer, Director of Retail Operations; Paige Turner, formerly Assistant Curator of Contemporary Art; Kirsten Verdi, formerly Registrar; and Amanda Zucker, formerly Assistant to the Chief Curator. Thanks are due to Thayer Tolles, Associate Curator of American Paintings and Sculpture, The Metropolitan Museum of Art, for her assistance with the Augustus Saint-Gaudens entry.

In addition, the authors are indebted to Steve Moss for his skill in digitally preparing the photographs for printing.

Finally, the authors would like to acknowledge with gratitude Zach Morfogen's unfailing confidence and tireless inspiration and encouragement to see this project through.

# Foreword

TO MOST OF THE WORLD, David Finn is known as the founder of Ruder•Finn, the powerful and innovative public relations firm that rewrote the rules of publicity and promotion while exploring new dimensions in that field. But, in fact, he has at least two identities, as a creative, hard-nosed entrepreneur and accomplished, widely published artist and photographer.

If, at first glance, David Finn seems a quintessential man of business, a closer look reveals broader dimensions. There is perhaps an atavistic quality that indelibly marks artists and intellectuals, compelling them to find outlets for their expressive instincts. Certainly this is strongly evident in David Finn, if not one of his defining characteristics. Walking through his home or the Ruder•Finn corporate headquarters in New York, one is struck by the presence of hundreds of drawings, con-structions, sculptures, and photographs that turn out to be products of his hand—an extraordinarily large and diverse output of art, created over a long, consistently productive period of time. Back in his other life, his artist-atavism undoubtedly was the force behind his creation of Ruder•Finn's pioneering arts division, today a staple of museum and philanthropic public relations practice.

Central among David Finn's many thousands of photographs is his important documentation of many of the world's great works of sculpture. From classical Greece through the Renaissance to the late twentieth century, he has recorded this art form with passion, sensitivity, originality, and understanding. The photography of sculpture allows David to creatively combine two of his most compelling interests. Today, after forty years of work and eighty-four books, he has established himself as a premier practitioner of this specialized photographic art.

The Corcoran is privileged to have had David Finn document its sculptural holdings. Working with Corcoran staff members over the course of four years, he painstakingly positioned, lighted, and photographed many of the three-dimensional works in our collection. Amazingly, and despite his continuing obligations as chairman of his company, he personally made key prints for every image, printing literally hundreds of photographs in his own darkroom.

This book and exhibition are a welcome celebration of the Corcoran's sculpture collection. Equally, they represent a celebration of the diverse talents of David Finn, who, at eighty-one years of age, continues to contribute actively and substantively to the worlds of art, business, literature, ideas, and information.

DAVID C. LEVY
PRESIDENT AND DIRECTOR
CORCORAN GALLERY OF ART

# Introduction

SCULPTURE COLLECTIONS in many museums have long been considered of relatively minor importance. Until recently paintings were thought to be the primary works of art, and sculptures were included almost as accessories. One would enter large galleries in which paintings in beautifully carved frames were carefully hung on well-lighted walls, and periodically, as one passed through the galleries, one would stumble across a work of sculpture. Among the few exceptions were *Winged Victory* (or more correctly, *Nike of Samothrace*) in the Louvre; Canova's *Theseus and the Centaur* in the Kunsthistorisches Museum in Vienna; and Michelangelo's *David*, which stands triumphantly under the central dome of the Accademia in Florence.

I have been photographing the works of sculptors—ranging from ancient times through the Renaissance to the present day—for almost forty years, and in recent years I have been encouraged by the public's increased interest in the art of sculpture. Perhaps the most obvious example has been the opening of outdoor sculpture museums in a number of countries. I have published books on some of those institutions, including the Hakone and Utsukushi-Ga-Hara open-air museums in Japan and the Storm King Art Center in Mountainville, New York. I have also photographed sculptures in other museums that have outdoor sculpture gardens, including those in England, Denmark, Norway, Sweden, the Netherlands, Belgium, Italy, Germany, Israel, Japan, and in many cities in the U.S.

Over the years, the Corcoran Gallery has received many gifts of sculpture from private collections. When visiting the Corcoran, I was always excited to see Hiram Powers' *Greek Slave*, Auguste Rodin's *Eve*, and the copy of Canova's *Venus*, but I admit that I wasn't particularly aware of the other sculptures in the collection. However, one day I asked David Levy, the director of the Corcoran and an old friend, if there were a large number of sculptures in the museum collection that were not on view. If so, I thought they might be the basis for a book. Knowing the range and quality of the works in the collection, he was intrigued with the idea. He and I walked through the storerooms and galleries and noted many outstanding works. Eventually finding far more than we could hope to include, I embarked on what has proven to be a most rewarding adventure, photographing a remarkable group of sculptures spanning many centuries.

The sculpture collection of the Corcoran reflects the generosity of many donors, and it was heartening to discover that the gifts accepted from patrons and contributors adhered, without

exception, to a high standard of quality. Each of the works I photographed was eminently worthy of its place in an outstanding museum collection. Altogether, I photographed seventy-two sculptures, all of which are included in this publication.

When photographing any work of sculpture, the quality of the light is critical. Early in my career as a photographer I did not use artificial lights; my theory was that knowledgeable and sensitive curators had taken the trouble to position the sculptures in their collections so that the lighting provided would bring out their best qualities. One of the first times I took lights with me was when I was working on a book about Donatello, and I knew there was no way I could do justice to the reliefs on the doors in the Old Sacristy of San Lorenzo in Florence with only natural light available. I almost burned down that great Renaissance church when the portable battery I used for my newly purchased strobe lights burst into flames, but the detail shots I was able to take with that kind of illumination were a revelation. In time, I came to the realization that if I wanted to achieve the best results I would have to provide my own lights, and that is precisely what I did when photographing at the Corcoran.

This was true for the works that were on display in the galleries as well as for those that were in storage and brought out for me to photograph. Moreover, because one can discover an almost endless variety of images in any three-dimensional work of art, as has long been my practice, I photographed each work from many angles. I took as many close-up shots of each sculpture as I could, for it is in the details that one can discover the essence of a work. Indeed, photographs of details are often the most exciting images one can capture with a camera.

The selection of works in this book is organized chronologically, beginning with ancient Greece and ending with the 19th and 20th centuries. What unites the Corcoran collection as an organic whole is its excellence, and what makes it exciting is its remarkable diversity. The photographic adventure I embarked upon proved to be both stimulating and satisfying for me—as I hope it will be for those who encounter it here.

DAVID FINN

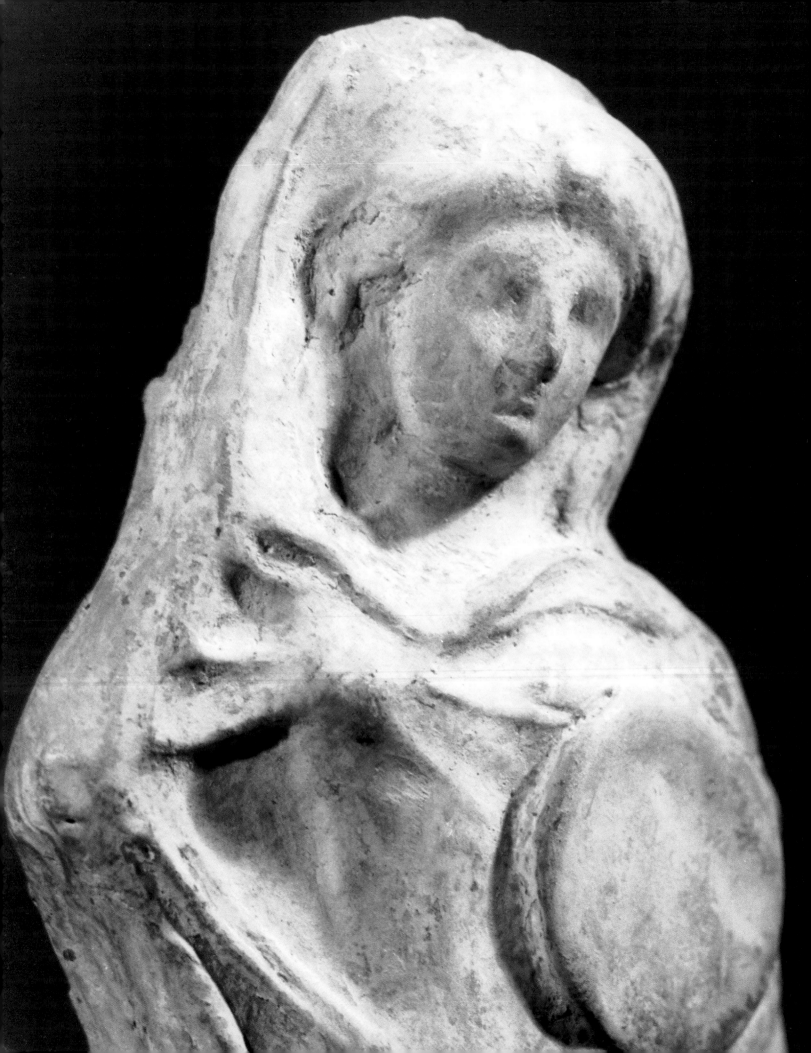

# Terracotta Figures

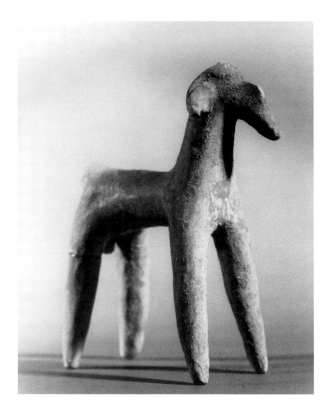

1. *Ram*, late 8th century B.C.
Cyprus
Terracotta
Height: 4⅜ in.
William A. Clark Collection, 26.505

THE OLDEST WORKS in the Corcoran collection are the small terracotta Tanagra figures, which date from the archaic through the Hellenistic periods of ancient Greek art. These extraordinary sculptures, most of which depict women in flowing robes standing in graceful poses, have a unique grace and delicacy. The finest of them were created during the Hellenistic period, from the late fourth century B.C. to the early second century B.C. They are called "Tanagra figures" after the site in Boeotia where many examples were found, although it is thought others were produced in both Athens and Alexandria. Similar figures were created in Roman times for another century or two, primarily on the coast of Asia Minor near Smyrna, but the quality and elegance of these later works never equaled that of the great figures of the earlier period.

The earliest work in the collection is a late-eighth-century B.C. figure of a ram (Fig. 1). Solidly standing on its four legs, its thin head perked forward, it has a strength and dynamism that would have excited twentieth-century sculptors like Henry Moore and Henri Gaudier-Brzeska. The sixth-century B.C. terracotta standing woman (Fig. 2) is still archaic but shows some

decorative features. The roughly formed face under a large headdress has bulging eyes and tight, expressionless lips, but the left hand lifts a long skirt almost as if the woman is about to curtsy. At a time when Archaic Greek sculpture was formalized and static, this represents an unusual concession to realism.

By contrast, the fourth- or third-century B.C. fragment of a veiled dancer holding a tambourine (Fig. 3) is all movement. The flowing robes are vigorously shaped and filled with energy. The woman playing a tambourine (Fig. 4) may be from the same period; although the head is more finely modeled, the folds of the garment are similar. The third-century B.C. terracotta of a standing woman (Fig. 5) appears more sophisticated, with a well-formed figure and a tilted head, long neck, and flowing robe. From the same period is a fragment of a statue of a young man (Fig. 6), with perfectly formed anatomy visible from all sides. Although a small work, its form seems monumental and could easily have been modeled after one of the great fifth-century B.C. Greek bronzes.

One of the finest sculptures in the collection is of a woman with a baby in her arms (Fig. 7). The composition of

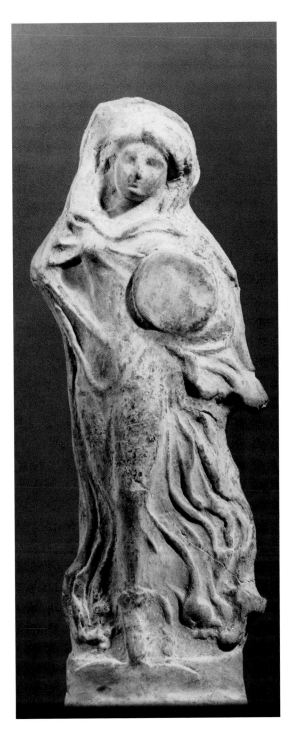

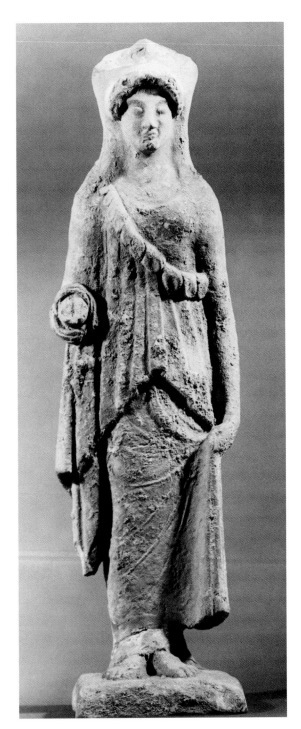

2. *Standing Woman*, 2nd half of 6th century B.C.?
Attic
Terracotta
Height: 13¾ in.
William A. Clark Collection, 26.518

3. *Veiled Dancer Holding a Tambourine*, 4th–3rd century B.C.
Boeotia
Terracotta
Height: 8 in.
William A. Clark Collection, 26.583

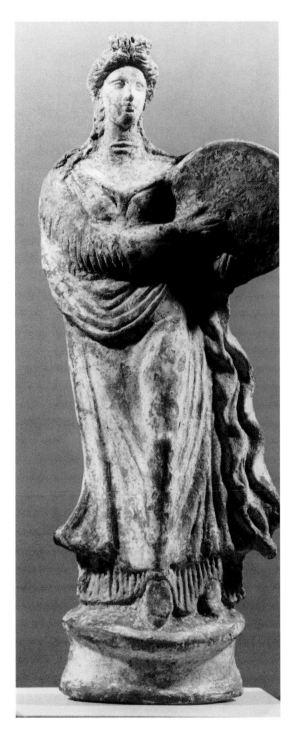

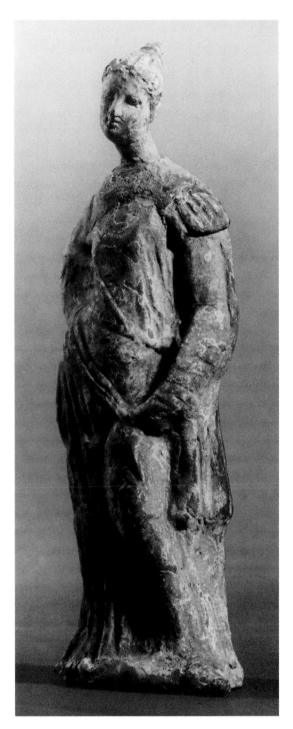

4. *Woman Playing a Tambourine*, 2nd half of
    4th century B.C. (or 4th–3rd century B.C.)
Boeotia
Terracotta
Height: 11½ in.
William A. Clark Collection, 26.587

5. *Standing Woman*, 3rd century B.C.
Italy
Terracotta
Height: 10¾ in.
William A. Clark Collection, 26.633

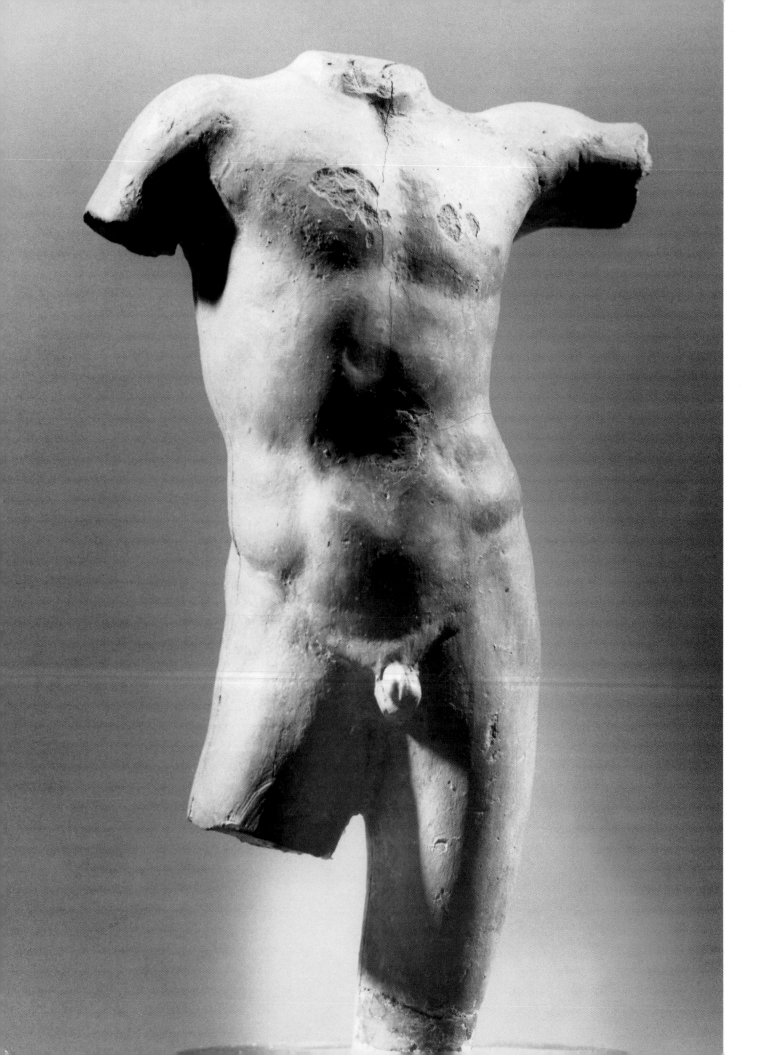

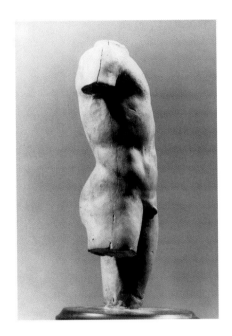 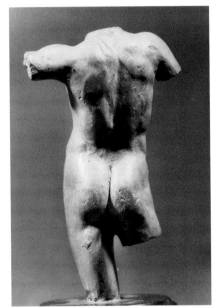 

6. *Fragment of Statue of a Young Man,* 2nd–1st century B.C.
Smyrna
Terracotta
Height: 5¾ in.
William A. Clark Collection, 26.593
ABOVE AND OPPOSITE

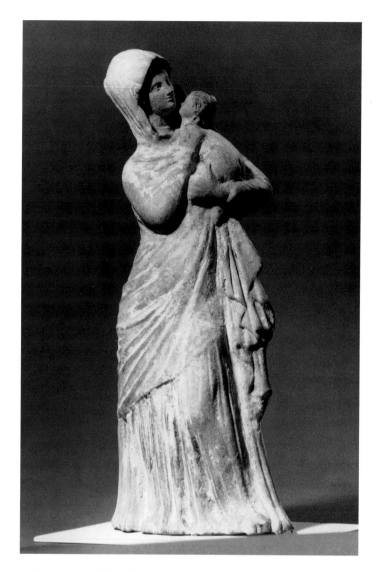

7. *Woman with a Baby in Her Arms,* c. 100 B.C.
Tanagra
Terracotta
Height: 11 in.
William A. Clark Collection, 26.576
ABOVE AND OPPOSITE

the figure is superb, with the woman's head tilted to one side, her hip extended to balance the child in her arms, one knee barely seen pressing against her skirt, and the folds of her garment all pointing to the child as the center of attention. The sensitively modeled face of the mother looks lovingly at her apparently newborn baby, whose head is held up by her right hand while her left arm encircles its body. Almost as impressive is a figure of Aphrodite with Eros (Fig. 8). Here again, there is a rhythm in the form. One bended knee echoes the shape of the two bent arms, with one hand resting on Aphrodite's hip and the other holding a piece of fruit, the folds of her garment designed to bring out the gracefulness of the figure. The proud, smiling face topped by well-groomed hair provides a finishing touch to the image of the happy goddess. Finally, there are the two tiny winged fighting Erotes (Fig. 9), which, when photographed with the proper lighting, reveal delightful details.

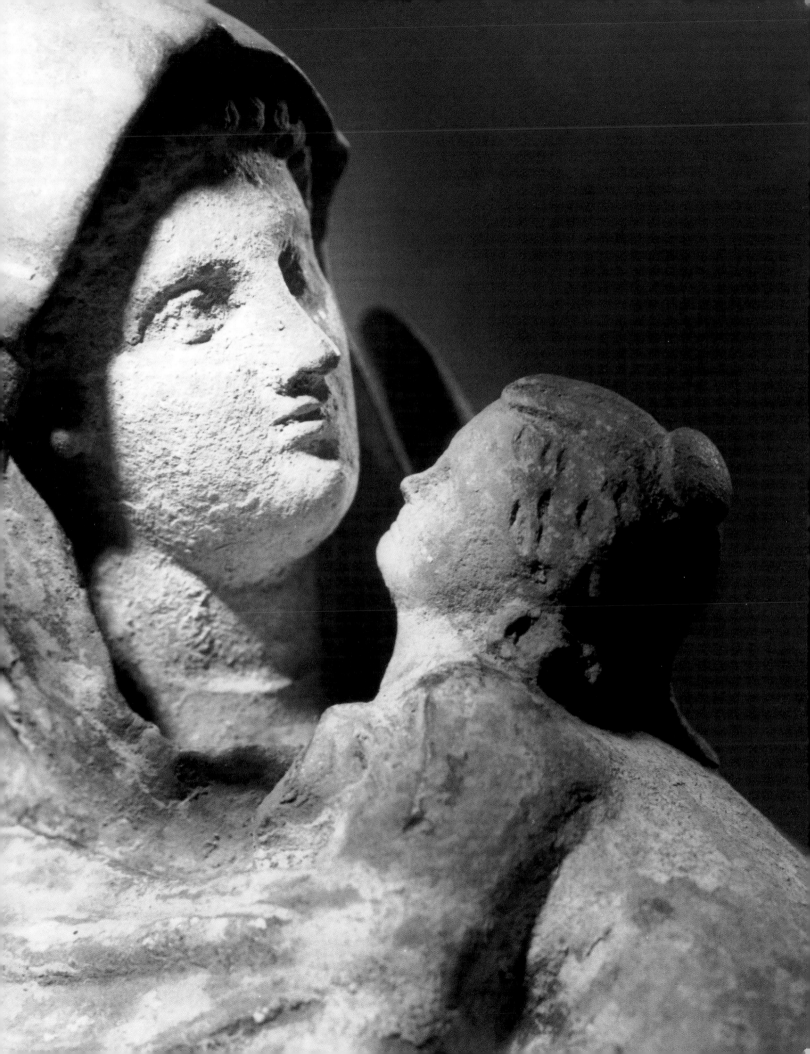

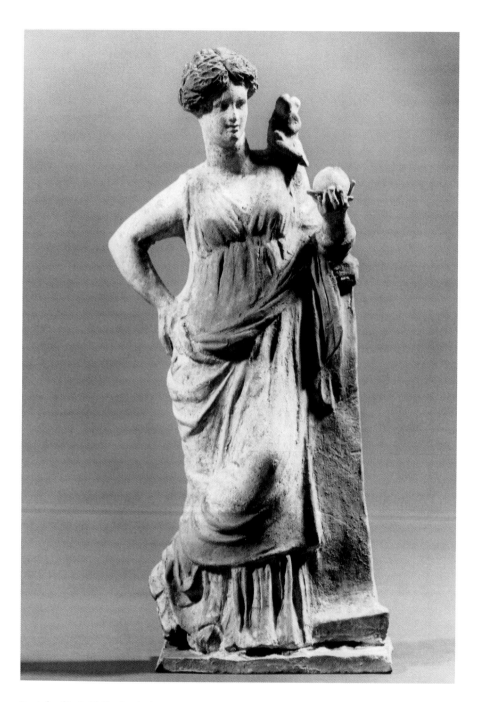

8. *Aphrodite (with Eros)*, 4th–1st century B.C.
Tanagra
Terracotta
Height: 7½ in.
William A. Clark Collection, 26.554

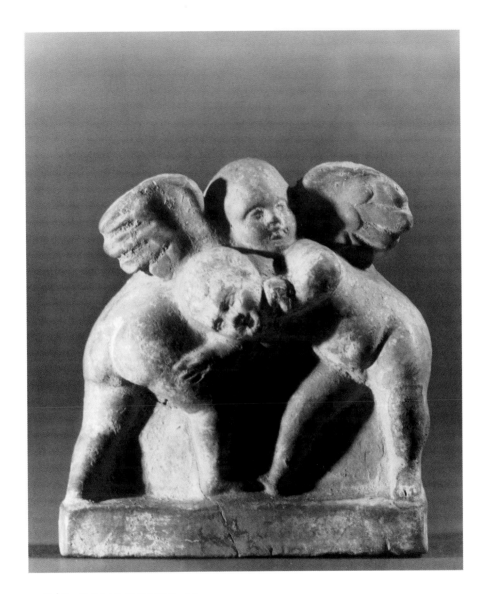

9. *Fighting Erotes,* 1st century B.C.–A.D.
Myrina, Asia Minor
Terracotta
Height: 3⅜ in.
William A. Clark Collection, 26.617

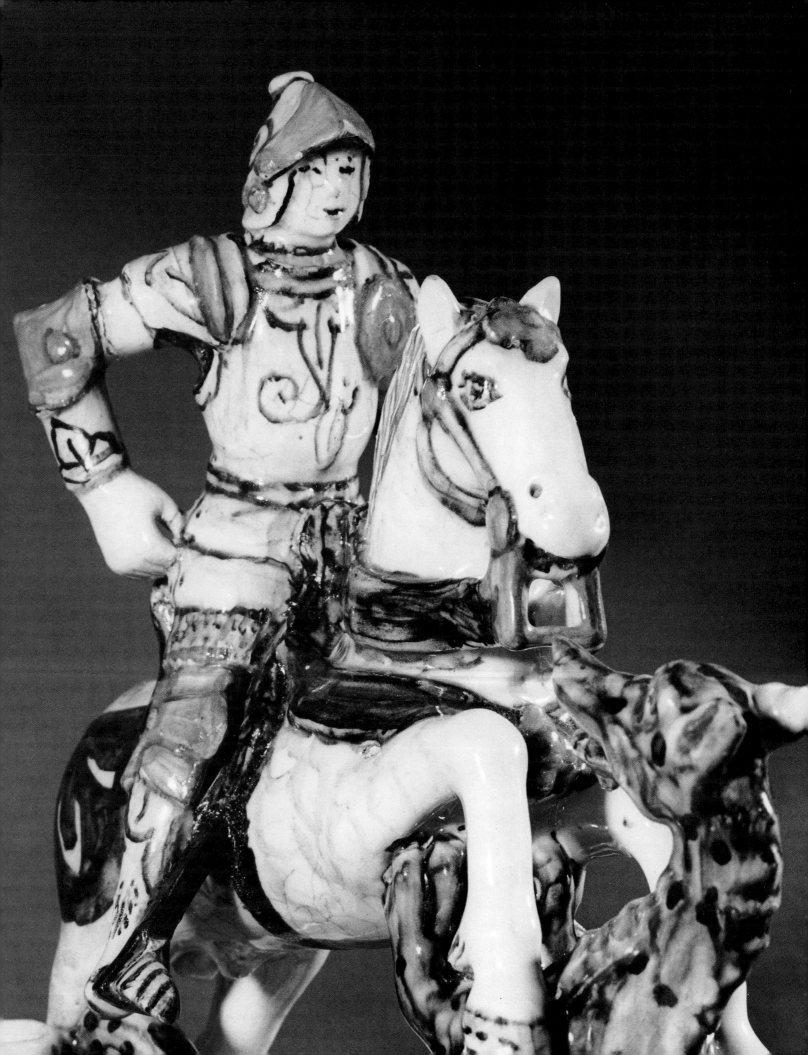

# Maiolica Inkstand

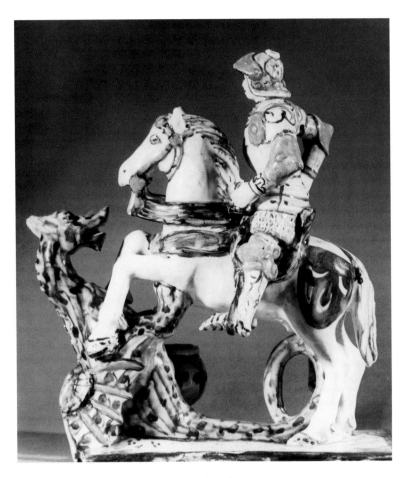

10. *St. George and the Dragon*, late 15th/early 16th century
Maiolica
10½ x 10 x 5 in.
William A. Clark Collection, 26.420
ABOVE AND OPPOSITE

MAIOLICA IS A TIN-GLAZED EARTHENWARE invented by Islamic craftsmaen in the eleventh century to imitate the look of Chinese porcelain. This decorative earthenware formed the basis for Hispano-Moresque ceramics, in turn, these inspired Italian Renaissance maiolica. Maiolica most commonly took the form of plates, but Renaissance artisans also created three-dimensional functional and purely decorative pieces. Although the inkstand served a practical purpose, its function was almost secondary to its decorative effect as a luxury item. The high quality of the work during the Reanaissance elevated what had been considered a craft to the level of impressive works of art.

Images of St. George and the dragon in painting and sculpture were popular during the Renaissance. My favorite is the stone relief by Donatello created for the church of Or San Michele in Florence. Besides being a dramatic representation of the famous legend and one of Donatello's early master-pieces, it has one of the first landscape backgrounds in which the newly discovered principles of perspective were intro-duced. The Corcoran Maiolica work, created around the same time, is far less dramatic in its form, but it has the luminosity found in some of the best glazed ceramic works of the period.

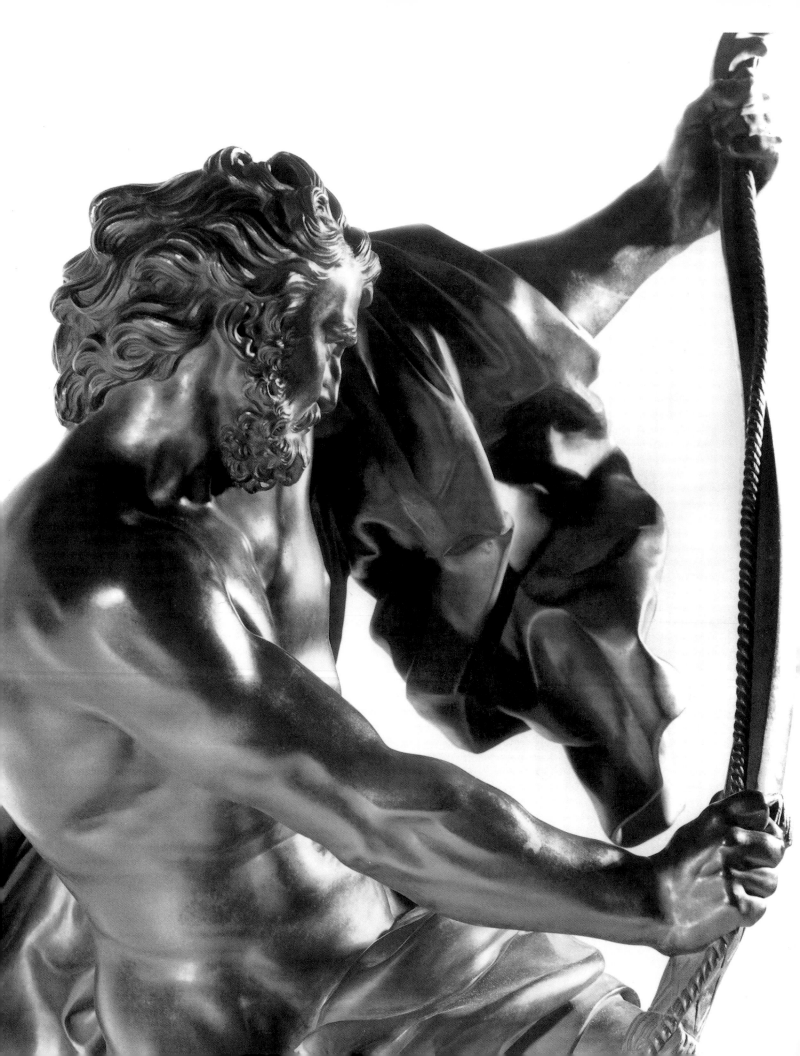

# BY OR AFTER Jacques Bousseau
## [1681–1740]

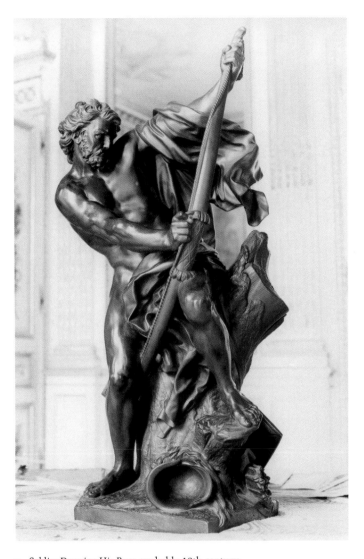

II. *Soldier Drawing His Bow*, probably 19th century
Bronze
35 x 15 x 13 in.
William A. Clark Collection, 26.705
ABOVE, OPPOSITE AND FOLLOWING

THIS SCULPTURE IS ONE OF A NUMBER of posthumous bronze copies of Bousseau's marble *Soldier Drawing His Bow* (the Louvre, Paris), which the sculptor presented to the Académie Royale in Paris in 1715 when he was accepted as a full member. Because they vary greatly in size, it seems likely the bronzes were cast by different foundries.

The swirling forms of the drapery and intricacy of the compositon made it a popular sculpture. Its many finely worked details and complex views from different angles made it a feast for my camera's eye. After producing what may have been his most famous work, Bousseau received a number of commissions in both France and Spain and was given the title Premier Sculpteur du Roi towards the end of his life.

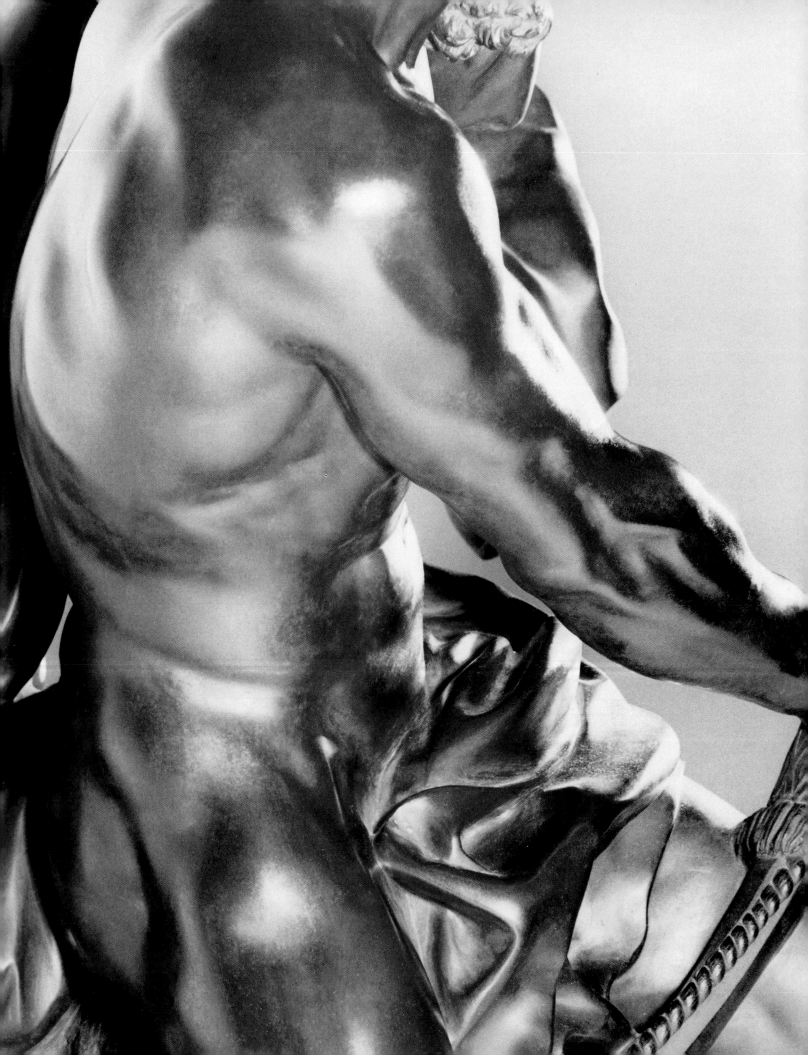

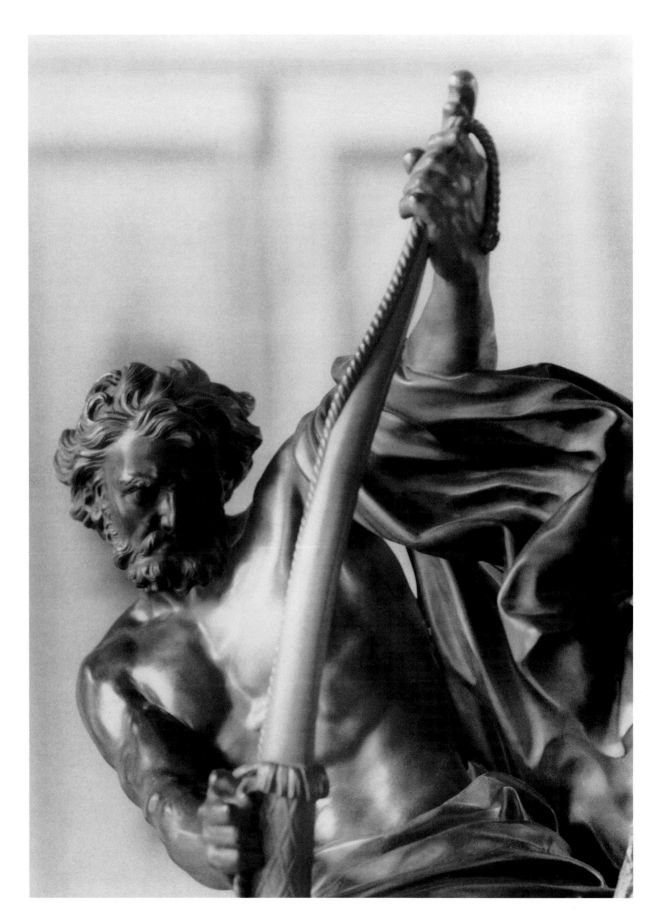

# Jean-Antoine Houdon
[1741–1828]

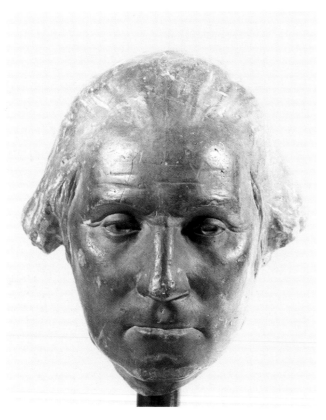

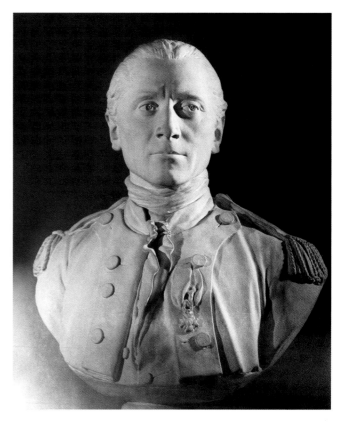

12. *Head of George Washington*, n.d.
Plaster cast (cast by Clark Mills after the original)
10½ x 8¾ x 10 in.
Gift of James D. Smith, 04.6

13. *Bust of John Paul Jones*, n.d.
Plaster
27½ x 17½ x 12½ in.
Gift of F. D. Millet, 04.7
ABOVE AND OPPOSITE

CONSIDERED THE GREATEST portrait sculptor of his day, Jean-Antoine Houdon was born in Versailles and won the Prix de Rome when he was twenty years old. Eight years later, he moved to Paris, where he began executing portrait sculptures of some of the most famous men of his time. He later traveled to the U.S., where he created sculptures of Benjamin Franklin, George Washington, Thomas Jefferson, and others. The Corcoran's head of George Washington (Fig. 12) is a plaster cast of perhaps the most realistic portrayal ever made of America's first president. It shows his wrinkled brow, knowing eyes, curved nose, tight lips, strong chin, and flowing hair. Rather than being an idealized portrait, this figure seems to reveal the real man. On the other hand, Houdon's bust of John Paul Jones (Fig. 13) is more formal and less convincing; Jones is depicted as a hero in full regalia rather than an individual whom the sculptor knew firsthand.

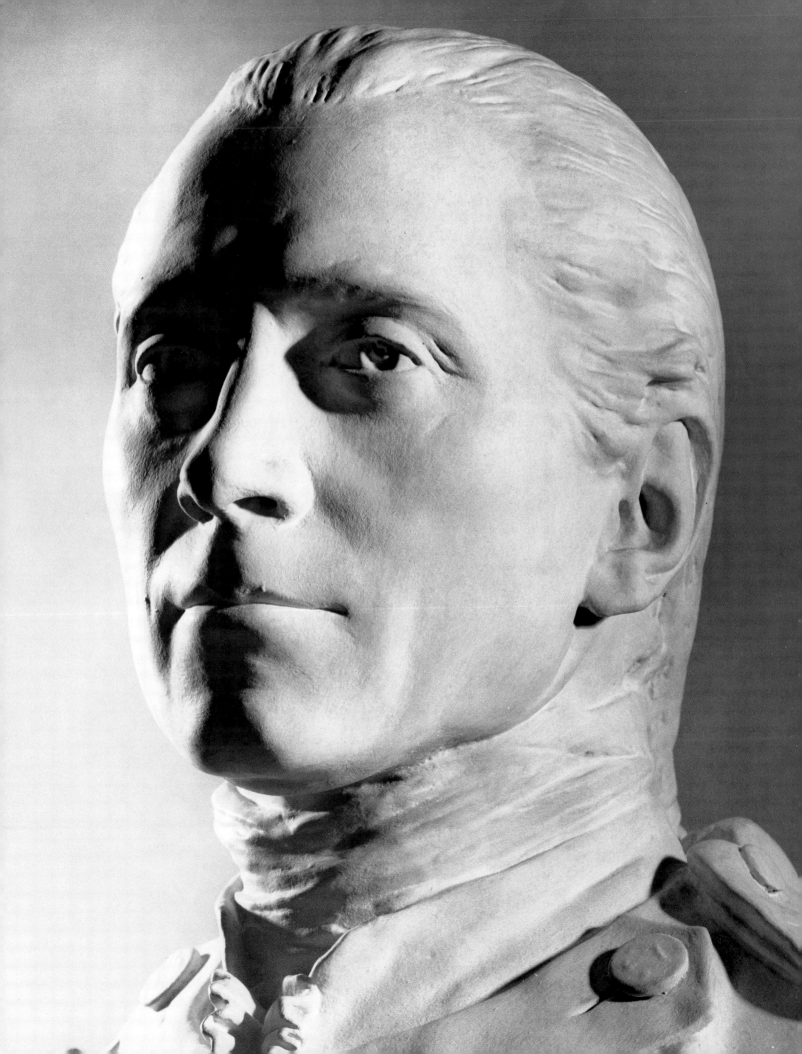

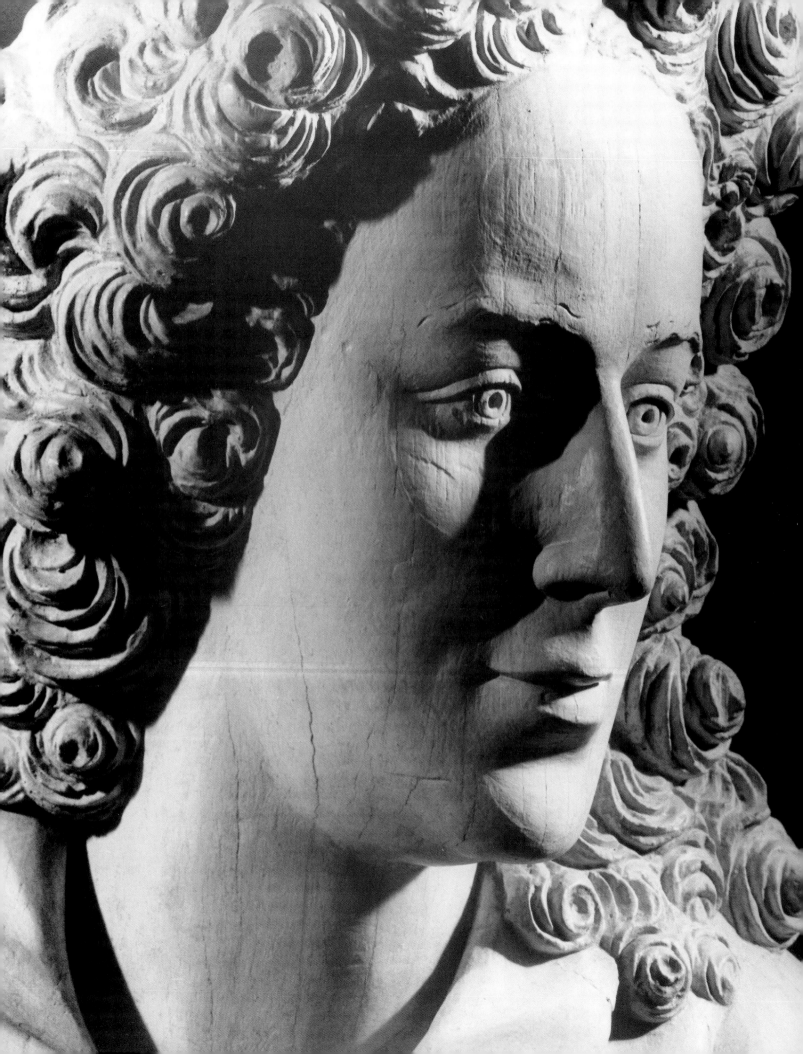

# William Rush
[1756–1833]

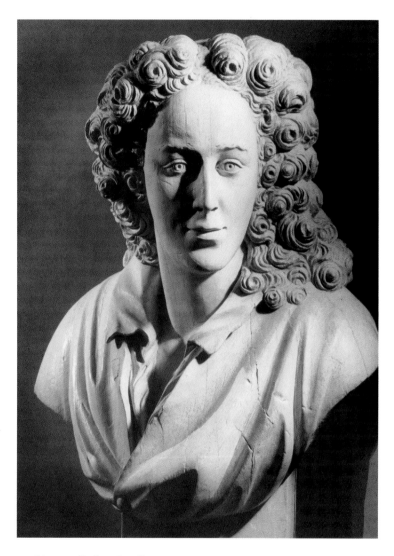

14. *Linnaeus (Carl von Linné)*, c. 1812
Carved wood
24¾ x 17½ x 12½ in.
Museum Purchase, 51.20
ABOVE AND OPPOSITE

WILLIAM RUSH is better known as the subject of a painting by Thomas Eakins than for his own work as a sculptor. The main visual focus of Eakins' work, called *William Rush Carving his Allegorical Figure of the Schuylkill River* (1876–77, Philadelphia Museum of Art), is the standing nude model. The sculptor is barely seen in the shadowy background, working with his tools on a marble figure. Rush, however, was a well-respected sculptor who produced portraits of Andrew Jackson and other contemporaneous personalities. The sculpture in the Corcor-an is a wood carving of the Swedish botanist Carl von Linné, better known as Linnaeus (1707–1778) (Fig. 14). It is a strange but striking work, with its heavy, curling hair and staring eyes. The system of classification of plants and animals the scientific world uses—taxonomy—was developed by Linnaeus, who was recognized as one of the leading scientists of his time.

# Charles-Alexander Renaud

[1756–1817]

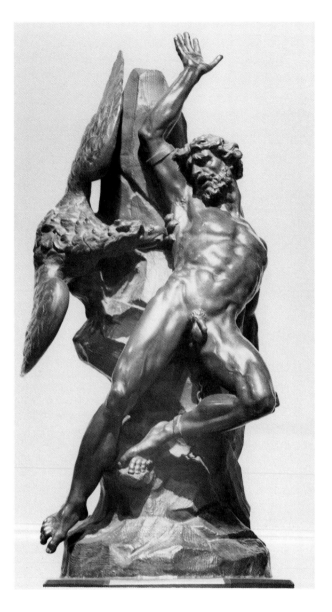

15. *Prometheus Attacked by the Eagle*, n.d.
Bronze
32 x 14 x 13 in.
William A. Clark Collection, 26.703

*PROMETHEUS ATTACKED BY THE EAGLE* (Fig. 15) is a bronze sculpture by a relatively obscure artist, Charles-Alexander Renaud. The original plaster is in the Musée des Beaux-Arts in Dijon, France. The Corcoran sculpture is an accomplished baroque work, with the diagonal movement of Prometheus' body offset by the bent left knee and right arm, as well as the outstretched wings of the eagle. The anatomy is carefully modeled, especially the tensed muscles of the twisting figure.

According to Greek mythology, Prometheus, one of the ancient race of Titans who preceded the Olympian gods, created mankind out of water and earth. He had little respect for the Olympians and tricked Zeus into accepting bones wrapped in animal fat, rather than good meat, as sacrifice. In his anger, Zeus took fire away from mankind, but Prometheus stole it back. As punishment for the trick and the theft, Zeus condemned Prometheus to be chained to a rock in the Caucasus mountains, where he would be tormented day and night by an eagle who devoured his liver. Each night, the liver would grow back, so that the torture was endless.

# AFTER Antonio Canova

## [1757–1822]

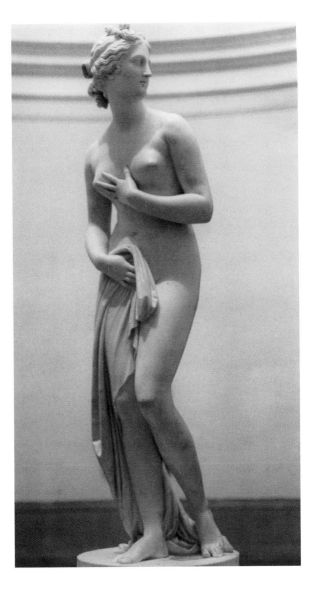

16. *Venus*, n.d.
Marble
69 x 20 x 18 in.
William A. Clark Collection,
    26.696a
LEFT AND FOLLOWING

ONE OF THE FINEST sculptures in the museum is a copy of Antonio Canova's *Hope Venus* (Fig. 16). The original marble was commissioned by the English banker and collector Thomas Hope. The Corcoran's copy was executed by an English artist after Canova's death. I have a long personal association with Canova's sculpture, which I photographed for a book published in 1983,[1] and I was delighted to see this piece in the Corcoran. Although museum records state that this is a copy of one of Canova's most famous works, in my opinion its workmanship equals that of any of the original marbles that I photographed in detail over the years.

In the early nineteenth century, Canova was revered as the finest artist who ever lived. When Napoleon conquered Italy, he was so impressed by *The Medici Venus*, an ancient Roman marble statue then considered to be one of the greatest masterpieces of all time, that he had it moved from Florence to Paris. Dismayed Florentines asked Canova to produce a new Venus to match the plundered treasure, which was later returned and is now in the Uffizi Gallery in Florence. Rather than copy the original, Canova created a new Venus

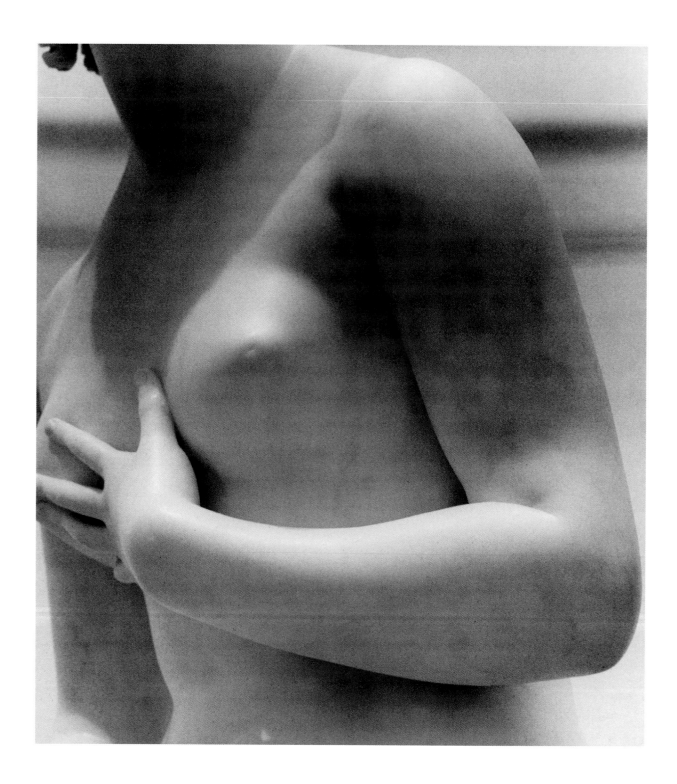

(1807–1810), which his contemporaries thought was even greater than the Medici version. Called *Venus Italica*, it is now in Florence's Pitti Palace. A few years later, in 1817–1820, Canova created the original *Hope Venus*, which I once photographed in the City Art Gallery in Leeds, England.

That is a long introduction to my photographs of the Corcoran Venus. When I photographed the exquisite marble sculpture from every angle and took close-up shots of details, I marveled at how the soft appearance of the surface of the skin was carved; the beauty of the delicate fingers touching the breast; the details of the hair; and the subtle grace of the folds and slight indentations of the garment held by the right hand.

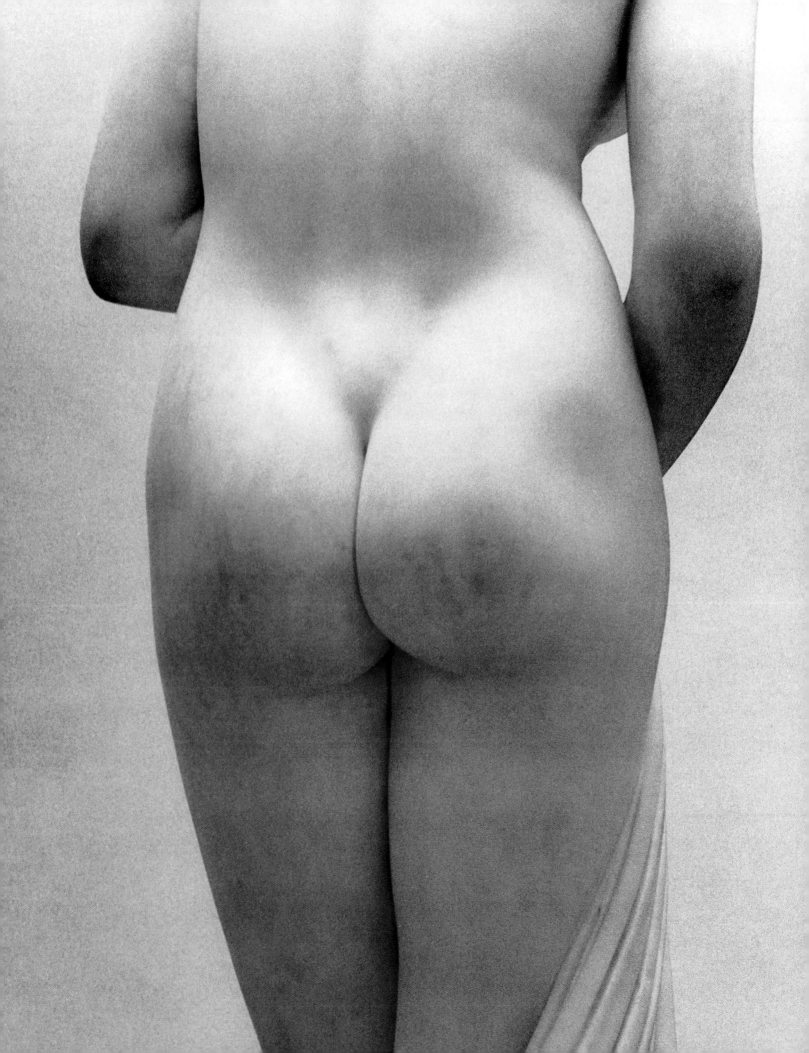

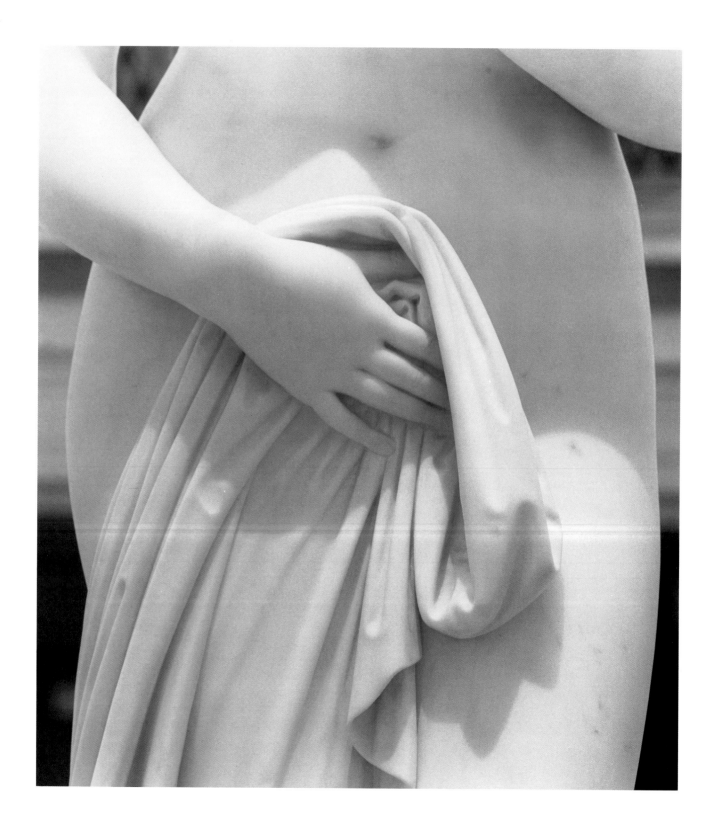

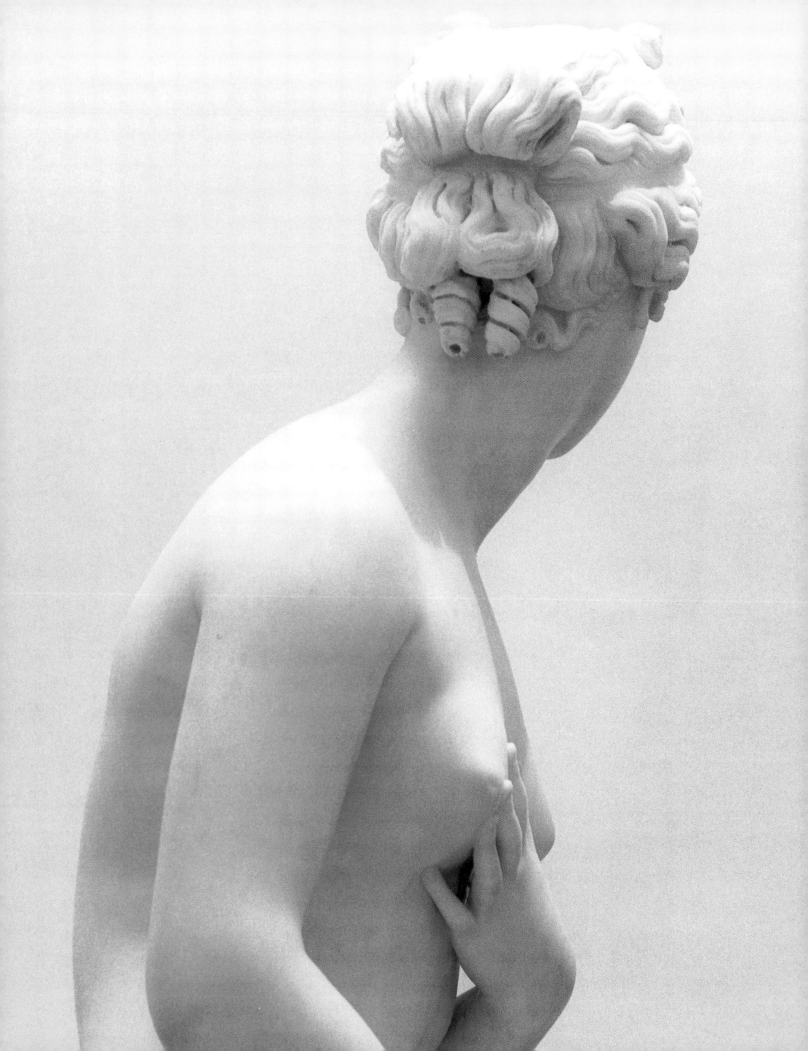

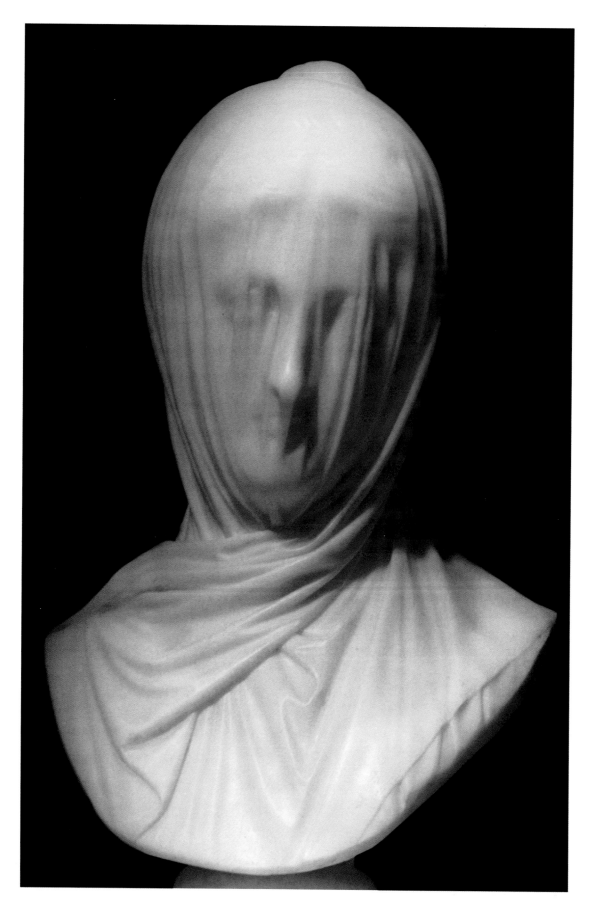

# Giuseppe Croff

[ D. 1869]

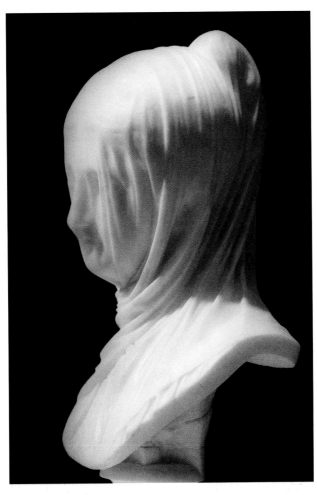

17. *Veiled Nun,* c. 1860
Marble
Height: 15 in.
Gift of William Wilson Corcoran, 73.9
ABOVE AND OPPOSITE

THE *VEILED NUN* (Fig. 17), by the little-known Milanese sculptor Giuseppe Croff, is one of the most popular works in the Corcoran's collection. Evidence suggests that Croff had an active artistic career near Lake Como, in Italy's lake region, and was particularly known for his terracotta figures. He also produced a figure of Saint John of God for the exterior of the Cathedral of Milan. Croff was one of a few Milanese sculptors from whom the Emperor of Austria ordered a sculpture to celebrate his coronation as King of Lombardy: the sculptor created a "Fate," a seated nude figure of a girl, which was placed on the ground floor of the Vatican Belvedere in 1845.

Visitors to the Corcoran are amazed to see how the sculptor created, through skillful carving of the marble, the illusion of a transparent veil covering the woman's face. Despite the sculpture's title, the subject is surely not a member of a religious order. Her elegant coiffure and the finely embroidered edging on her veil suggest a woman of means, or perhaps an allegorical figure. However, the mysterious nature of the work, its inward focus, and the relative "foreignness" of veiled figures to American museumgoers caused early visitors to refer to her as a nun, and the appellation has remained.

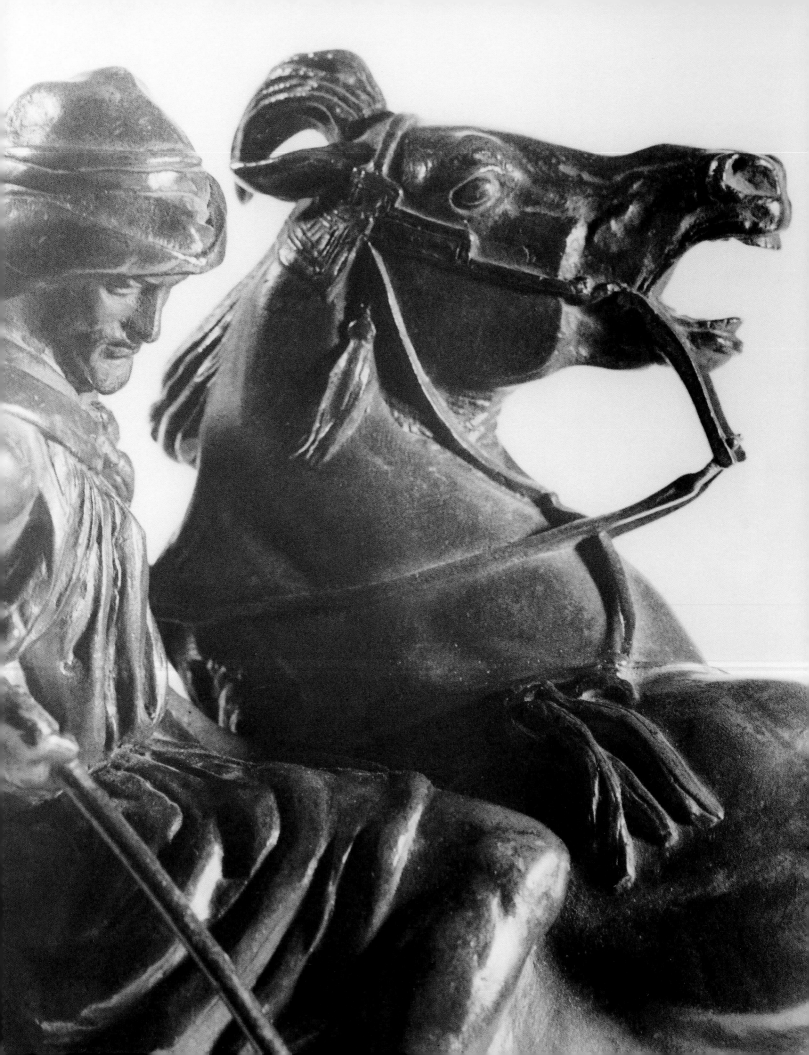

# Antoine-Louis Barye

[1796–1875]

THE CORCORAN COLLECTION of about one hundred bronzes by Antoine-Louis Barye was acquired in 1873—with the encouragement of its founder, William Wilson Corcoran—by board member William T. Walters, four years after the gallery was founded. The Bayre collection was exhibited in 1988 to commemorate the bicentennial of the French Revolution, and a catalogue was published with essays on various aspects of Barye's work. Five of his most important sculptures are included here.

Most of Barye's sculptures are of animal subjects, and they include, among others, bears, deer, horses, jaguars, lions, panthers, tigers, and a number of equestrian figures. Although many of the sculptures in the Corcoran are small, Barye did produce large works as well, including the *Seated Lion* commissioned by King Louis Philippe following the Revolution of 1830 for the Tuileries gardens in Paris. Later it was placed in front of the Louvre.

One of the most complex Barye sculptures in the Corcoran collection is *Two Arab Horsemen Killing a Lion* (Fig. 18). The lion majestically faces inevitable death at the hands of one horseman, even as his body is pierced by the horseman's lance. Seated triumphantly on his rearing mount, the horseman is especially dramatic owing to the sweep of his garment, the tilt of his head, and the tension of his arm muscles. There is also a remarkable interplay of forms among the two horses' heads, legs, and tails, all of which are rendered in great detail.

In *Horse Attacked by a Lion* (Fig.19), the king of the beasts is shown biting into the body of a noble horse rearing up on its hind legs, its forelegs struggling in the air, its head thrown back, its mouth agape as if screaming in pain.

The *Tiger Devouring a Gavial* (Fig. 20) is an even more gruesome piece. Barye had seen stuffed specimens of tigers in the National Museum of Natural History and knew about the gavial (a rare Asian crocodile found in India and Burma) from a skeleton in the same museum. Here the tiger bites with great ferocity into the writhing body of its victim, and the result is a swirling composition embodying enormous tension. The piece won second prize at the French Salon of 1831 and is credited with establishing Barye's reputation. Here is what one critic wrote about it:

> The tiger hugging the crocodile [*sic*] in his paws, and this reptile in fear and agony doubling on himself, form a group so true, so dreadful that it is difficult to withdraw your attention once fixed upon it. And although the beings here represented belong to a lower creation, *life* is rendered with such force and passion in these two animals, that we do not hesitate to pronounce the group which they form, the strongest and best work of sculpture in the Salon.[2]

In *Theseus Fighting the Minotaur* (Fig. 22), Barye shows his mastery of both human and animal anatomy. The piece represents a critical moment in Greek mythology, when the hero Theseus is about to kill the mighty Minotaur, offspring of Pasiphae, the wife of King Minos of Crete, and a beautiful white bull sent by the sea god, Neptune. The intertwining of the bodies is particularly dramatic and some have suggested that Barye was influenced by a drawing of boxers by Théodore Géricault.

*Python Crushing a Gazelle* (Fig. 21) depicts a huge snake preparing to devour a vulnerable animal. The serpent looks particularly vicious and the gazelle remarkably sweet. The frightening image reminds us that when an innocent victim is overwhelmed by a cruel attacker, the end is inevitable. Although we feel pity for the gazelle, we recognize this as the law of nature.

*Two Arab Horsemen Killing a Lion,* (detail, Fig. 18)

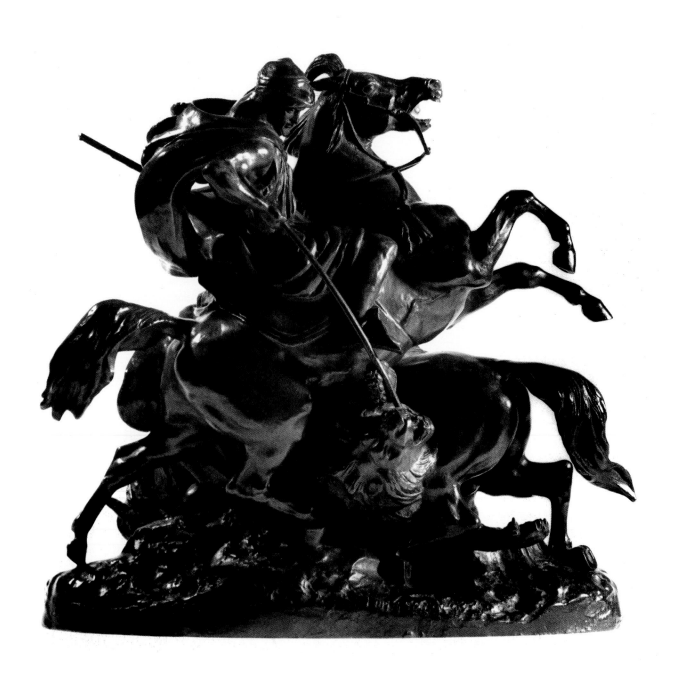

18. *Two Arab Horsemen Killing a Lion*, late 1830s
Bronze
14⅛ x 14⅞ x 9 in.
Museum Purchase, 73.32

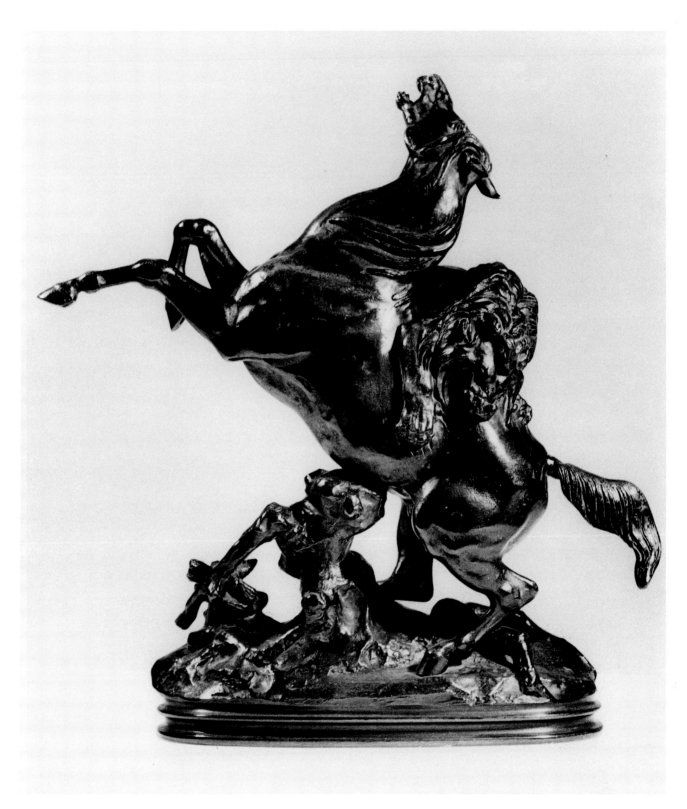

19. *Horse Attacked by a Lion*, 1833
Bronze
15¾ x 15⅛ x 6¼ in.
Museum Purchase, 73.69
ABOVE AND FOLLOWING

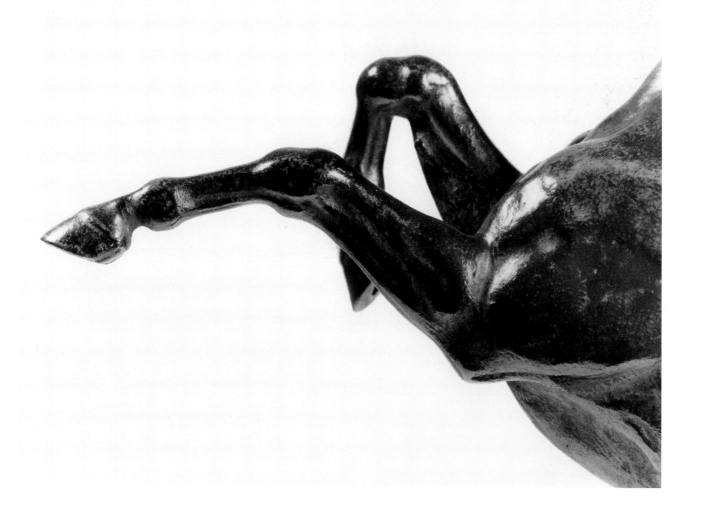

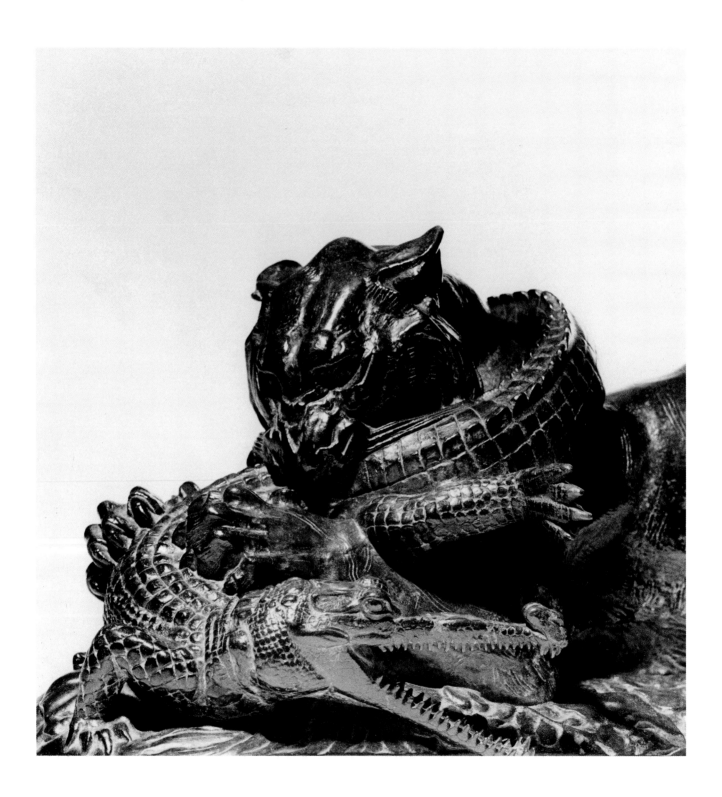

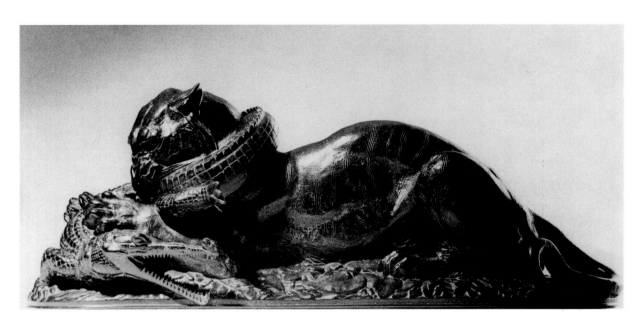

20. *Tiger Devouring a Gavial,* c. 1831
Bronze
7¾ x 19¾ x 7¾ in.
Museum Purchase, 73.56
Above and opposite

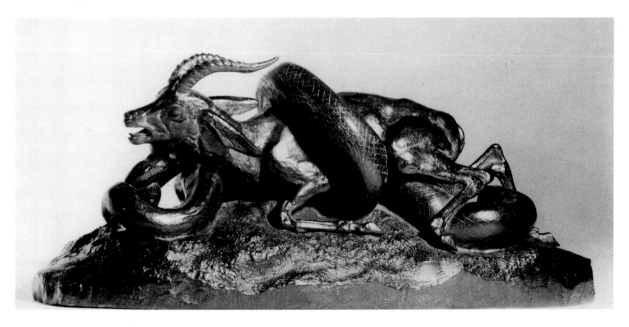

21. *Python Crushing a Gazelle,* 1830s
Bronze
6 x 15⅜ x 5¾ in.
Museum Purchase, 73.87

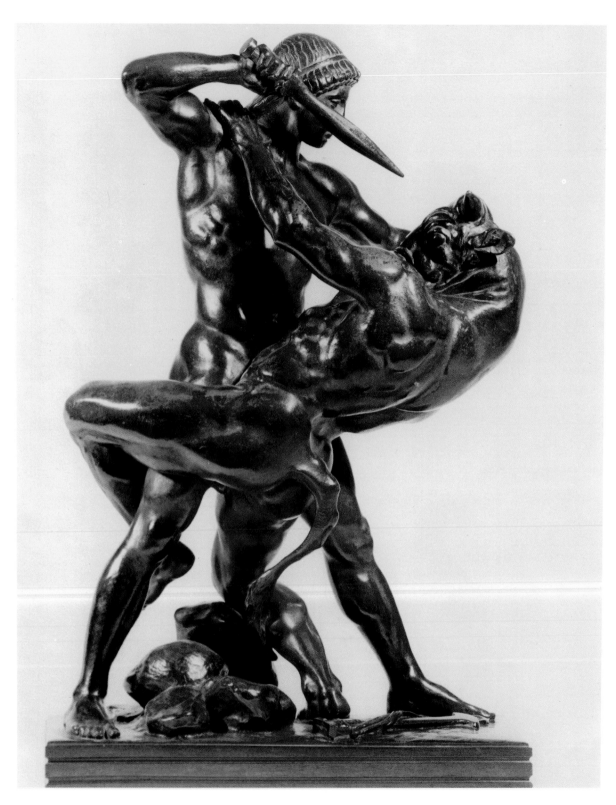

22. *Theseus Fighting the Minotaur*, c. 1843
Bronze
17¾ x 11¾ x 6⅜ in.
Museum Purchase, 73.38
ABOVE AND OPPOSITE

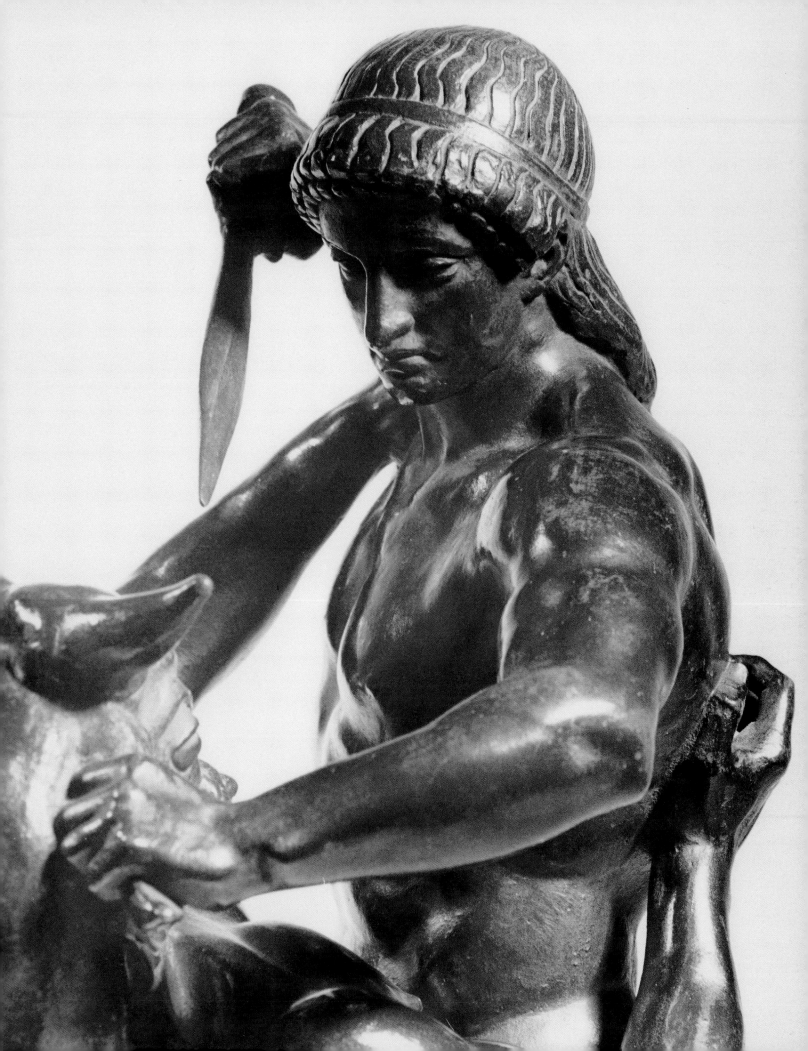

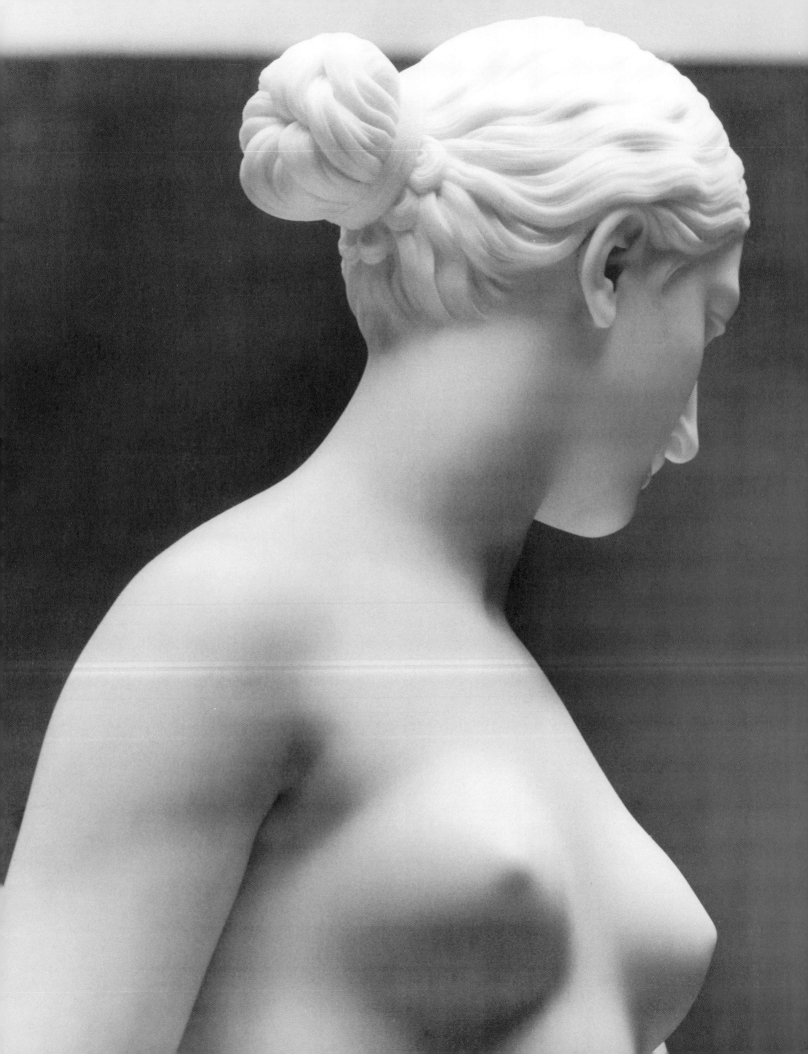

# Hiram Powers

[1805–1873]

THE GREEK SLAVE (Fig. 23) is the most famous sculpture in the Corcoran collection. It was first shown in 1845 in London and two years later toured the U.S., where it created a sensation. More than 100,000 people paid admission to see it, many considered it one of the greatest works of the century. During the 1847–1848 tour of the United States, Powers himself is said to have described the sculpture this way:

> The Slave has been taken from one of the Greek Islands by the Turks, in the time of the Greek Revolution; the history of which is familiar to all. Her father and mother, and perhaps all her kindred, have been destroyed by her foes, and she alone preserved as a treasure too valuable to be thrown away. She is now among barbarian strangers, under the pressure of a full recollection of the calamitous events which have brought her to her present state; and she stands exposed to the gaze of the people she abhors, and awaits her fate with intense anxiety, tempered indeed by the support of her reliance upon the goodness of God. Gather all these afflictions together, and add to them the fortitude and resignation of a Christian, and no room will be left for shame.[3]

The reviews of the U.S. exhibition of the sculpture were extraordinary:[4]

> It appears to me difficult to imagine a more beautiful and faultless representation of the 'human form divine.' So perfect is the form, and so delicate the finish, you forget you are looking at cold and lifeless marble, and yet such a sentiment of purity and innocence is stamped upon it that you lose the impression that it is nude. *Daily National Intelligencer, Washington, D.C., 30 August 1847.*
> Its presence is a magic circle within whose precincts all are held spell-bound and almost speechless. *The Courier and Enquirer, New York, NY, 31 August 1847.*

> People sit before it as rapt and almost as silent as devotees at a religious ceremony. As to the perfection with which the figure itself is executed, we cannot convey an adequate idea; in this respect the best works of the antique are certainly very far inferior to the Slave. *New York Daily Tribune, 15 September 1847.*

> The artist has had the creative vigor to reproduce, in its indescribable symmetry, its matchless grace, its infinite beauty, that chief marvel of the earth, the human body, making transparent through these attributes, deep inward power and emotion; and it is because he has had this inspired mastery, that, standing before his work, the beholder is not only spell-bound by beauty, but awed by a solemn, ineffable feeling, and mysteriously drawn closer into the chastening presence of God. *G.H. Calvert, "The Process of Sculpture," The Literary World, New York, 18 September 1847.*

As the sculpture traveled across the United States, the ecstatic reviews followed it. In some cities, however, the slave was considered such a challenge to contemporary mores that men and women visitors had to view her separately. Poets extolled her beauty with such lines as: "Thou art become a soul, sweet marble life;"[5] "Freedom from touch of sacrilegious hands, / And homage of pure thoughts;"[6] "I gaze alone / Upon the heart's long throbs – / Still – and so slow! – They melt – they die!;"[7] "Immortal in thy beauty, / Sorrow grows with thee divine."[8]

Such paeans of praise about a sculpture might seem strange to us today, but as I gazed through my camera lens and snapped my shutter again and again to capture every detail of this sensuous figure on film, and as I worked in the darkroom printing many of those images, I could understand why people were so taken by this female beauty.

I have photographed other sculptures by Powers and have always felt that he had a unique way of representing the softness of a woman's body. There are nine other marble sculptures by him at the Corcoran, all busts. When I photographed them they were installed in niches above eye level, however, I was able to see them clearly through a long lens. *Proserpine* (Fig. 25) has a lovely face and perfectly formed breasts surrounded by a wreath of flowers that add to their sensuousness. *Genevra (A Country Woman)* (Fig. 24) is unusual for Powers, for her bosom is covered with a simple dress; yet her face has the same lovely quality found in his other works.

*The Greek Slave* (detail, Fig. 23)

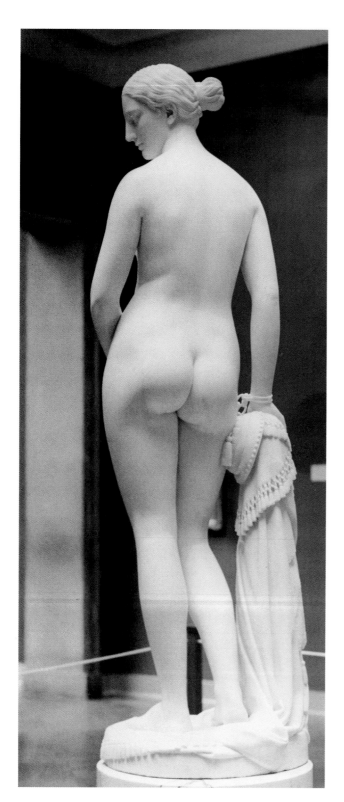
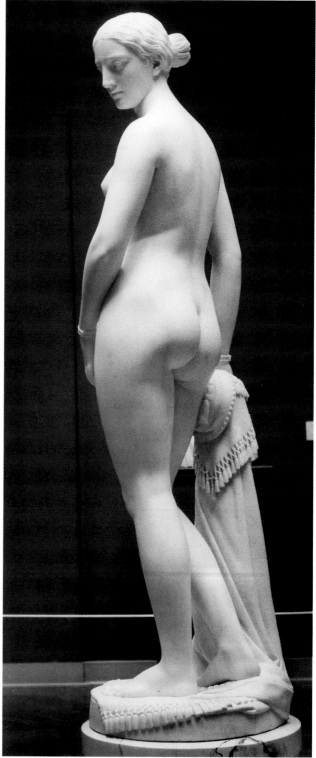

23. *The Greek Slave,* modeled 1841–43, carved 1846
Marble
65 x 19½"x 19½ in.
Gift of William Wilson Corcoran, 73.4
ABOVE, OPPOSITE AND FOLLOWING

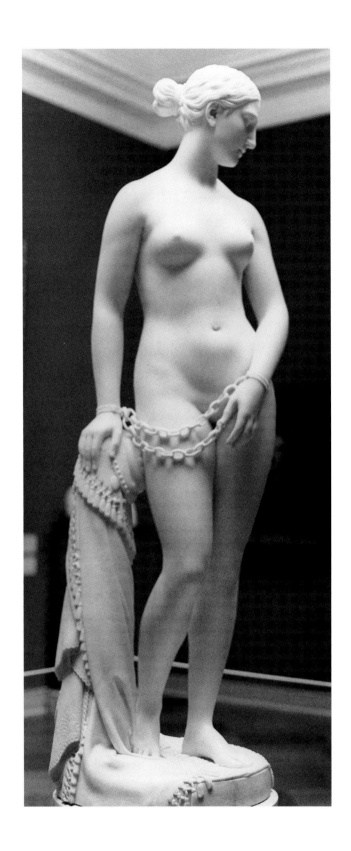

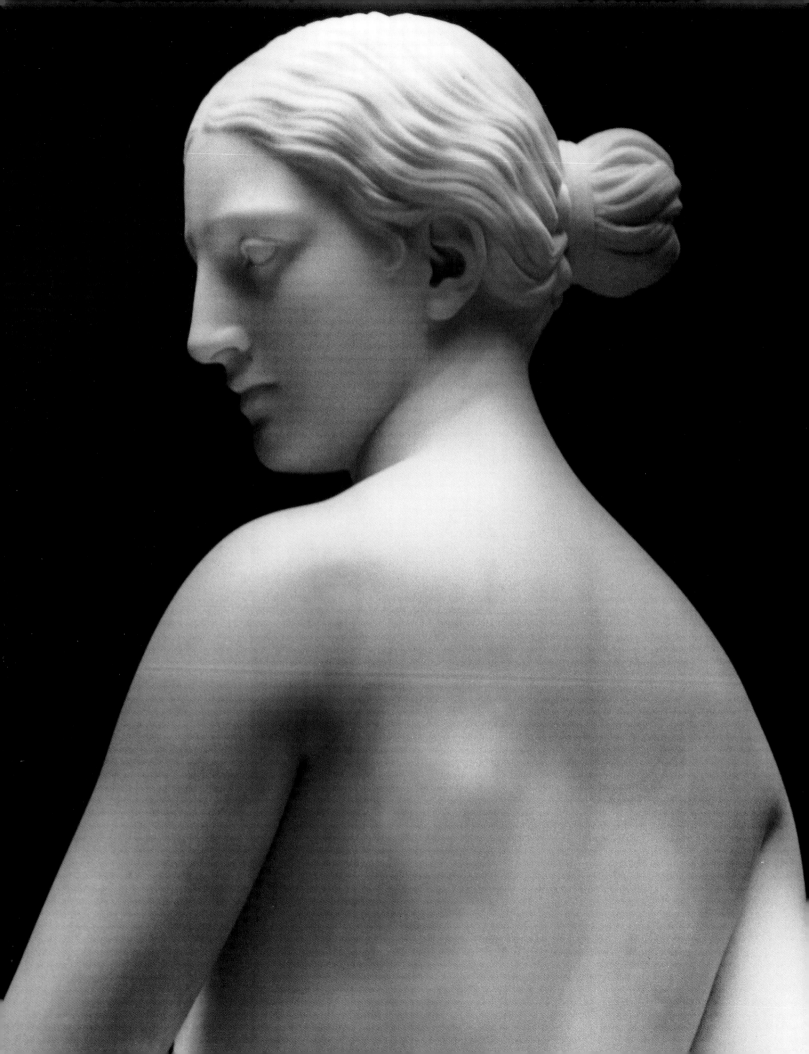

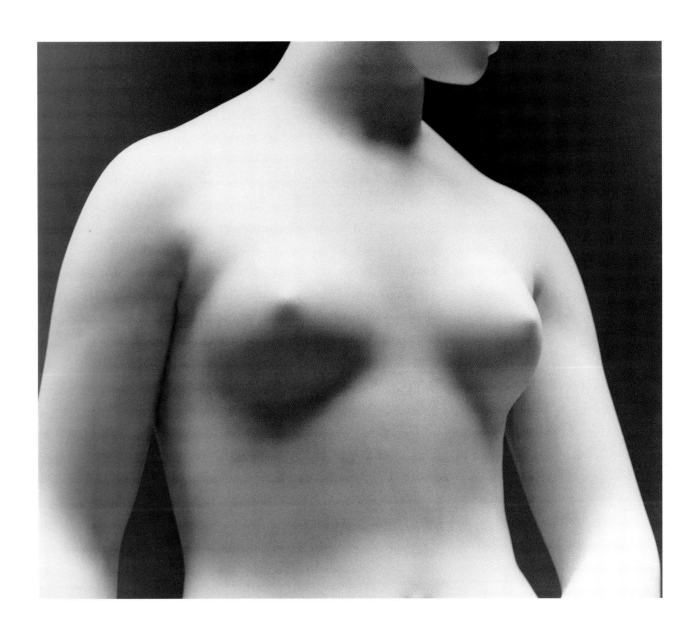

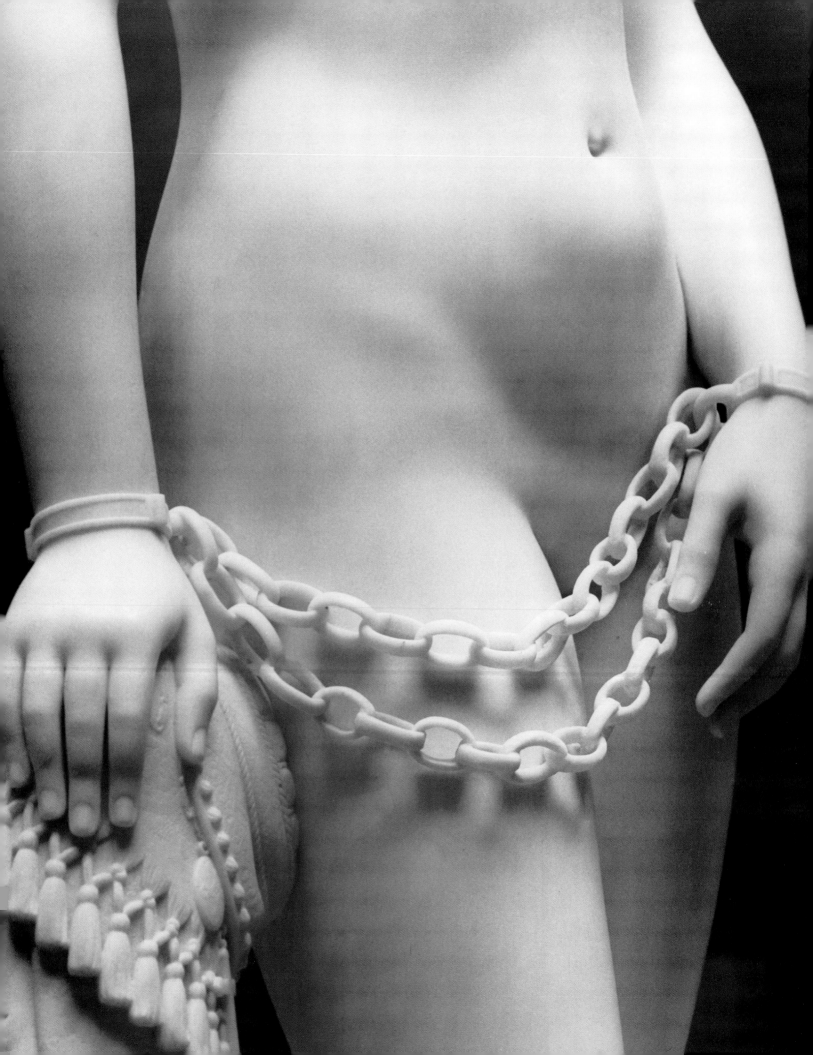

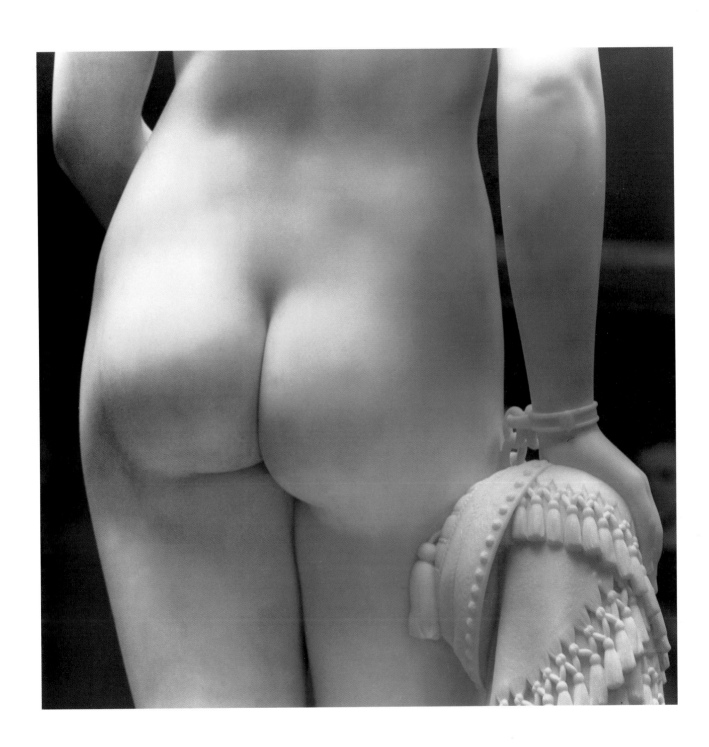

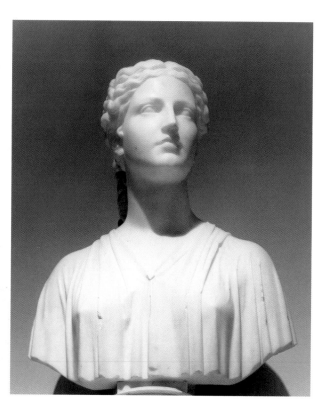

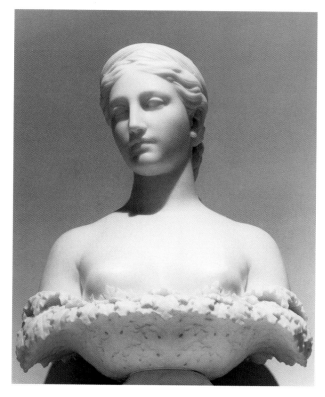

24. *Genevra (A Country Woman)*, 1837
Marble
23 x 18 x 10 in.
Gift of William Wilson Corcoran, 73.5

25. *Proserpine*, 1857
Marble
22 x 19⅜ x 11¼ in.
Gift of William Wilson Corcoran, 73.6
ABOVE AND OPPOSITE

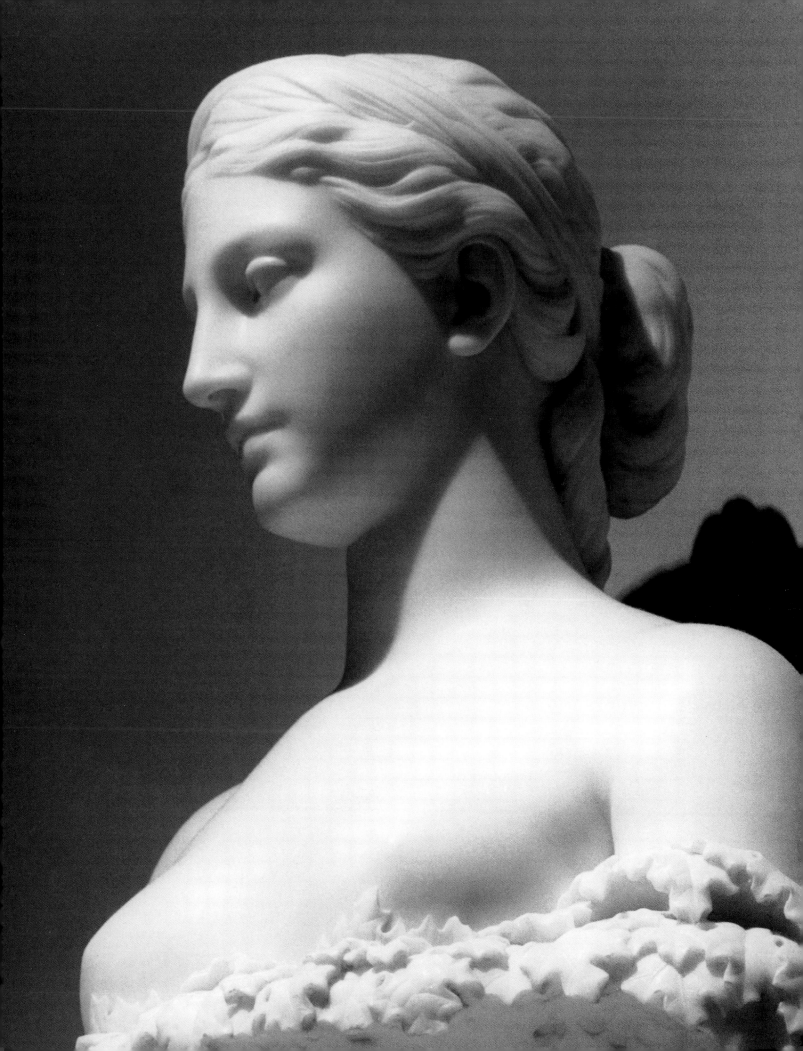

# Honoré Daumier

[1808–1879]

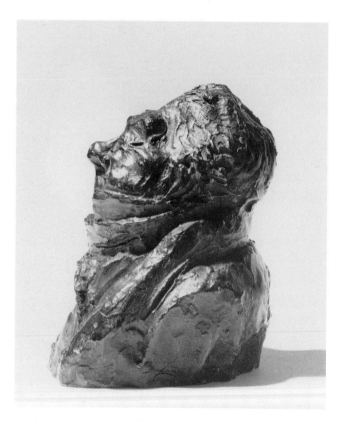

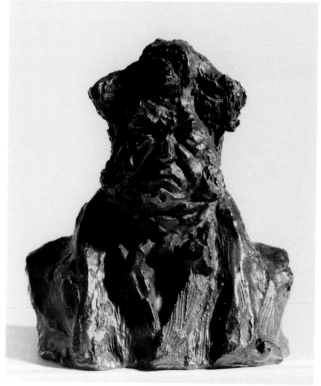

26. *Laurent Cunin (called Cunin-Gridaine), 1836*
Bronze
6¼ x 6 x 5½ in.
Gift of the Armand Hammer Foundation, 1980.93.3

27. *Charles-Guillaume Étienne, 1848*
Bronze
6 x 5¼ x 3¾ in.
Gift of the Armand Hammer Foundation, 1980.93.7
ABOVE AND OPPOSITE

KNOWN PRIMARILY for his satirical lithographs, of which he made over four thousand, Honoré Daumier also produced paintings and drawings that were admired by such friends as Delacroix, Corot, and Degas. Daumier's sculptural work is less well known; the Corcoran has nineteen of his bronzes. One of my favorites is a bust of Charles-Guillaume Étienne (Fig. 27), who, with piercing eyes, upturned nose and high collar, looks like a startled imp. Another favorite is a bust of Laurent Cunin (called Cunin-Gridaine) (Fig. 26), a fierce-looking gentleman with oddly shaped hair, heavy jowls, and down-turned lips; his dour expression gives the impression of a thoroughly unpleasant individual.

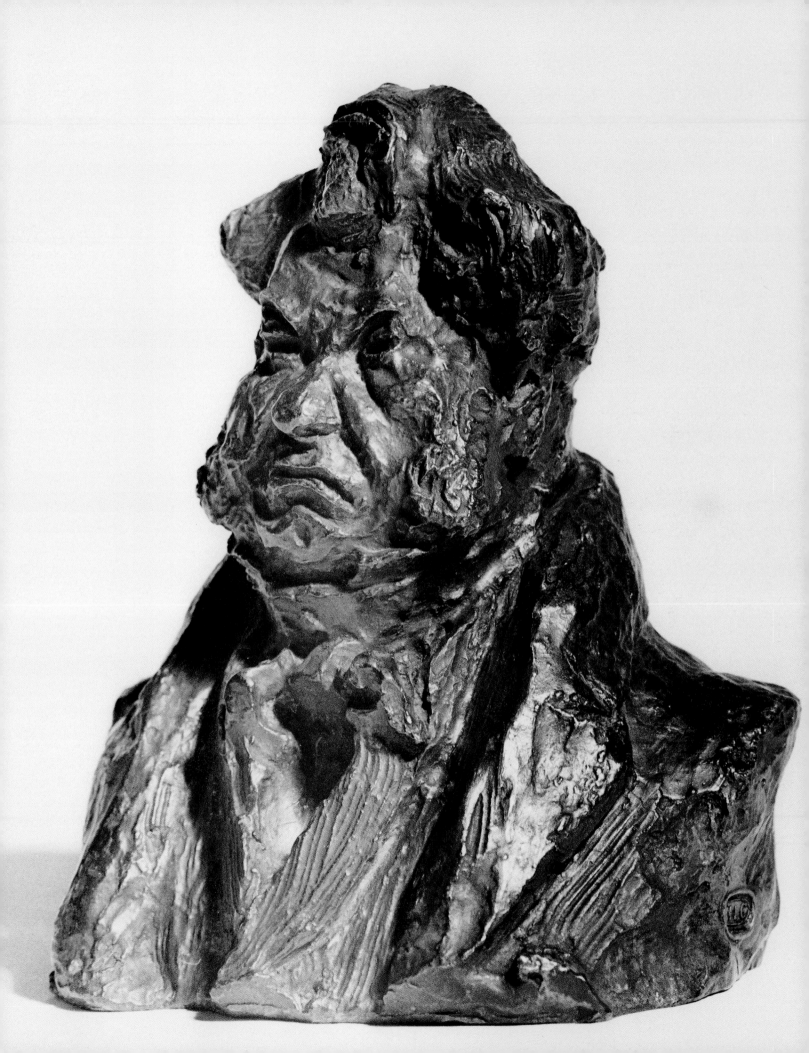

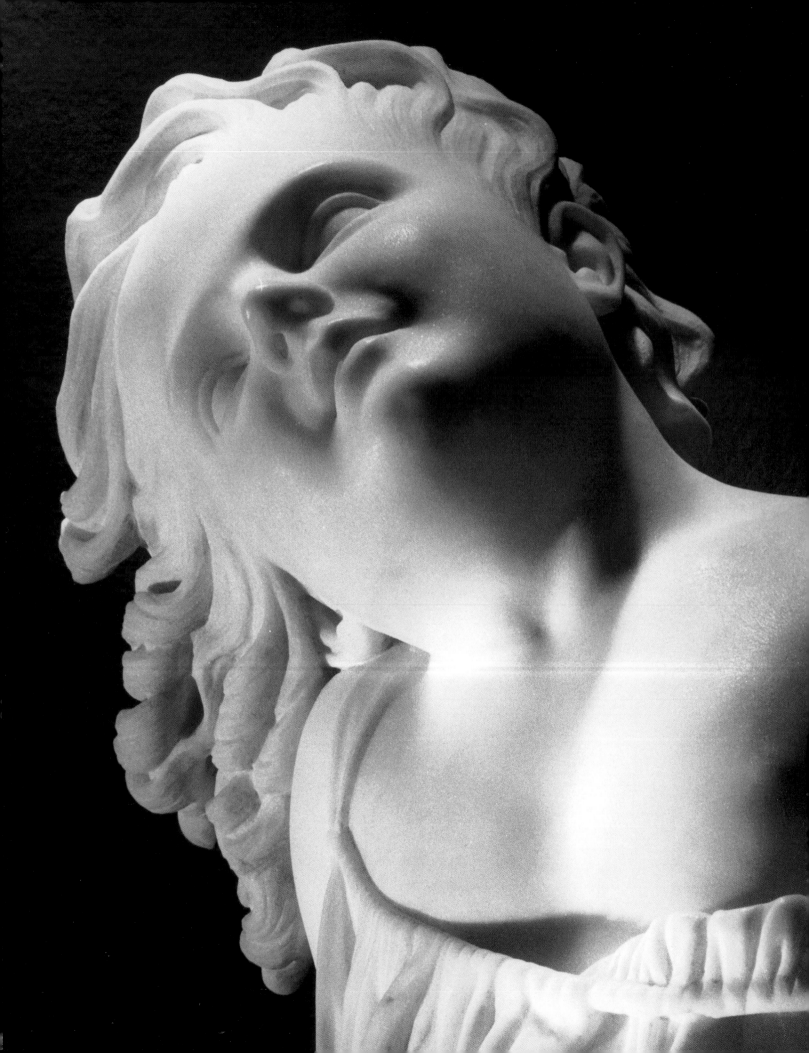

# Chauncey B. Ives

[1810–1894]

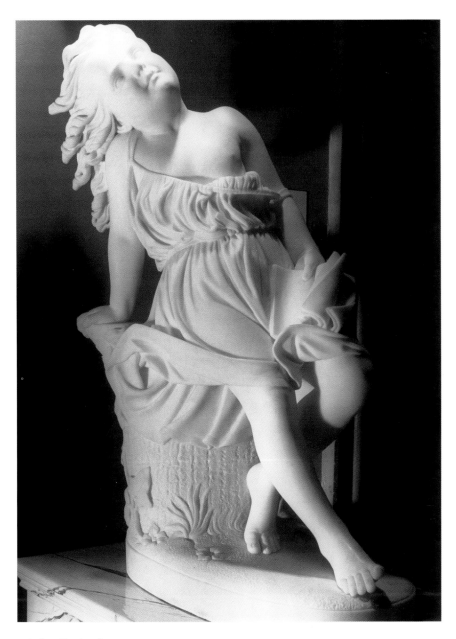

28. *Sans Souci*, n.d.
Marble
37 x 26 x 12 in.
Gift of John B. Henderson, 99.17
ABOVE AND OPPOSITE

BORN ON THE FAMILY FARM IN CONNECTICUT, Chauncey Ives' father apprenticed him early in life to a wood carver. Ives later had his own studio in Boston. When he was in his thirties he moved to Florence, Italy, and subsequently to Rome, where he spent the rest of his life. The swirling folds of the garment of this sculpture are well designed and a delight to photograph, as is the charming face of the child.

# Thomas Crawford

[1813–1857]

AMERICAN-BORN Thomas Crawford lived and worked in Rome for almost twenty years, and was widely recognized for his outstanding neoclassical sculptures. The Corcoran's version of one of his most striking works, *Peri at the Gates of Paradise* (Fig. 29), is over life-size. This grand portrayal of an angelic figure is sensitively carved, with a pensive, almost brooding face, hands clasped together, and one slightly raised knee. The drapery falls gracefully down the figure leaving one breast bare. As I photographed the sculpture, I wondered if "Peri" was a character from a mythological story, and discovered that it indeed was a kind of fairy in Persian mythology. Peris are delicate, gentle beings begotten by fallen spirits. Said to be of great beauty, they guided mortals who were pure of mind on their way to the land of the blessed. One of the tales included in the nineteenth-century Irish poet Thomas Moore's poetical romance, *Lalla Rookh*, is entitled "Paradise and the Pe'ri:"

*One morn a Peri at the gate*
*Of Eden stood, disconsolate;*
*And as she listen'd to the Springs*
*Of Life within, like music flowing*
*And caught the light upon her wings*
*Through the half-opened portal glowing,*
*She wept to think her recreant race*
*Should e'er have lost that glorious place!* [9]

These lines introduce the story of a Peri lamenting her expulsion from heaven and learning that she will be readmitted only if she brings to the Gate of Heaven the "gift most dear to the Almighty." She fails twice in her attempts, but finally succeeds by offering the tear of a repentant man. Crawford's sensitive figure, with its downcast eyes and supplicating manner, may well depict this forlorn spirit awaiting God's judgment outside heaven's gate.

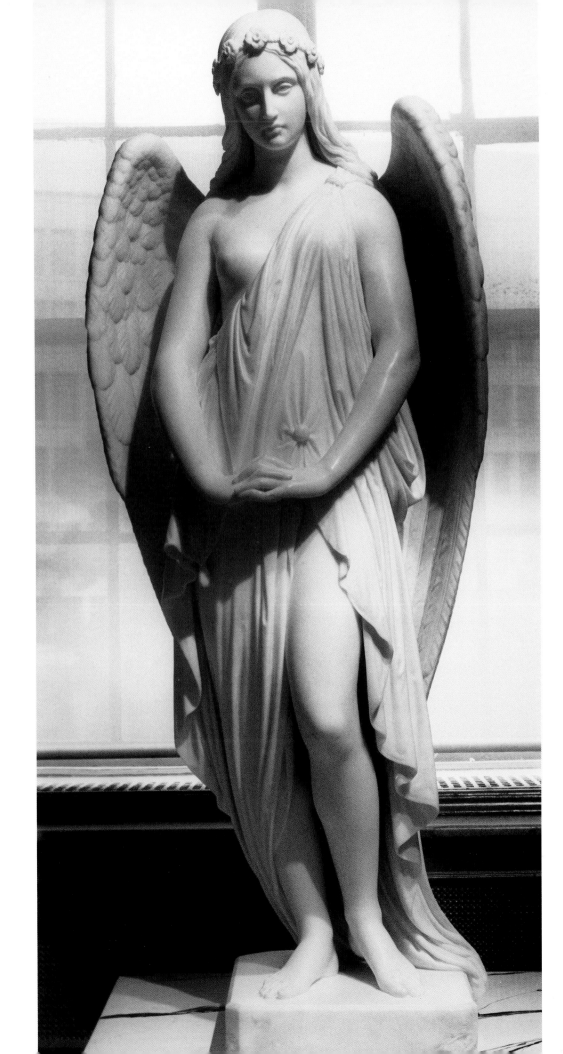

*29. Peri at the Gates of Paradise*, 1855
Marble
60 x 27¼ x 18¾ in.
Museum Purchase, 86.10
RIGHT AND FOLLOWING

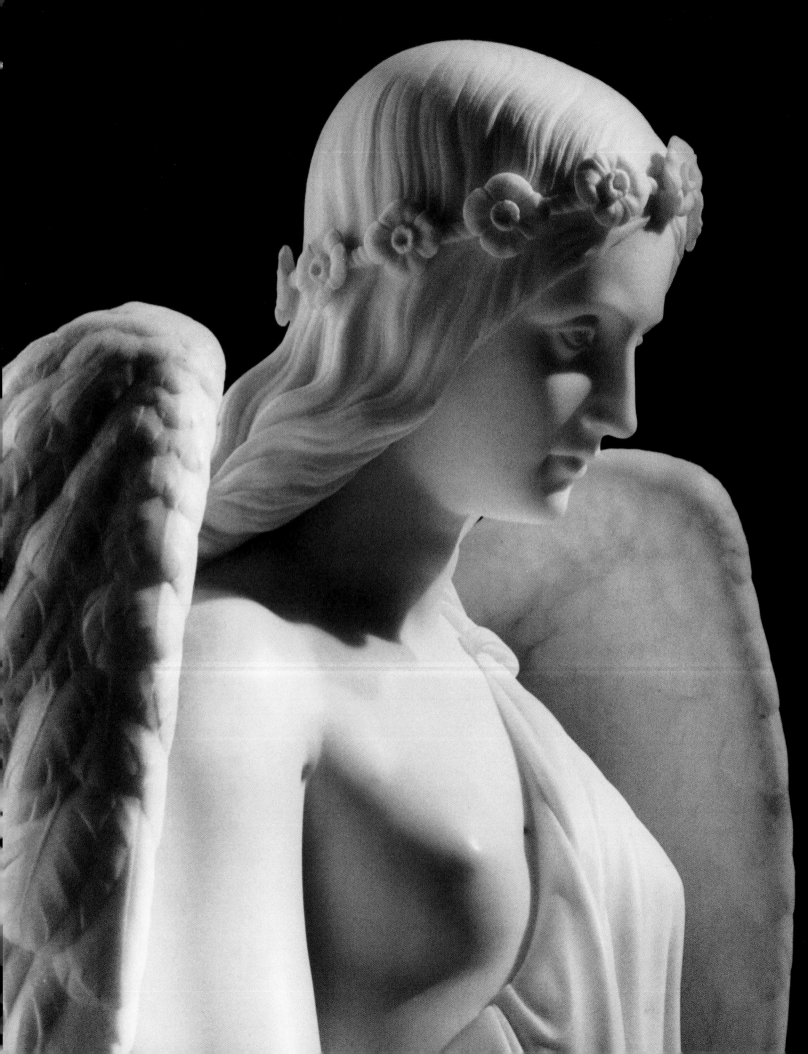

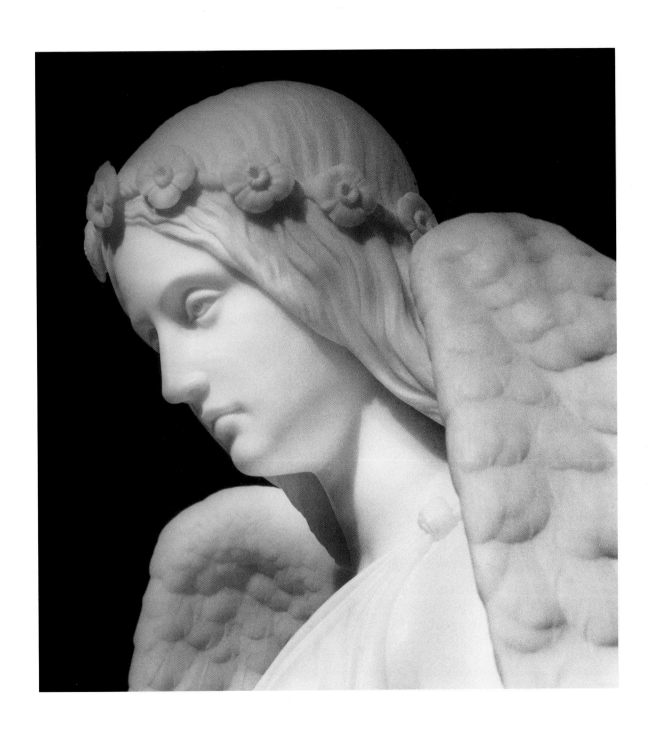

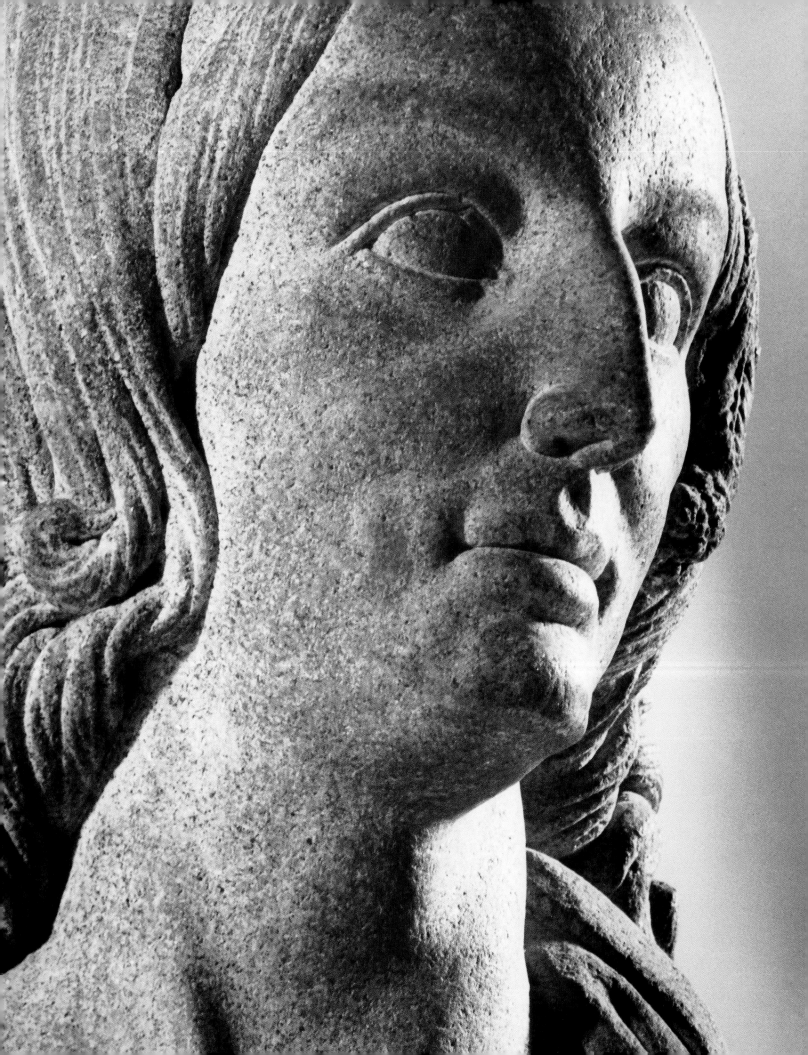

# William Rimmer

[1816–1879]

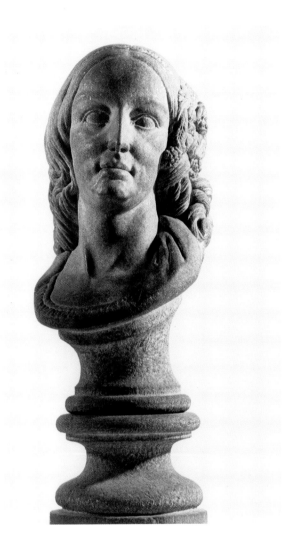

30. *Head of a Woman*, n.d.
Granite
19 x 9 x 9⅜ in.
Gift of Mrs. H. Simonds, 20.4
LEFT AND OPPOSITE

WILLIAM RIMMER was not recognized by his contemporaries as a major figure in the world of sculpture. However, in the words of artist/sculptor Leonard Baskin, who wrote a preface to a book on his work: "Rimmer stands after [William] Rush and [John Quincy Adams] Ward as the great American sculptor of the nineteenth century, with the possible exception of Eakins, with whom he shared the calumny of the philistines and the obloquy of the academy." [10]

Rimmer was born in Liverpool and brought to Boston by his parents when he was two years old. He eventually went to medical school and practiced as a doctor, later becoming a painter of some note and, finally, a sculptor. In 1855, Rimmer moved with his family to East Milton, Massachusetts, where, according to all accounts, his medical practice was quite small and his income limited. However, one of his patients, who happened to be in the granite business, recognized that his doctor was an uncommon man, and not only helped financially but provided him with the granite he used to carve this life-size *Head of a Woman* (Fig. 30) as well as his better-known bust, *St. Stephen*. Rimmer worked directly in stone, never preparing sketches or models in advance. His thorough knowledge of anatomy enabled him to produce works with much delicacy and fine modeling, despite the coarseness of this medium. As I photographed *Head of a Woman*, I was struck by the strength of the forms, the softness and sensitivity of the eyes and mouth, and the delicacy of the flowers entwined in the hair, as well as by the unusual effect of the rough granite.

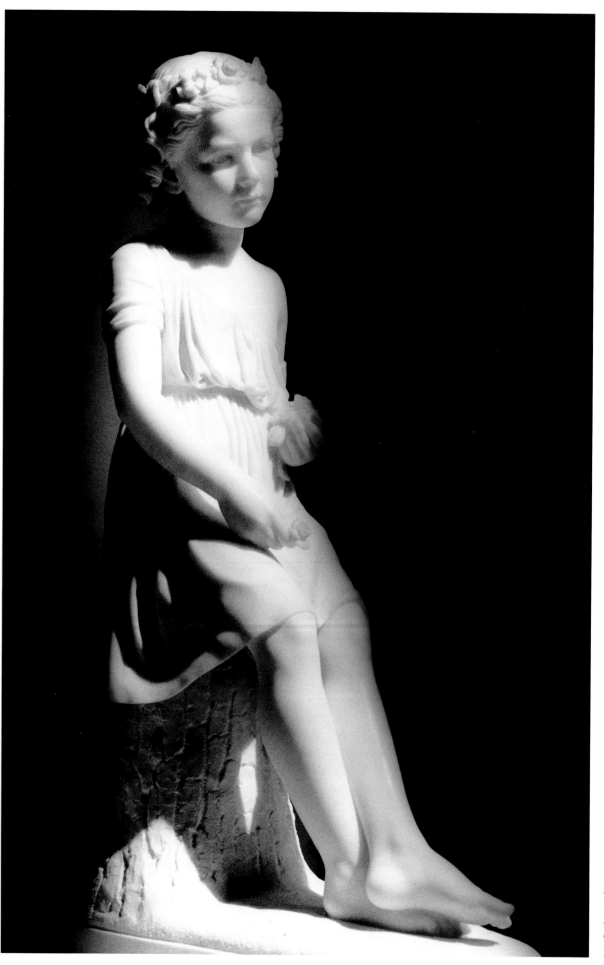

31. *Roma Lyman,* 1873
Marble
42½ x 24 x 12½ in.
Gift of the subject, Roma
Lyman Niles, 47.19

# William Henry Rinehart

[1825–1874]

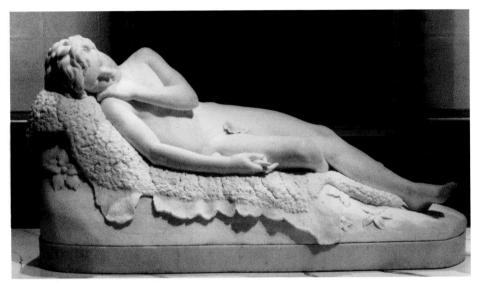

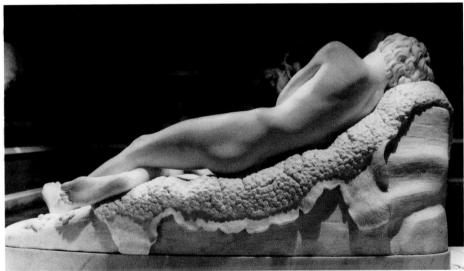

32. *Endymion*, 1874
Marble
23½ x 50¾ x 16¼ in.
Museum Purchase, 75.9
LEFT AND FOLLOWING

THE CORCORAN owns six sculptures by William Henry Rinehart. Born on a farm near Union Bridge, Maryland, Rinehart worked at his father's stone quarry at an early age. Later, he was employed as a stonecutter in Baltimore and began to accept private sculpture commissions. When he was 30 years old, a group of his patrons financed a trip to Florence, Italy, where he studied classical sculpture. After a brief trip home, he returned to Italy and settled in Rome, where he concentrated on portrait busts. The two works at the Corcoran, however, depict full figures. One, *Roma Lyman* (Fig. 31), portrays a young girl with a wreath around her head, seated in a classical pose. It is an accomplished work; the fleshly surfaces of the child's face, arms and legs, and the folds of the garment are well executed. The second sculpture, *Endymion* (Fig. 32), is even more impressive. Here, the face of the youthful sleeping shepherd, upon whom the Greek god Zeus is said to have bestowed the gift of perpetual youth united with perpetual sleep, is sensitively carved. Endymion's unclothed figure, lying on a soft animal skin, is finely modeled, his left hand resting under his chin and his right arm stretched out.

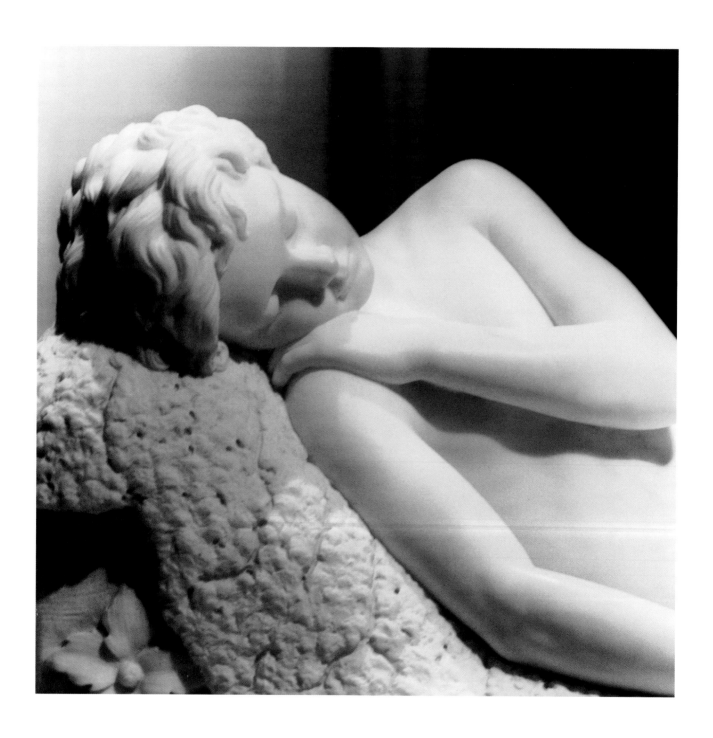

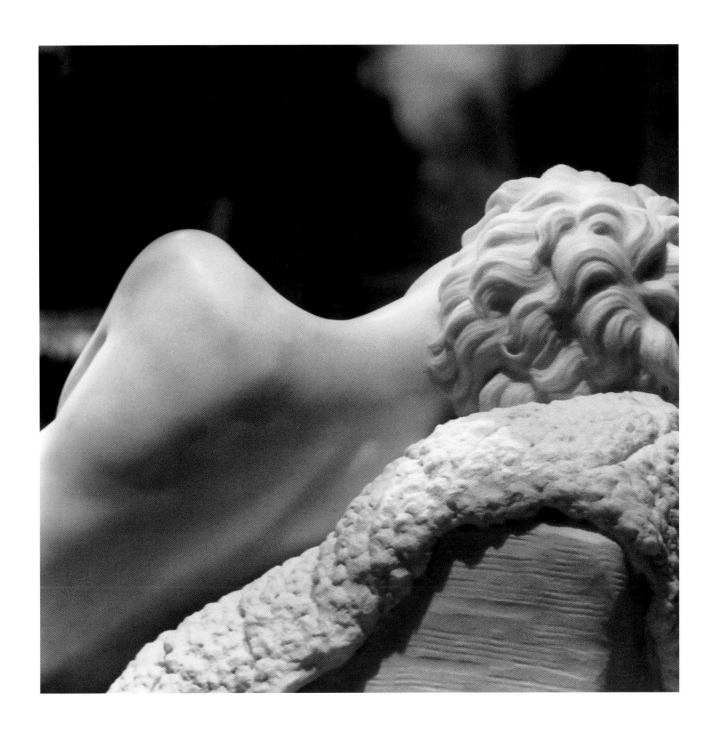

# Alexander Galt

[1827–1863]

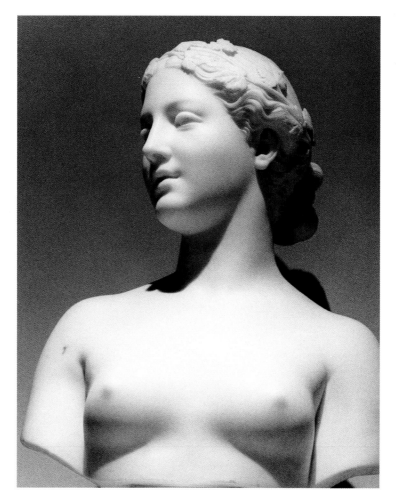

33. *Bacchante*, n.d.
Marble
20⅞ x 16 x 8⅞ in.
Gift of William Wilson Corcoran, 73.7
ABOVE AND OPPOSITE

ALEXANDER GALT was born in Norfolk, Virginia, the son of the local postmaster. Galt's first sculptures were miniatures carved from chalk; later he created small alabaster figures and cameos from conch shells. At the age of twenty-one he traveled to Florence to study, and by 1853, at the age of 26, was an established sculptor. During his short life he created a number of impressive pieces, but the one for which he is best remembered today is the life-size marble of Thomas Jefferson commissioned by the Virginia General Assembly in 1854 as a gift to the University of Virginia. It stands today in the Rotunda of the University. Galt enlisted on the side of the South when the Civil War broke out, and in 1862, while visiting General Stonewall Jackson's camp to take measurements for a proposed statue, he contracted smallpox. He died the following year.

Galt drew inspiration for a number of his works from ancient Greece and Rome. The marble bust in the Corcoran's collection is called simply *Bacchante* (Fig. 33). The smiling figure has some of the same formal qualities as busts by Hiram Powers, although it lacks the magical rendering of flesh characteristic of the older sculptor's work.

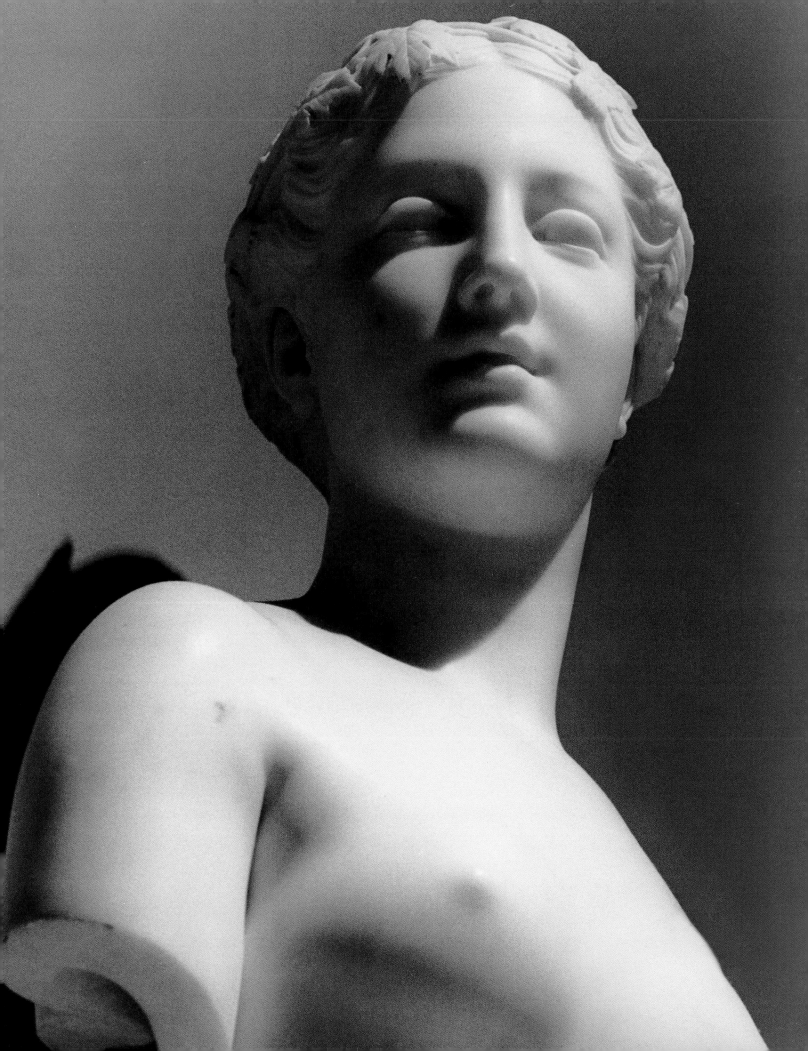

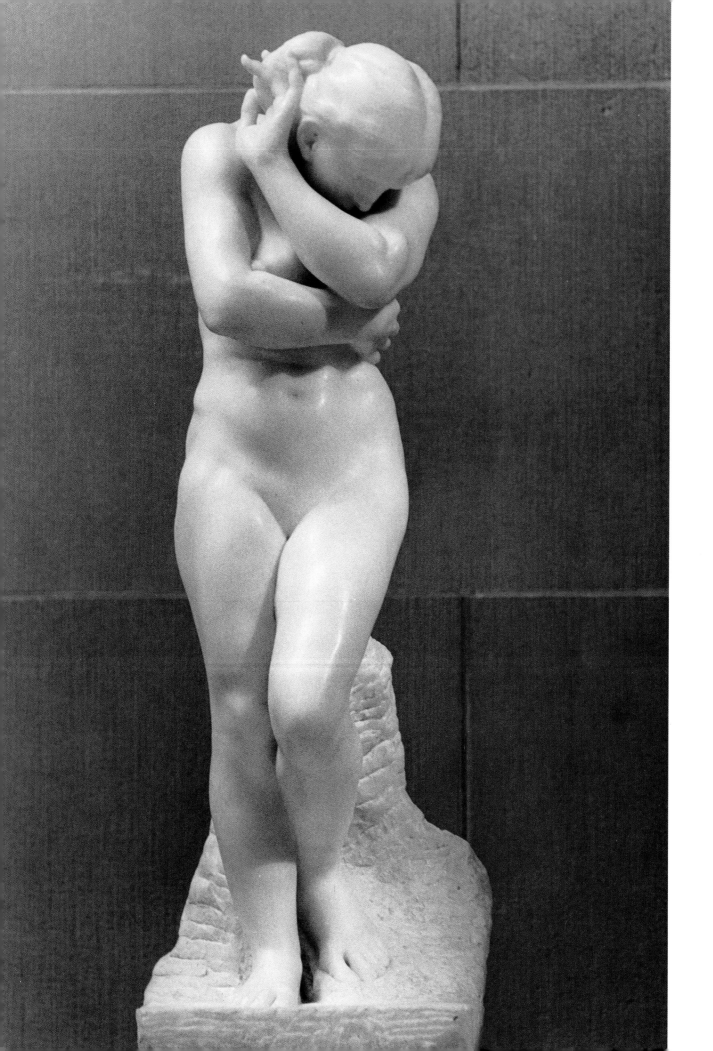

# Auguste Rodin

[1840–1917]

BEFORE DISCUSSING two fine marble sculptures by Auguste Rodin in the Corcoran collection, I must apologize for a slight diversion. Many years ago I attended a lecture by the art historian Herbert Read at the New School in New York. I was surprised when Read stated that the four greatest sculptors in the history of Western art were Phidias, Michelangelo, Rodin, and Henry Moore. Moore, who later became a good friend of mine, laughed when I told him years later about the remark. He said that as a student, he was devoted to the concept of "truth to materials," and had scorned the sculptures of the Parthenon by Phidias. But Michelangelo had always been a heroic figure for him and Rodin was another sculptor whom he admired greatly. He would not have disagreed that these three were among the greatest sculptors of all time, and was obviously complimented to have been ranked with them.

My guess is that Moore would have preferred the bronze version of *Eve* to the marble (Fig. 34), but to my eyes the marble, which was created afterward, is exquisite. The sculpture was originally created for Rodin's famous work *The Gates of Hell,* and subsequently exhibited together with his figure of *Adam* at the Paris Salon of 1899. Several other sculptors exhibited their versions of *Eve* at the Salon, but none matched the emotional strength of Rodin's. With head bent down in shame, face buried in one arm while the other covers the breasts, her nude body still seeming too naked, she is an unforgettable figure. Although there are several other versions of this marble, there is no doubt that the Corcoran *Eve* is a masterpiece.

The other Rodin in the Corcoran is less well known. It is of *Paolo and Francesca* (Fig. 35), inspired by the passage in Dante's *Inferno* (v. 73–138) where Dante describes the two lovers cleaving the air, "so light before the wind / as doves / on wide wings / wafted by their will." Francesca de Rimini was married to a wealthy but deformed man, and had fallen in love with her husband's handsome brother, Paolo Malatesta. One day, carried away with emotion, the two stole a kiss. The husband caught them and killed them both. The doomed couple were condemned to the second circle of hell—designated for carnal sinners—where they were tossed about ceaselessly by furious winds. Dante was so moved by their love for each other and their tragic doom that he fainted, "not far from death," upon seeing them. Rodin has captured the story with a marble carving of forms that swirl about the two nude figures locked in a passionate embrace. Despite their tragic fate, the faces of Paolo and Francesca, frozen in ecstasy, reveal their eternal love for each other.

34. *Eve,* c. 1881
Marble
30 x 9¾ x 12 in.
William A. Clark Collection, 26.704
OPPOSITE AND FOLLOWING

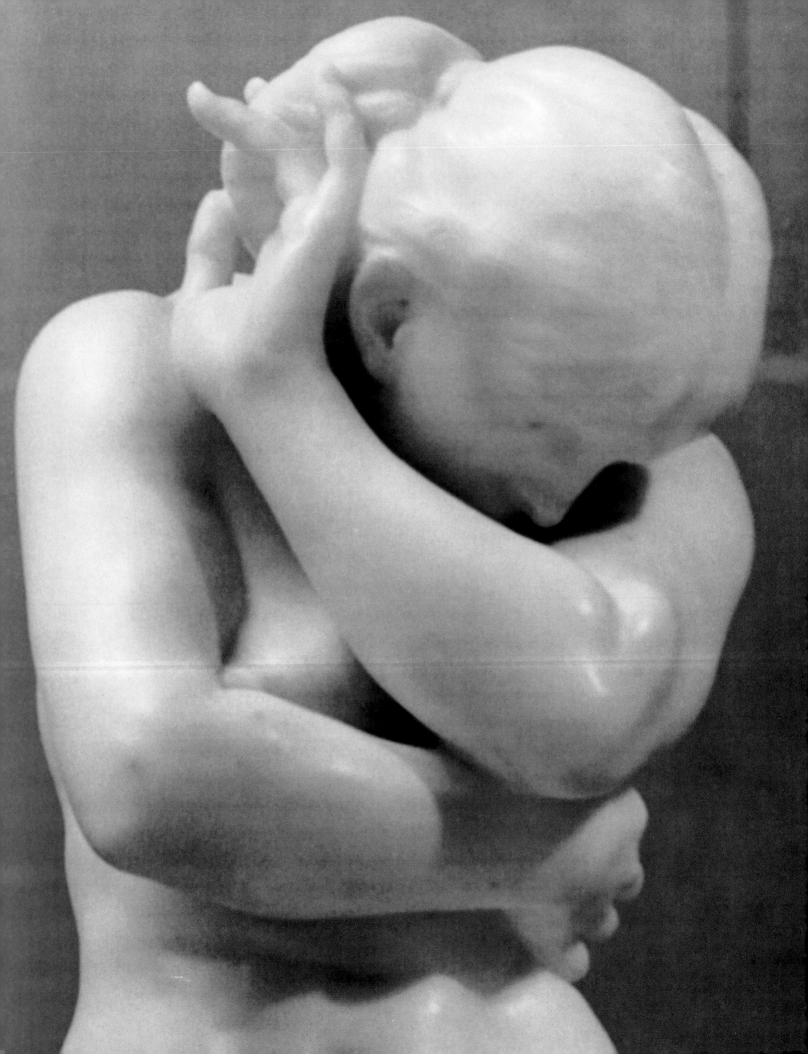

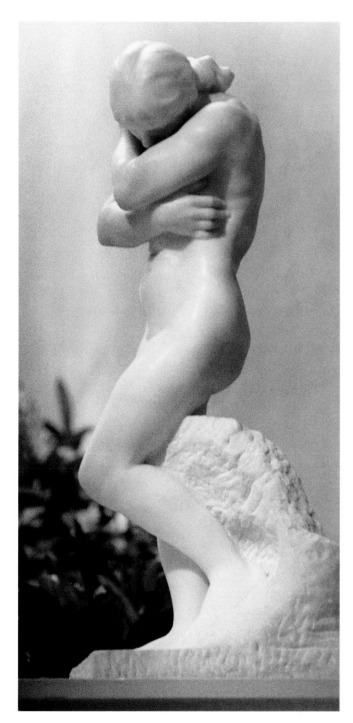
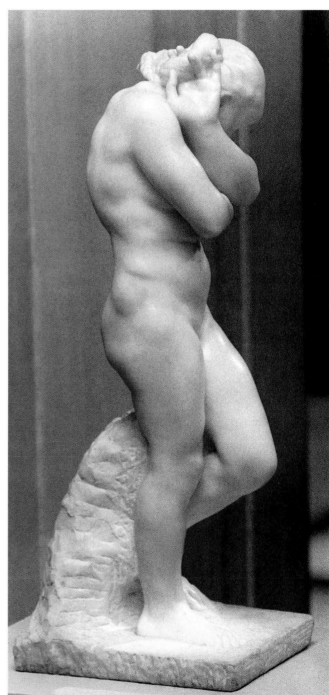

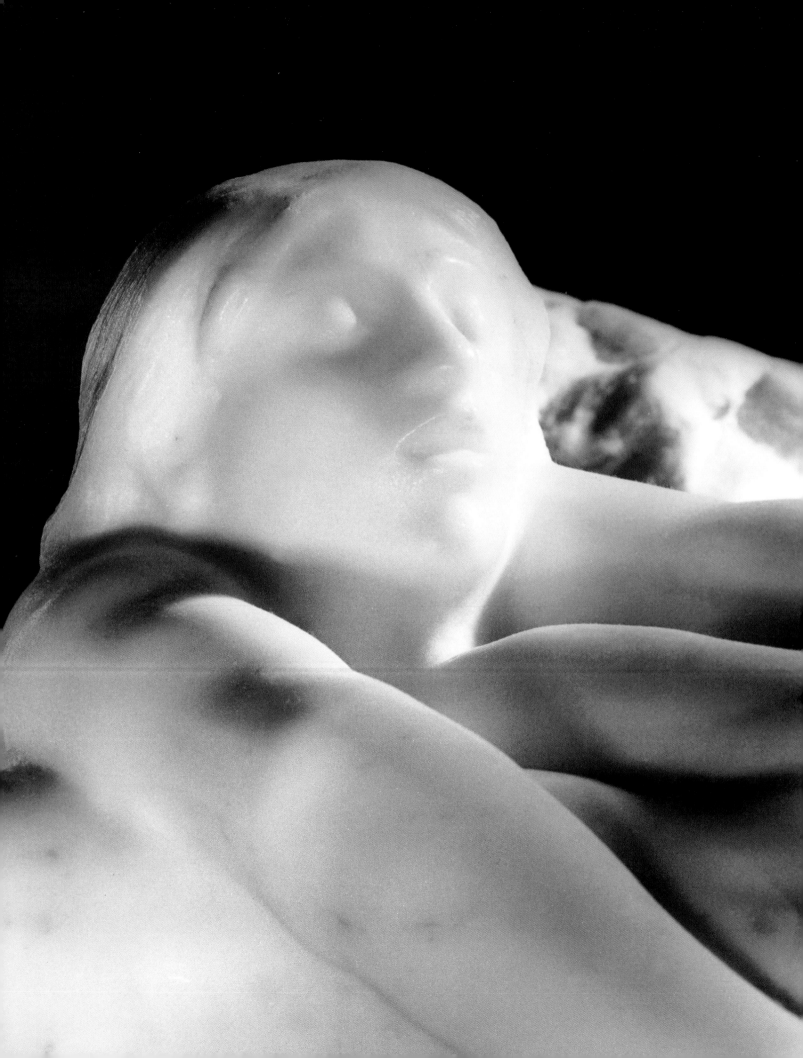

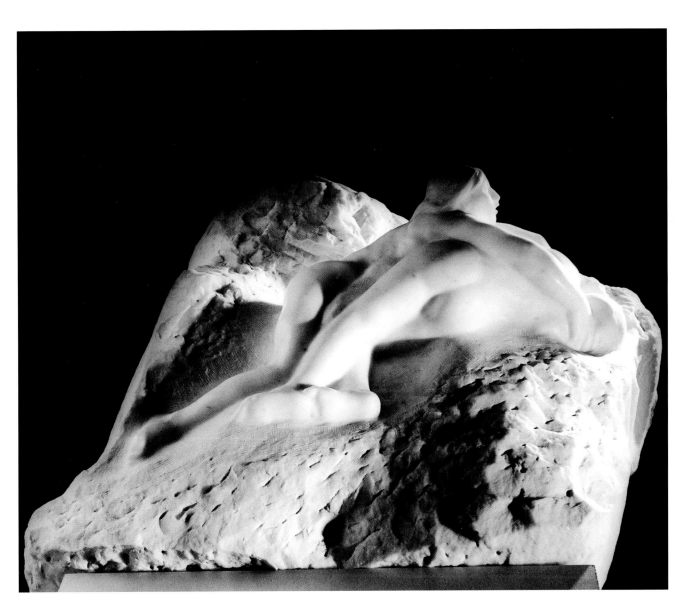

*35. Paolo and Francesca*, c. 1909
Marble
21 x 36 x 42 in.
Gift of Mrs. Eugene Meyer, 36.5
ABOVE, OPPOSITE AND FOLLOWING

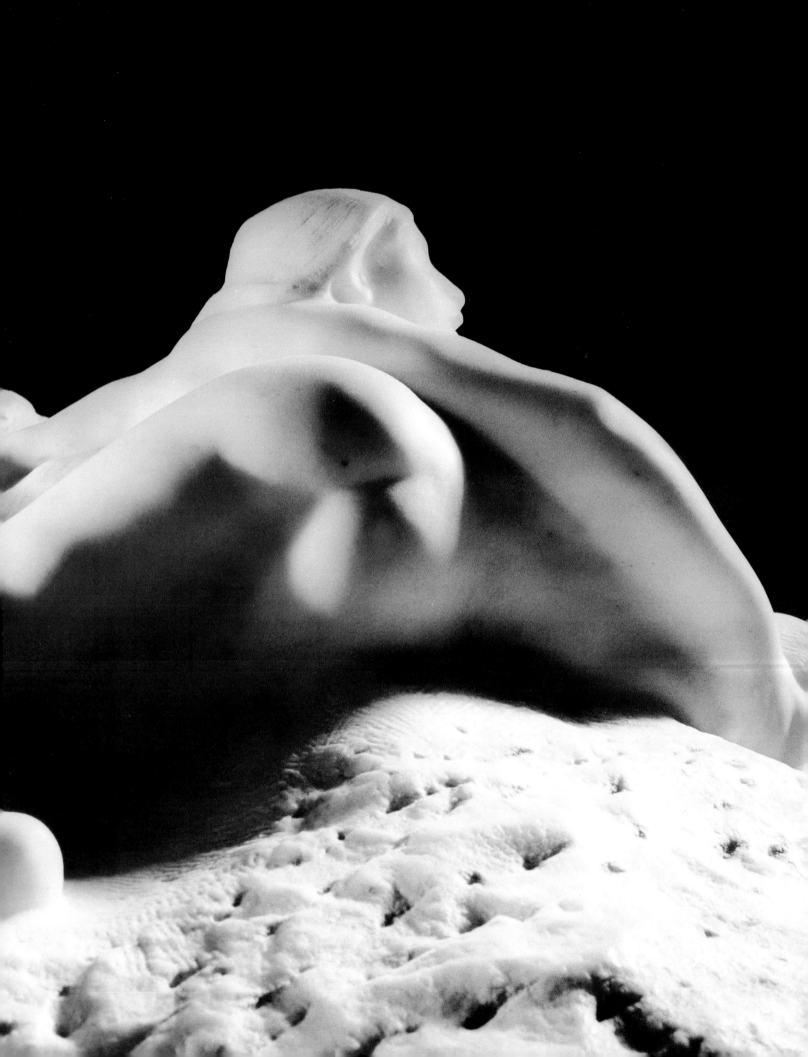

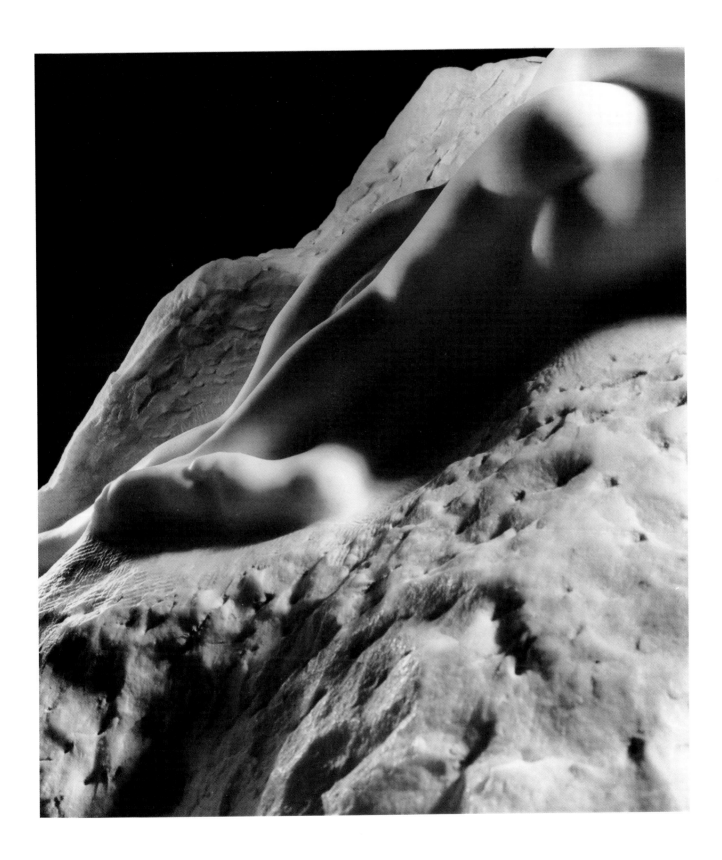

# Thomas Eakins

[1844–1916]

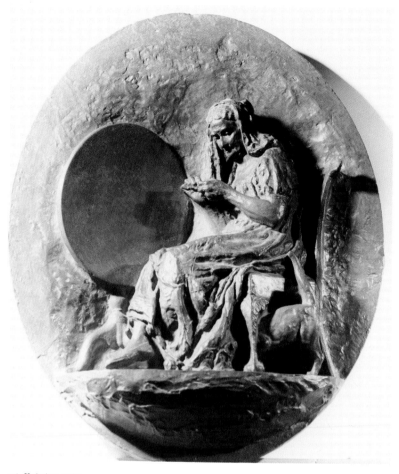

36. *Knitting*, 1881
Bronze
18½ x 14⅞ in.
Casting (1967) made from plaster owned by the Corcoran Gallery of Art, 67.19
ABOVE AND OPPOSITE

IT WAS A DELIGHTFUL SURPRISE for me to photograph the small oval relief sculpture of a woman, entitled *Knitting* (Fig. 36), by Thomas Eakins. Eakins is known primarily as a painter, although his friend, Walt Whitman, called him "a force." As Director of the Schools and Professor of Painting at the Pennsylvania Academy of the Fine Arts, he encouraged the study of anatomy, dissection, and scientific perspective, but he was ultimately dismissed from his position after he removed the loincloth from a male model in a class of male and female students. Eakins believed that the nude human figure was the most beautiful thing in nature. An often-repro-

duced drawing of his shows a masked figure of a non-idealized female nude with drooping breasts and bulging thighs, which seems to be a critique of the prudery of his time. His photographs of figures in motion, stimulated by the work of his friend Eadweard Muybridge, were made with a device utilizing revolving discs that he designed and built himself. The Corcoran relief (there are two versions in the collection, one bronze and one plaster) is similar in technique to Eakins' relatively few other sculptures, particularly the frieze *Arcadia*. *Knitting* is an impressive figure of a woman similar to some of those seen in his genre paintings.

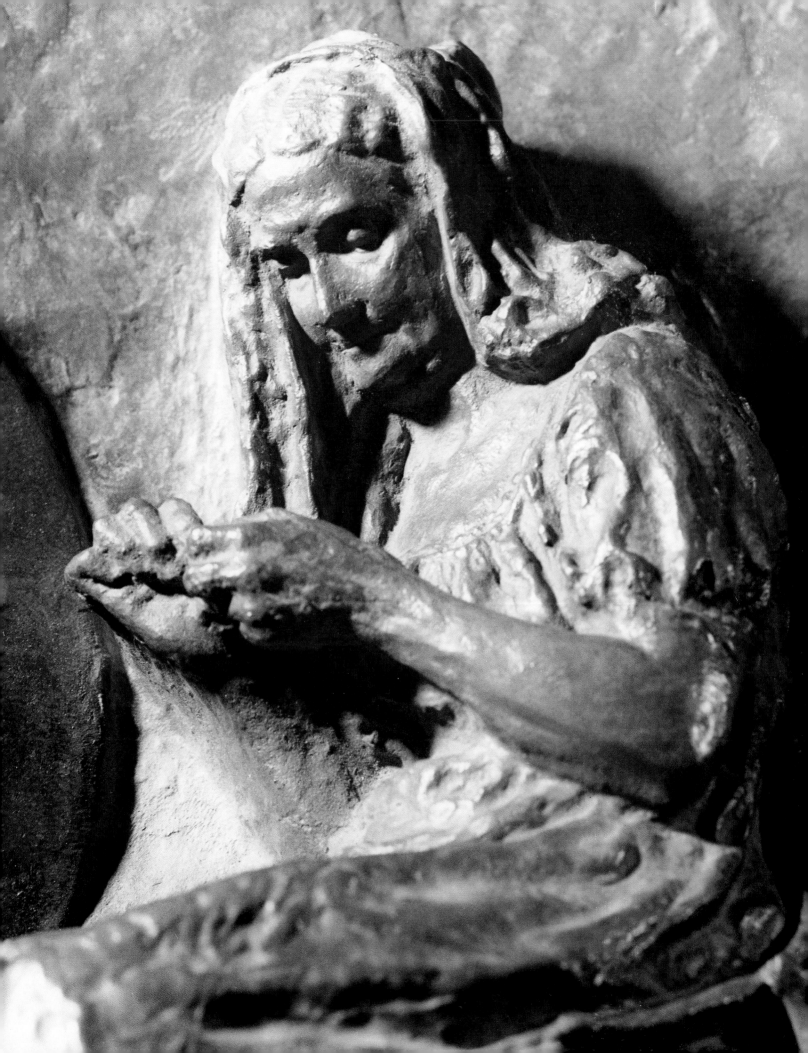

# Augustus Saint-Gaudens

## [1848–1907]

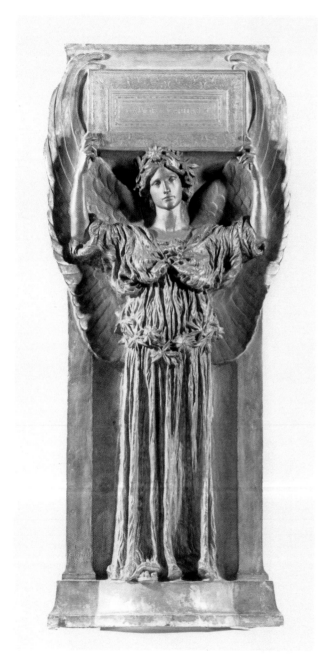

37. *Amor Caritas*, 1898
Bronze
40⅜ x 18½ x 3½ in.
Museum Purchase, 42.4
ABOVE, OPPOSITE AND FOLLOWING

THE BEST-KNOWN American sculptor at the turn of the twentieth century was Augustus Saint-Gaudens. Some years ago, when a biography of Saint-Gaudens, *Uncommon Clay* (Harcourt Brace Jovanovich, 1985), was being written, its author, Burke Wilkinson, asked if I wanted to photograph all of Saint-Gaudens' major sculptures for the book. I was delighted to do so and it proved to be an adventure to photograph the monuments in New York, Philadelphia, Washington, D.C., Boston, Chicago, and other cities, as well those in the sculptor's home in Cornish, New Hampshire, now a National Historic Site. I was impressed by the monumental realism of his public sculptures and the sensitivity of his smaller portraits.

Among the seven impressive Saint-Gaudens sculptures at the Corcoran, I have two favorites. One is an especially moving angelic figure holding up a tablet inscribed *Amor Caritas* (Fig. 37). It is unusual for a sculpture to have its title—in this case, literally translated as "Love Charity"—displayed so prominently, and I couldn't help wondering if it was originally intended for a memorial or a monument. As I researched the sculpture, I found that my suspicion was correct. The figure is a reworking of one of three angels carved for the tomb of Edwin D. Morgan, a former governor of New York State. But before the tomb was completed, the figures were destroyed in a fire. The original eight-foot-high bronze cast of *Amor Caritas* was purchased by the French government in 1898; Saint-Gaudens also created forty-inch versions beginning in the 1890s. The woman who modeled for the sculpture (and many other of Saint-Gaudens' works) was his muse and mistress, Davida Johnson Clark. Her striking figure can also be seen in various versions of Saint-Gaudens' *Diana,* but in *Amor Caritas* we get a good look at her extraordinarily sensitive face, captivating eyes, classical nose, inviting lips, strong chin, flowing hair, and her delicate hands holding the plaque. The rest of the figure is less impressive—at least to me—with its lavishly flowing robe, the garland and crown of flowers around her waist and head, and her wings stretched out on both sides.

My other favorite Saint-Gaudens sculpture is a low-relief portrait in bronze of Saint-Gaudens' friend, the French painter Jules Bastien-Lepage (Fig. 38). This is one of many sensitively rendered portrait reliefs by Saint-Gaudens and one of three in the collection of the Corcoran Gallery of Art.

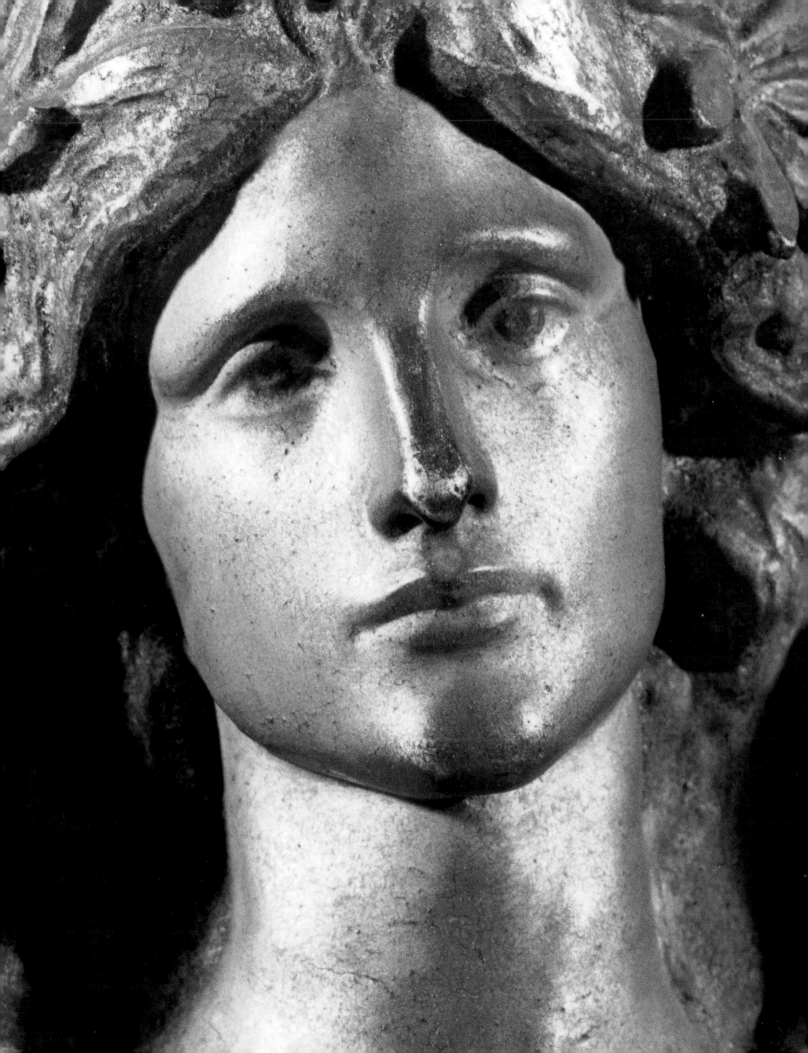

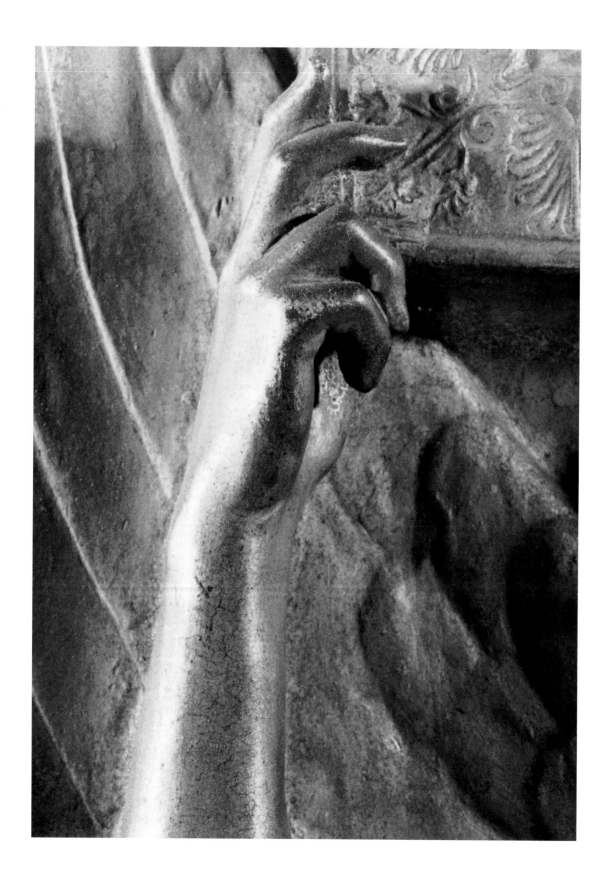

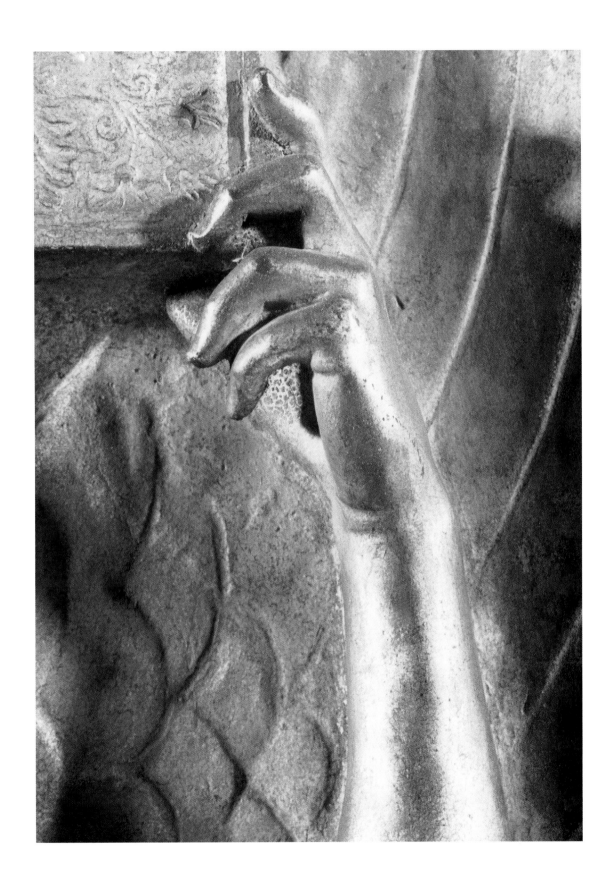

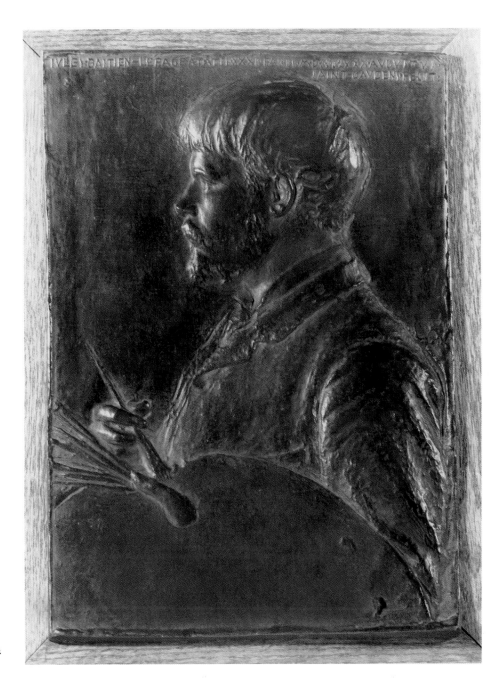

38. *Jules Bastien-Lepage*, 1880
Bronze
14½ x 10½ x ⅞ in.
Gift of Louis E. Shecter, 66.5.2

# Daniel Chester French

## [1850–1931]

DANIEL CHESTER FRENCH, like Augustus Saint-Gaudens, enjoyed great fame and critical success in the late nineteenth century. Although only two years younger than Saint-Gaudens, he lived twenty-four years longer and executed some of his best-known works in his later years, including several major monuments in New York City as well as the sculpture of Abraham Lincoln in the Lincoln Memorial in Washington, D.C. In the last year of French's life he completed a particularly sensuous sculpture, *Andromeda,* a reclining nude. This work and many others by the sculptor are preserved at Chesterwood, French's summer home and studio in Stockbridge, Massachusetts, now an historic house museum and National Historic Landmark. I have photographed the Chesterwood sculptures and others by French for various articles and books, and I find his artistic personality easier to grasp than that of Saint-Gaudens, although clearly both were great sculptors.

The major work by French in the Corcoran collection is a romantic sculpture with an imposing title taken from a verse in the Bible (Genesis VI:2), *The Sons of God Saw the Daughters of Man That They Were Fair* (Fig. 39), completed in 1923. It is a sensuous portrayal of a male angel embracing a young woman. Both figures are magnificently formed nudes, and their interlocking bodies create a brilliant composition framed by the angel's sweeping wings. The woman is in ecstasy, her body arched, her head bent backward, her eyes closed, one hand circling the angel's body and the other touching his wing; her hips are pressed against his thigh, her long hair curls downward, and her feet are crossed. The angel is bent forward enfolding his beloved in his arms, his handsome face crowned by thick locks of hair, leans forward to kiss her waiting lips. To emphasize their different natures, the woman's figure stands on a base that appears solid under her feet, while the angel's feet rest on a cloud. The sculptor must have been heartbroken when some naturally occurring gray inclusions in the marble appeared as he carved the woman's left buttock, left thigh, and right foot. Nevertheless, it is spellbinding, and to my eye, one of French's most outstanding works.

One of the other three sculptures by French in the museum's collection is a small bronze model (Fig. 40), for *Alma Mater,* a large bronze figure prominently located before Low Memorial Library on the campus of Columbia University in New York. It is an idealized version of the university's seal – a female figure sitting on a thronelike chair, her arms outstretched with her right hand holding a scepter, a book open on her lap. The Corcoran model has a certain charm and intimacy that distinguishes it from the monumentality of the larger-than-life-size version at Columbia.

*39. The Sons of God Saw the Daughters of Man That They Were Fair,* 1923
Marble
79½ x 42 x 25 in.
Museum Purchase, 24.1
OPPOSITE AND FOLLOWING

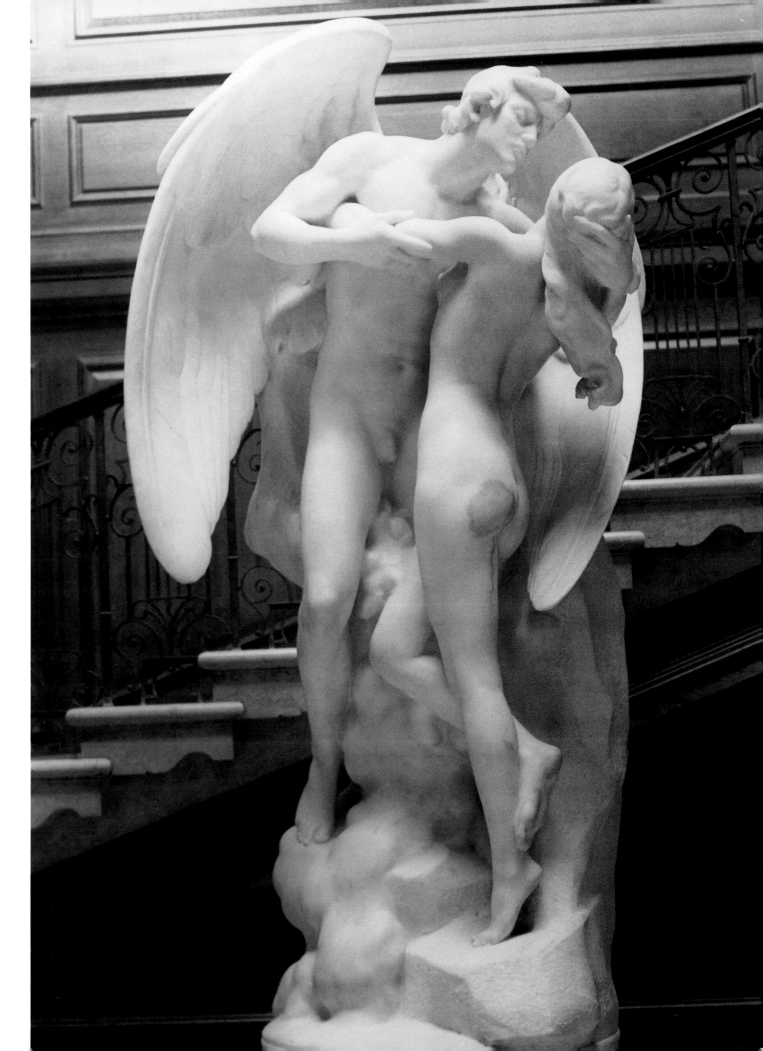

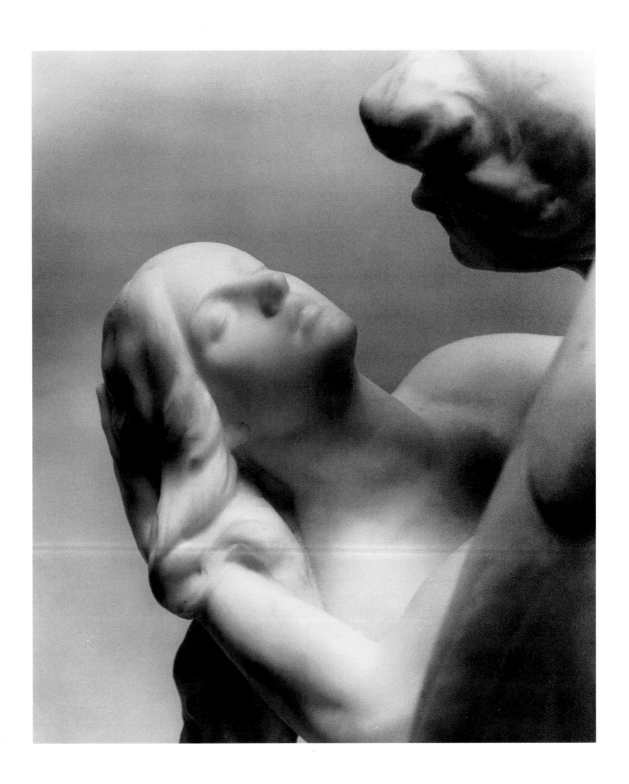

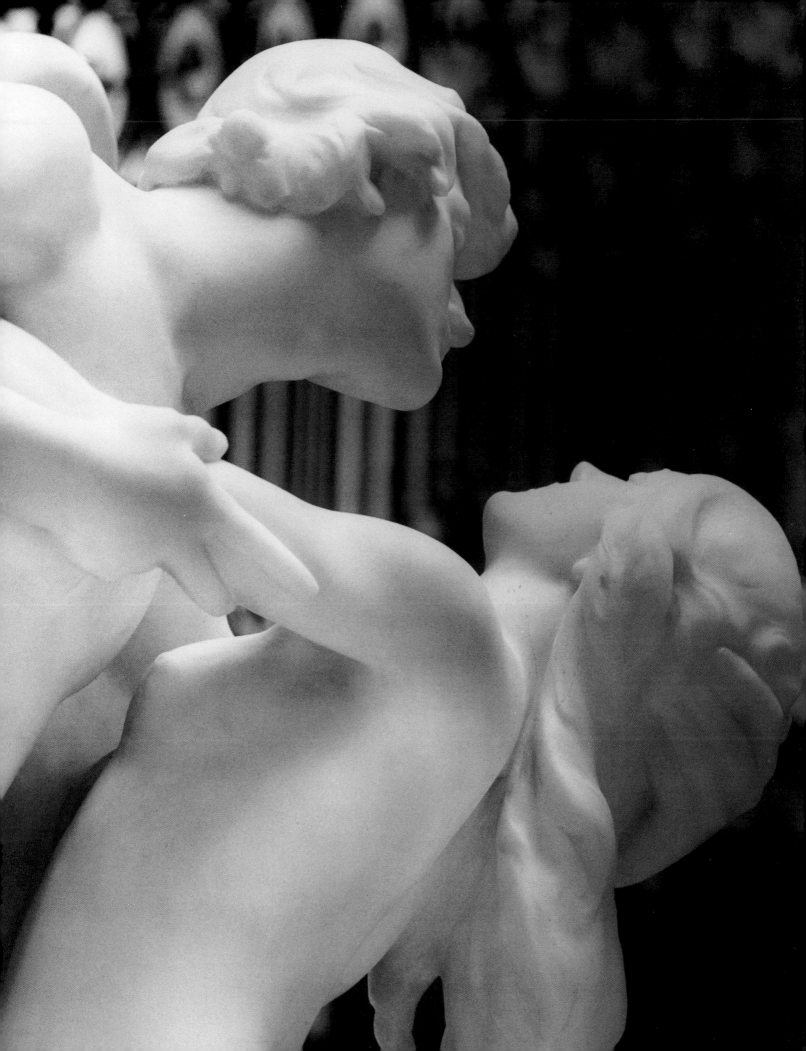

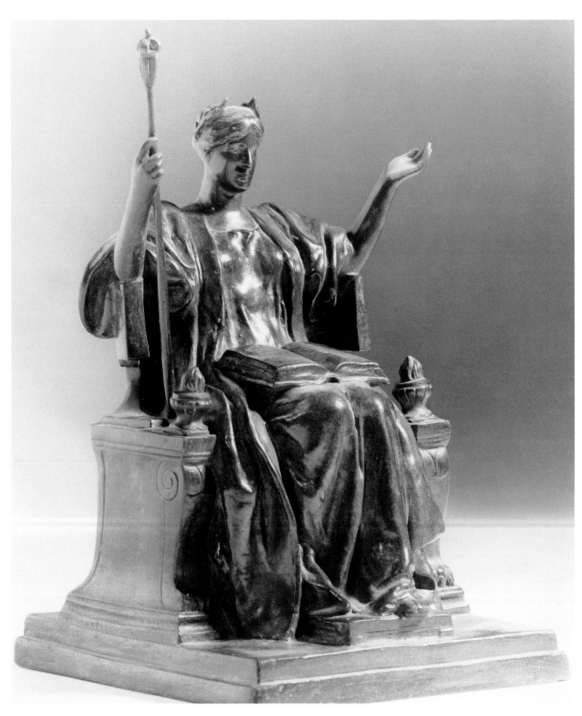

40. *Alma Mater*, c. 1875
Bronze
8¼ x 6 x 6 in.
Anonymous gift in memory of Helen Minshall, 55.79

# Aristide Maillol
[1861–1944]

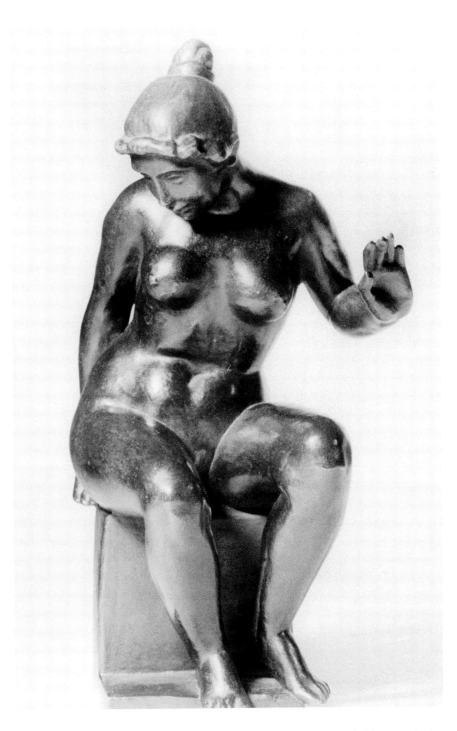

41. *Seated Nude,* n.d.
Bronze
11⅜ x 6½ x 5 in.
Gift of The Honorable Francis Biddle, 61.21
ABOVE AND FOLLOWING

THE SMALL BRONZE model *Seated Nude* (Fig 41) by Aristide Maillol was one of his earliest sculptures. His lifelong subject, like that of Gaston Lachaise, was the nude female figure. Unlike the latter, whose inspiration was his wife, Maillol's fig-

ures seem impersonal. But there is a remarkable grace in the way this figure is seated, body tilted forward, down-turned head tipped to the side, one hand raised in a delicate gesture. It is a lovely, perfectly composed work.

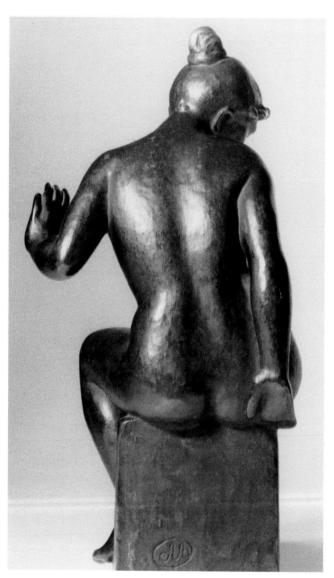 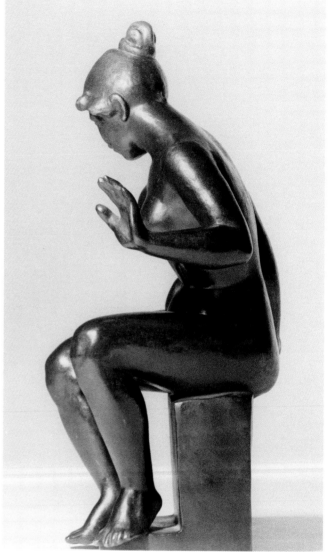

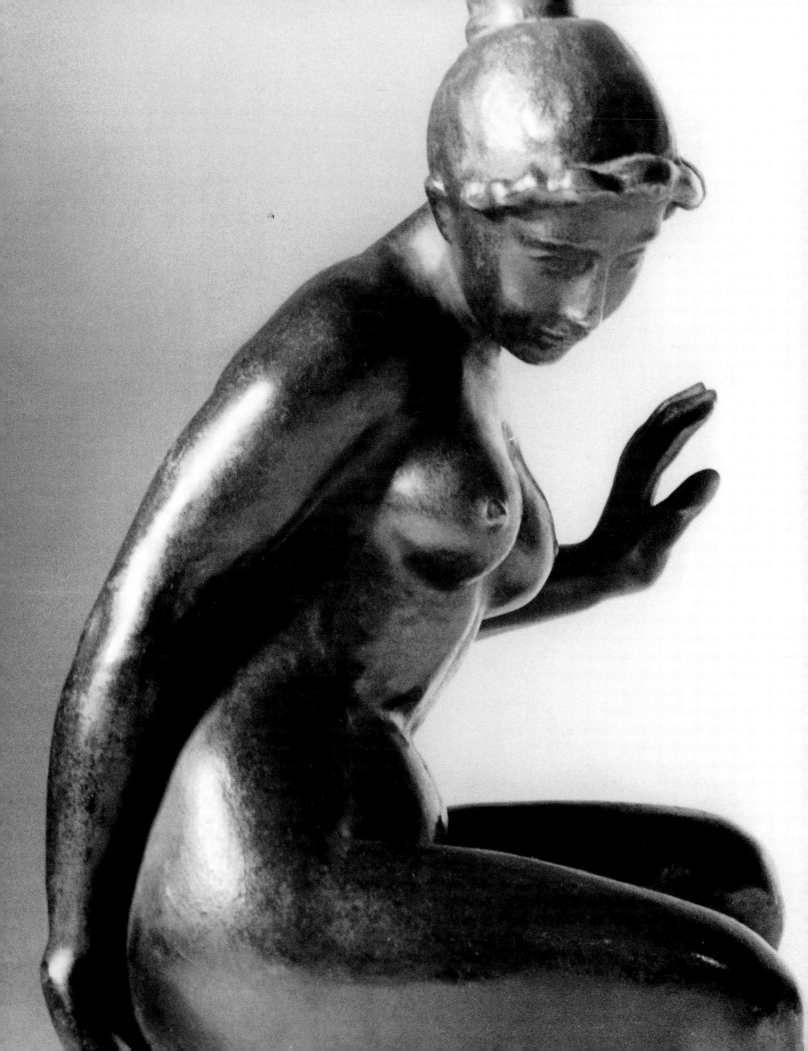

# Frederic Remington

[1861–1909]

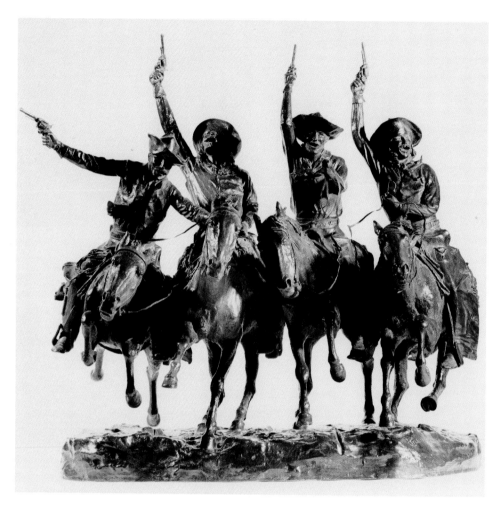

42. *Off the Range (Coming through the Rye)*, modeled 1902, cast 1903
Bronze
28¾ x 28 x 28⅝ in.
Museum Purchase, 1905, 05.7
ABOVE AND OPPOSITE

ALTHOUGH HE WAS BORN in Canton, New York, attended the Yale School of Fine Arts and the Art Students League in New York, and later in life had his studio and home in New Rochelle, New York, Frederic Remington was fascinated by images of the vanishing Wild West. The Corcoran has one of his most familiar bronzes, entitled *Off the Range* (known for many years as *Coming through the Rye*) (Fig. 42), depicting four exuberant cowboys riding galloping horses and firing their pistols into the air. The details of the figures are impressive, in both the men and the horses, and the composi-

tion is excellent. When photographing this work I was particularly conscious of the way the feet of the four horses form a harmonious pattern. This is very much in the tradition of the well-known frieze of horsemen from the Parthenon, in which the juxtapositon of the horses' legs is masterfully designed. Remington was so skilled a sculptor that he succeeded in balancing this energetic figural composition in such a way that, in his own words, "I have six horses' feet on the ground and ten in the air;"[11] four of these ten belong to the horse on the far left, whose hooves do not touch the ground at all.

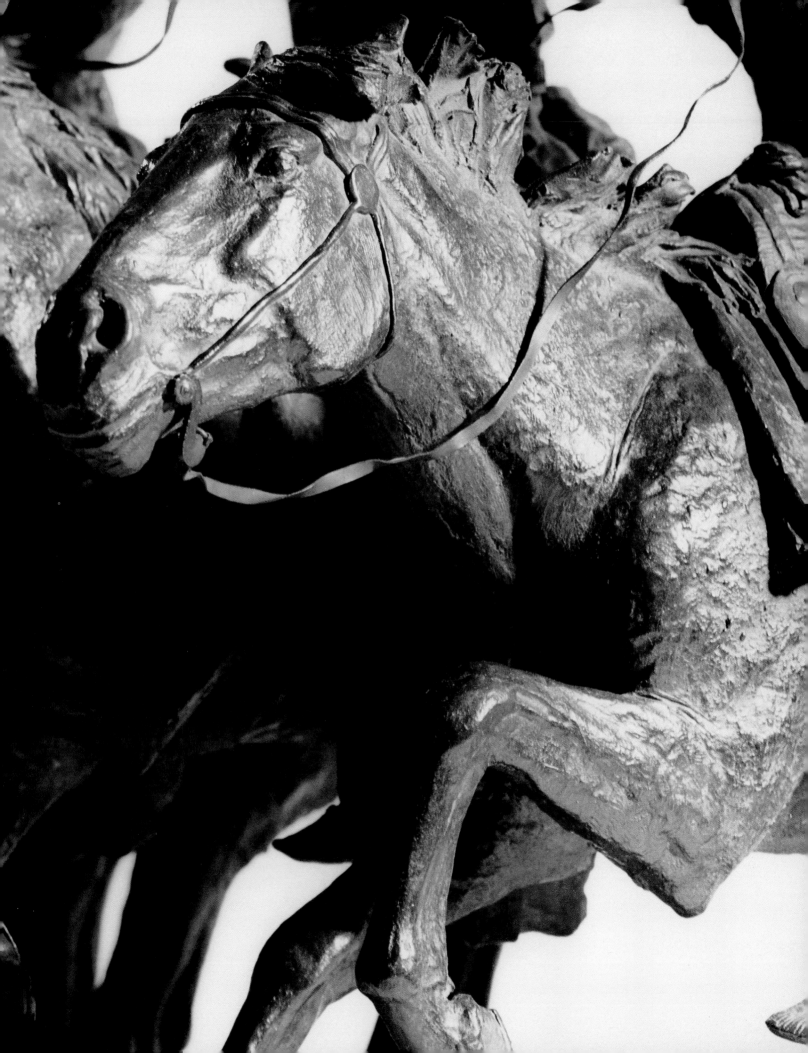

# Frederick MacMonnies

[1863–1937]

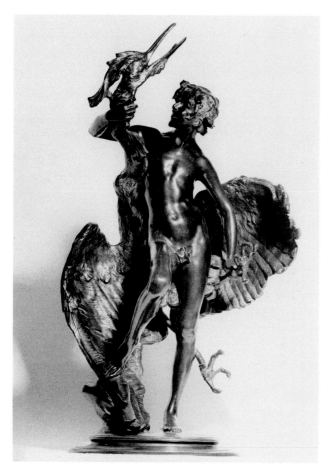
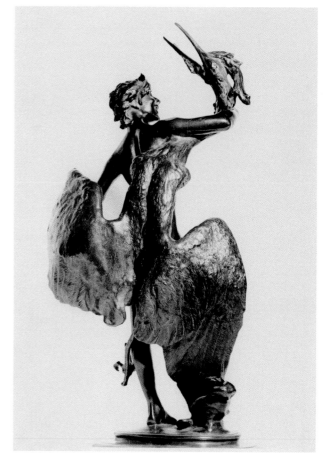

*43. Young Faun with Heron,* 1890
Bronze
27¾ x 15 x 11¼ in.
Gift of Mr. Louis E. Shecter, 66.5.1
ABOVE, OPPOSITE AND FOLLOWING

FREDERICK MACMONNIES was one of the most gifted and successful students of Augustus Saint-Gaudens. He grew up in New York, where he left school at age thirteen to start earning a living. Later, however, he was able to take some art courses, and eventually a friend introduced him to Saint-Gaudens, who became his mentor. After studying at the Art Students League, the National Academy of Design, and Cooper Union, all in New York, and the École des Beaux-Arts in Paris, he began to receive commissions from the architect Stanford White, and was soon recognized as a major figure in the world of contemporary sculpture. *Young Faun with Heron* (Fig. 43) a garden sculpture commissioned by White, was first created in large scale in 1890 for a private home. Later, it was reduced in size and sold widely. Characteristic of MacMonnies' sculptures, it is a graceful work, with the well-modeled body of the standing youth embraced by the wings of the giant bird whose neck he holds. Looking closely at the sculpture from different angles, one discovers how skillfully MacMonnies modeled the surfaces of the faun's body, as well as the heron's feathered wings.

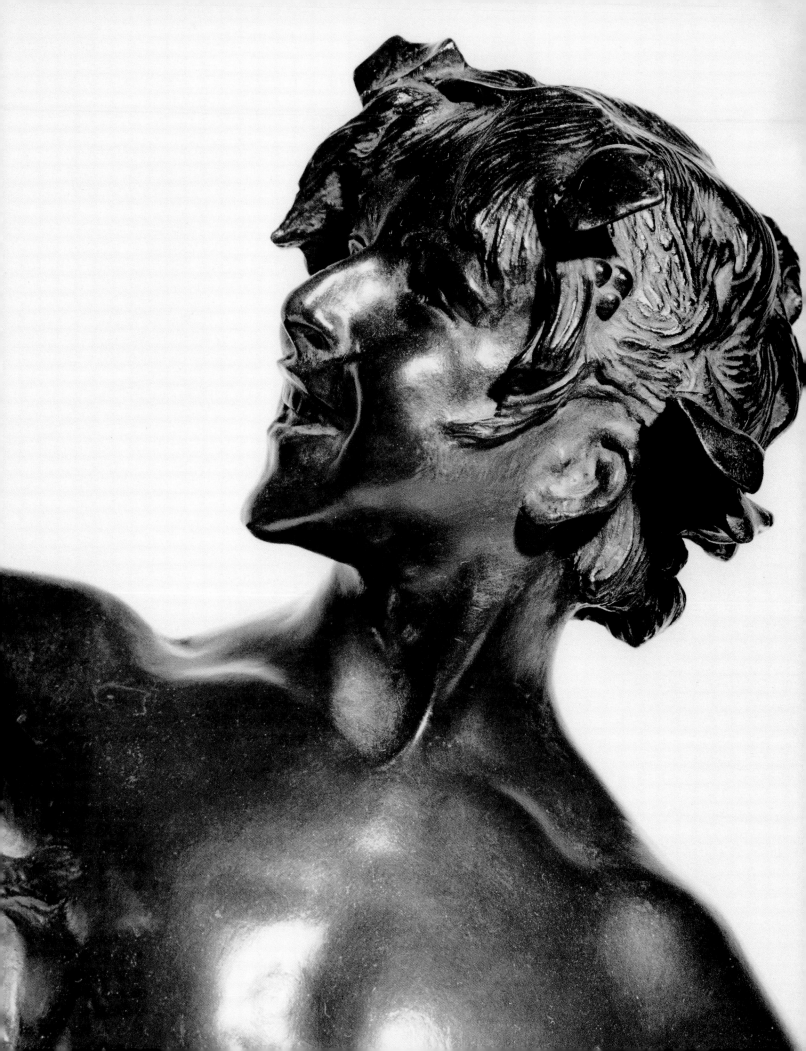

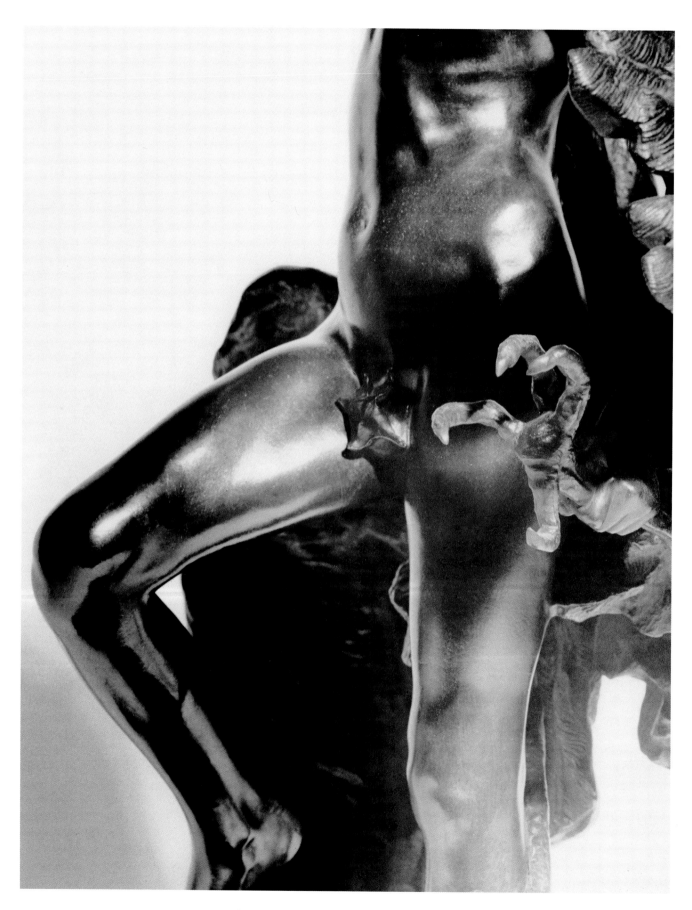

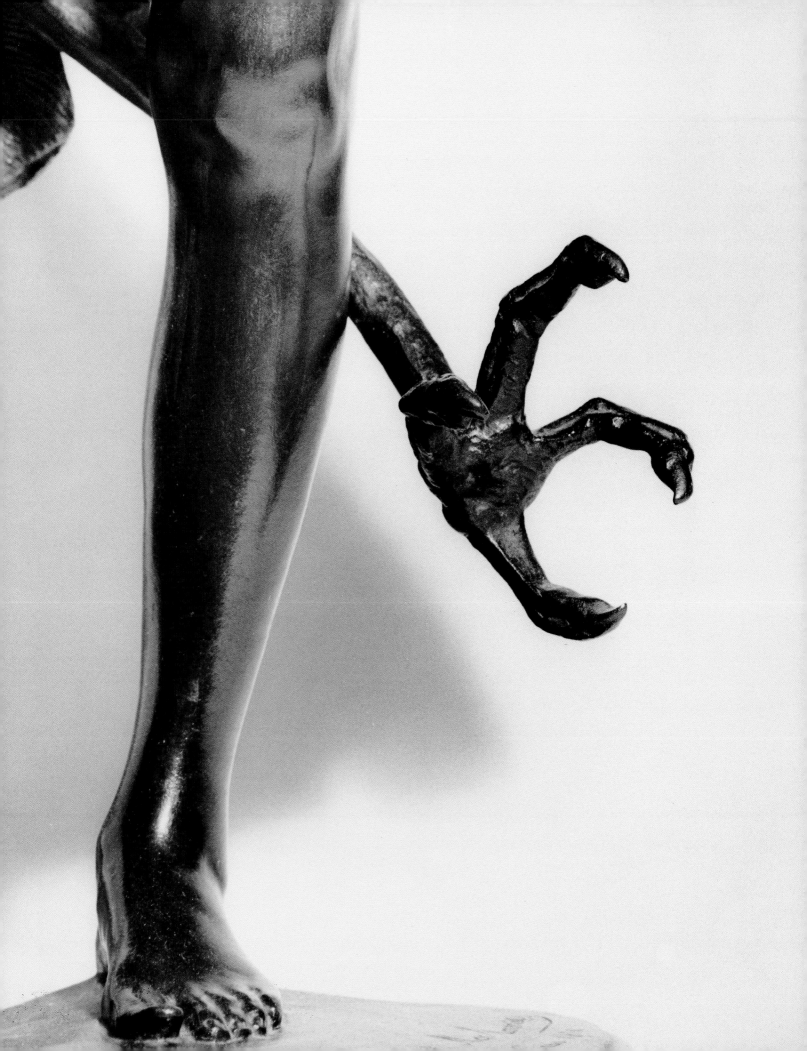

# John Gutzon Borglum
[1867–1941]

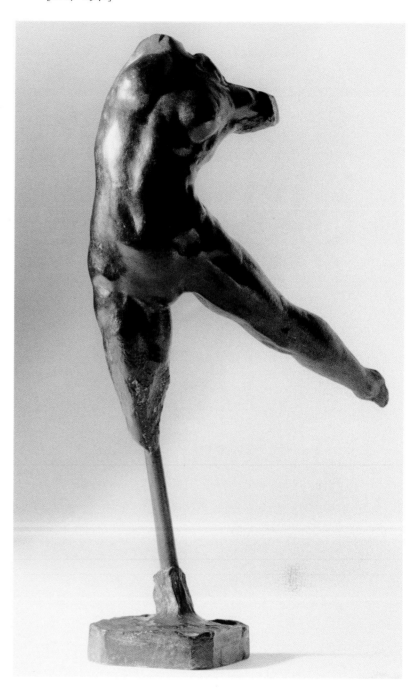

44. *Dancer,* n.d.
Bronze
13 x 9½ in.
Gift of the Artist, 32.5
ABOVE, OPPOSITE AND FOLLOWING

JOHN GUTZON BORGLUM is best known for the monumental heads of four presidents that he carved into the side of Mount Rushmore in South Dakota. He was a friend and admirer of Auguste Rodin, and Borglum's *Dancer* (Fig. 44) clearly shows the French master's influence. This small sculpture is a fine work, with the dancer's muscles clearly articulated, and the armless, partially legless torso forming a striking figure that is graceful from all angles. By contrast, Borglum's famous sixty-foot-high portraits of Washington, Jefferson, Lincoln, and Theodore Roosevelt are among the largest sculptures ever produced anywhere. Borglum worked on them for fourteen years; they were completed by his son, Lincoln Borglum, after his father's death.

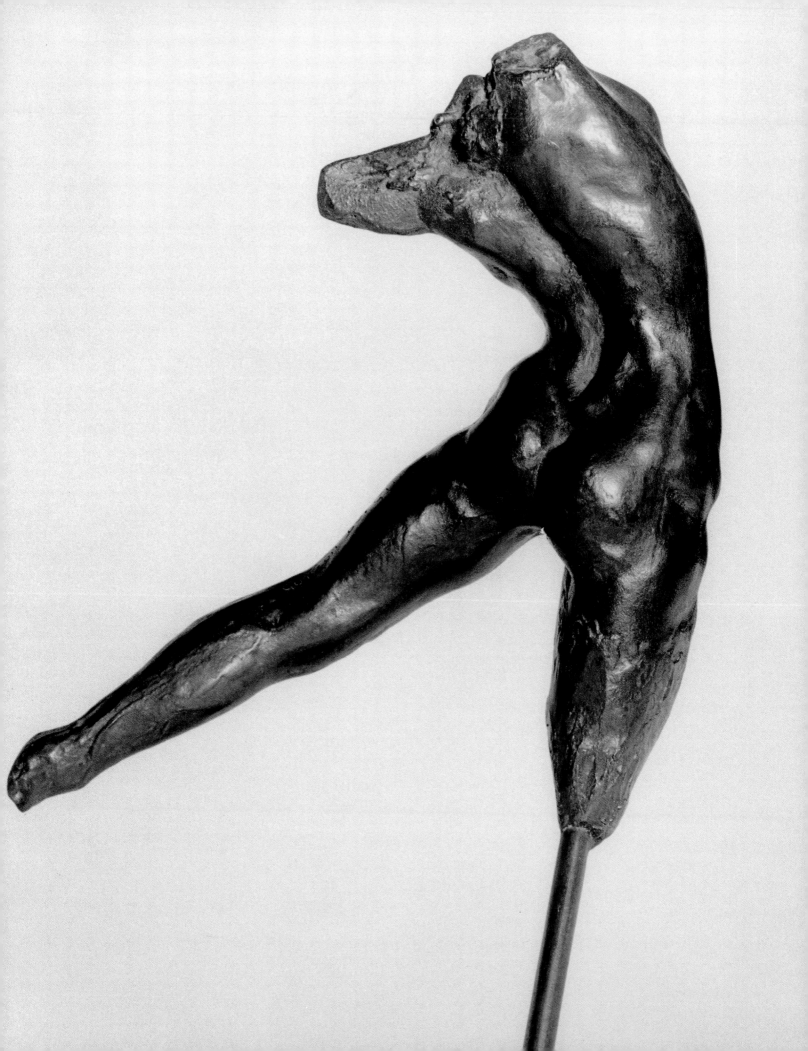

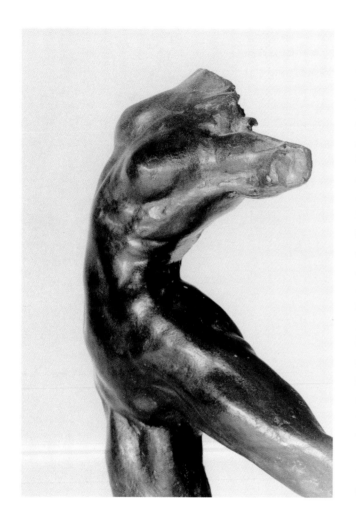

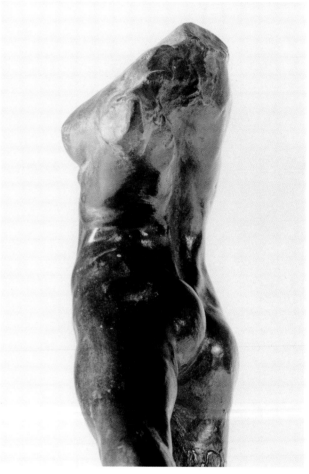

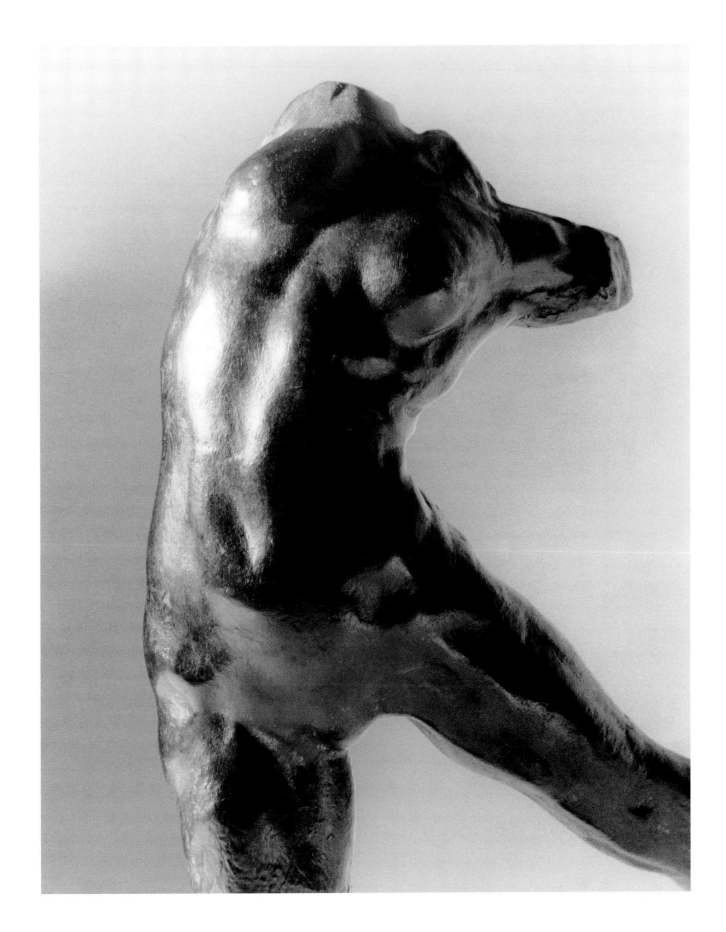

# Bessie Potter Vonnoh

[1872–1955]

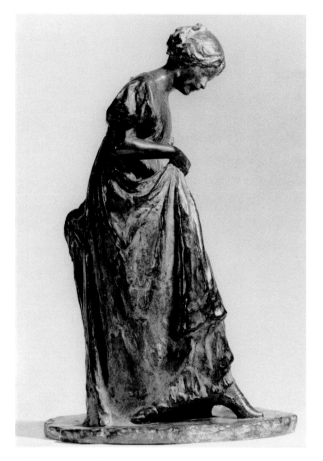

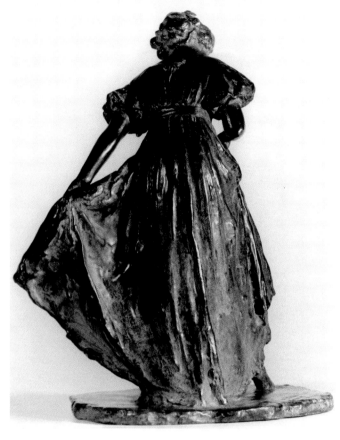

45. *Girl Dancing,* n.d.
Bronze
13¾ x 11¼ x 8 in.
Bequest of Bessie Potter Vonnoh Keyes, 55.76
ABOVE AND OPPOSITE

BESSIE POTTER VONNOH chose young women, dancers, and mothers and children as her special subjects. Her husband was an impressionist portrait and landscape painter; they shared a studio in New York and often exhibited their works together. Having no children of her own, Vonnoh referred to her sculptures as her children, and once said, "I have only my bronze and marble babies, but I love them as much as if they were flesh and blood."[12] She traveled to Europe a number of times and was influenced by the work of the Russian-born artist Paul Troubetskoy. Vonnoh enjoyed a distinguished reputation and had many exhibitions of her work, including several at the Corcoran Gallery. The Corcoran owns sixteen of her sculptures—the largest holding in a public collection. I pho-

tographed two of them. One, *Girl Dancing* (Fig. 45), is a charming bronze figure of a young woman with an attractive face—typical of Vonnoh's work—her head bent downward, apparently following the music, her long skirt held lightly in her hands, her feet moving to the melody. The surface of the sculpture is handled with a soft touch that creates a delicacy of form.

The second sculpture, *Allegresse* (Fig. 46), consists of three dancers—one lightly clad and the other two nude. The dancers' hands and feet seem to form a garland around them. The lithesome, youthful figures are modeled with particular sensitivity, and their faces glow with pride. The upraised hands clasped together in a delicate, well-composed design, represent a particularly graceful feature of this bronze.

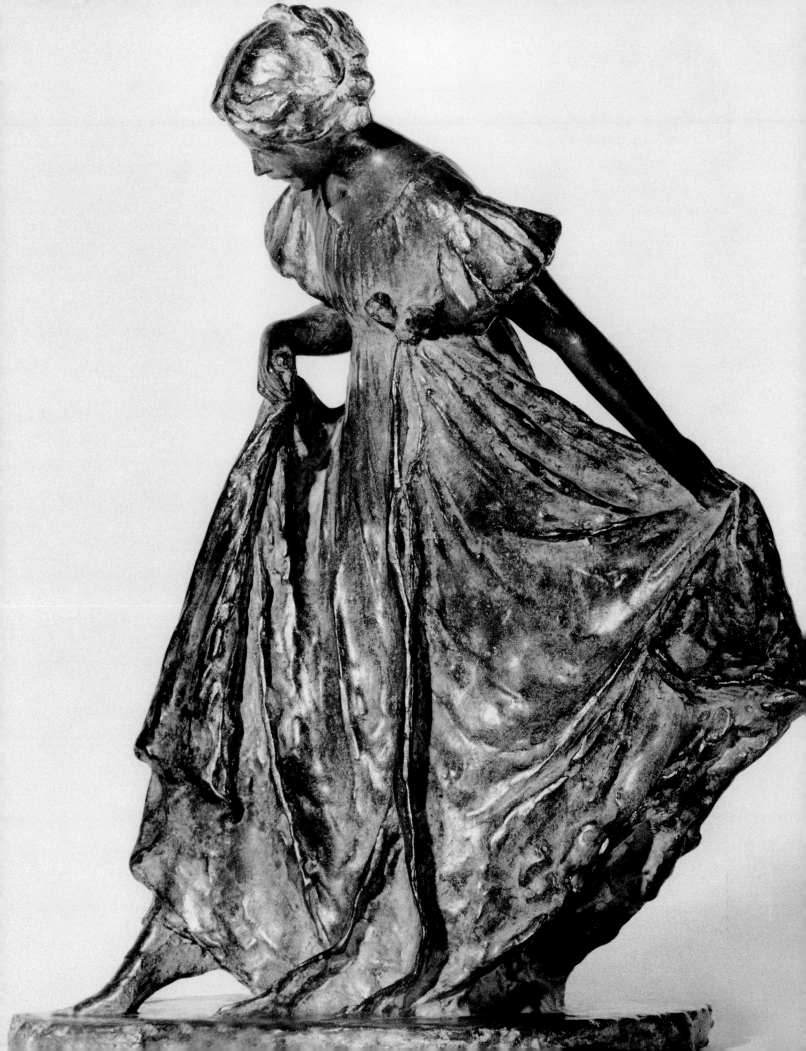

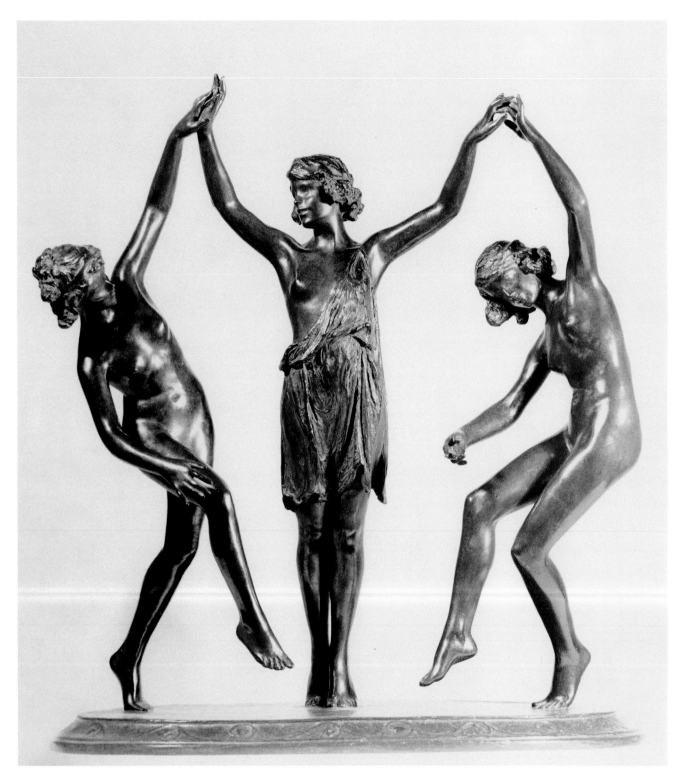

46. *Allegresse*, 1901
Bronze
25½ x 23 x 12½ in.
Bequest of Bessie Potter Vonnoh Keyes, 55.71
OPPOSITE, ABOVE AND FOLLOWING

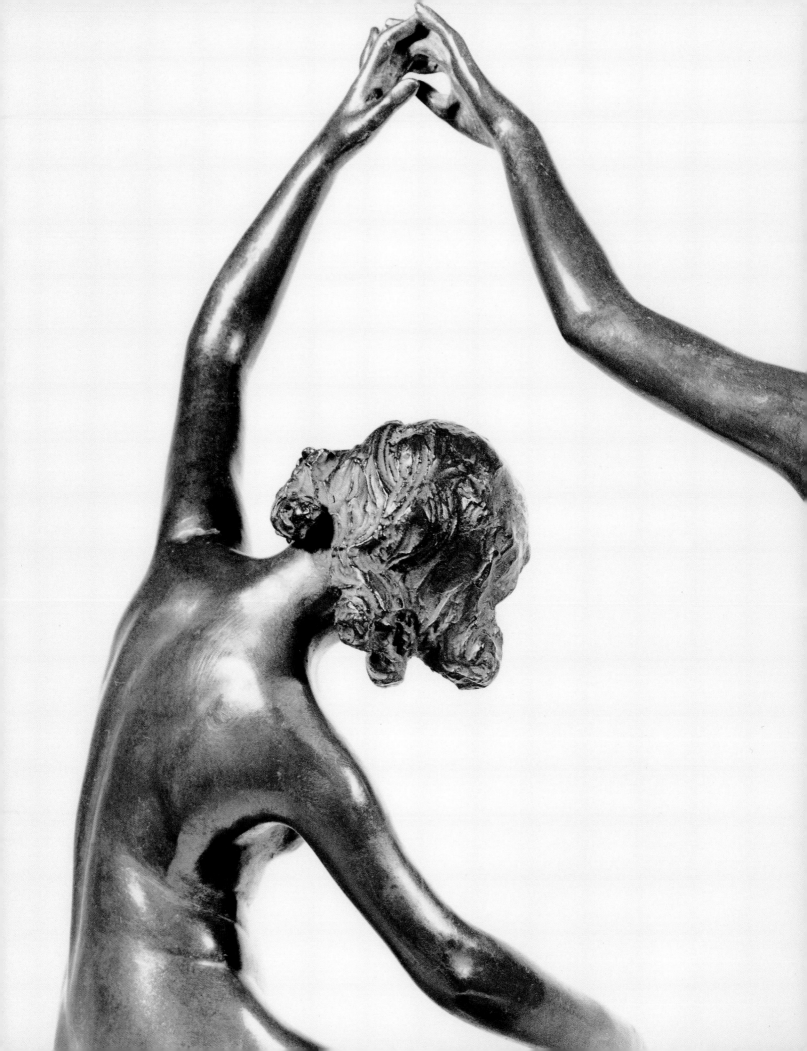

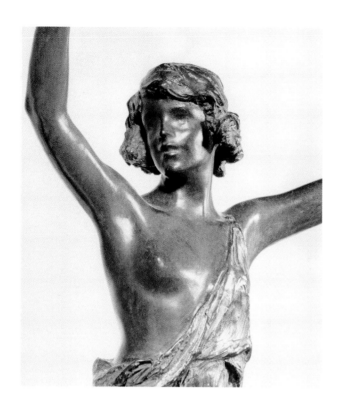

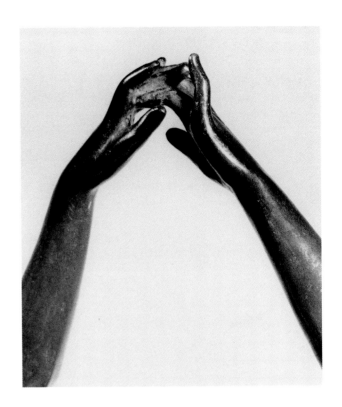

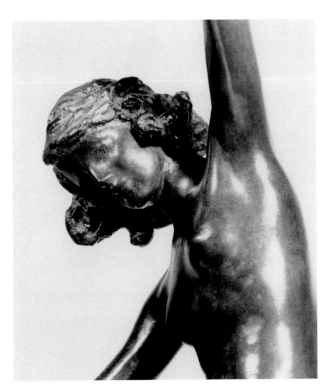

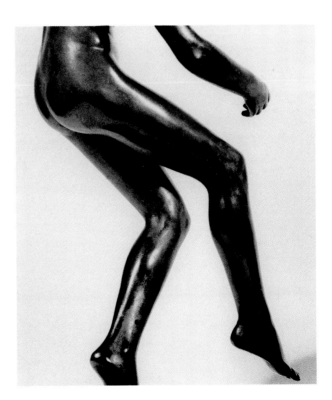

# Anna Hyatt Huntington

[1876–1973]

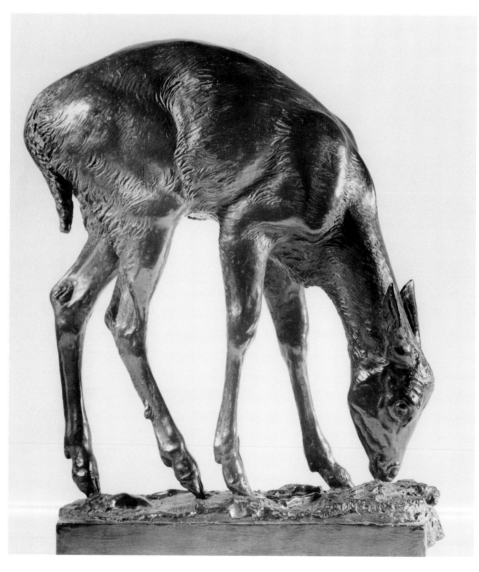

47. *Fawn,* 1923–27
Bronze
17 x 13¼ x 3½ in.
Gift of the artist, 39.11

ONE OF THE FEW serious sculptors whose primary subject was animals, Anna Hyatt Huntington had a fascinating life as both an artist and a patron of the arts. Her love for animals was encouraged by her father, a professor of paleontology and zoology at the Massachusetts Institute of Technology and at Boston University. When his daughter was very young, he set up a laboratory at the family's summer home in Annisquam, Massachusetts, which helped nurture her love of animals and her sculptural interests. In her early years, her subjects were mostly pets and farm animals, but soon her interests broad-

ened to include the more exotic species she saw at live animal shows and at the Bronx Zoo. She won increasing recognition for her work through exhibitions and commissions in which her knowledge of animals was highly praised. "She knows not only their forms," wrote one reviewer, "but their movements, the way they carry their heads, the way in which their feet grip the ground. There is something immediately convincing about these creatures of hers."[13]

In 1914, the artist won a competition for an equestrian sculpture of *Joan of Arc,* to commemorate the 500th anniver-

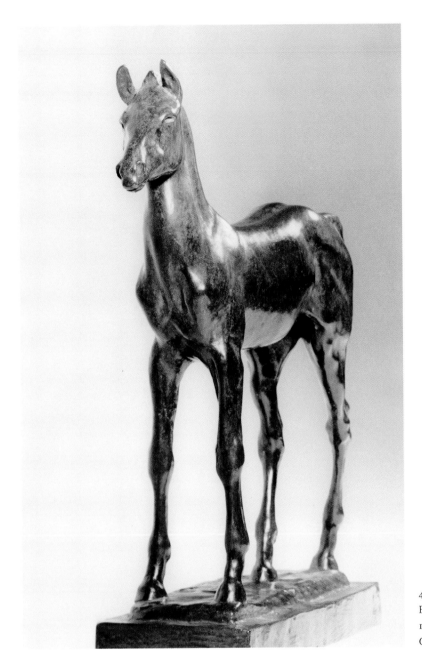

48. *Colt, Six Months*, n.d.
Bronze
13-7/16 x 2¾ x 9⅛ in.
Gift of the artist, 39.15

sary of the martyr's birth, and the following year the complet-ed monument was installed on New York's Riverside Drive at Ninety-third Street. When she was forty-seven years old, the artist married Archer Milton Huntington, the son of railroad tycoon Collis P. Huntington and one of the wealthiest men in America. Her husband was a scholar rather than a business-man, and was especially interested in Hispanic art. He founded a number of museums, including the Hispanic Society of America in New York. Archer and Anna gave their townhouse in Manhattan to the National Academy of Design and created

Brookgreen Gardens in South Carolina, one of the finest out-door settings for sculpture in the world. One of the seven works by Anna Hyatt Huntington at the Corcoran is a sensi-tive bronze figure of a fawn (Fig. 47), its head bent down, per-haps sniffing for food, its body gracefully curved, its legs stand-ing gingerly and gracefully on the ground. The animal's soft hide and its bone structure are rendered with superb skill. Another bronze, *Colt, Six Months* (Fig. 48), is more awkward and less finely modeled, but after all, a six-month-old colt is an ungainly subject!

# Robert Ingersoll Aitken

[1878–1949]

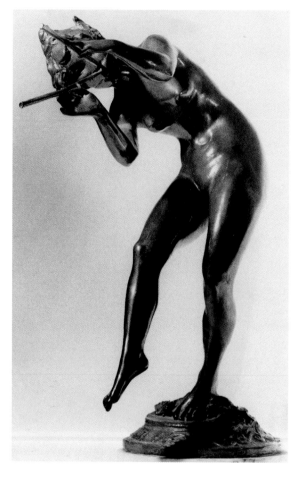 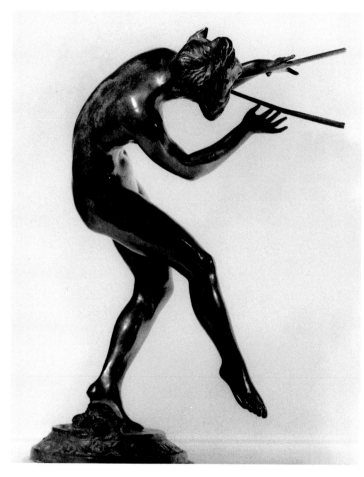

49. *Naiad*, n.d.
Bronze
17 x 11 x 6 in.
Bequest of James Parmelee, 41.60
ABOVE, OPPOSITE AND FOLLOWING

ROBERT INGERSOLL AITKEN was for many years a teacher at the National Academy of Design in New York. His public works include monuments to the U.S. Navy and to President William McKinley in Golden Gate Park in San Francisco. Although not as well known as many of the other sculptors in the Corcoran collection, his bronze figure *Naiad* (Fig. 49) is elegantly modeled. The well-formed young woman stands on one foot, with the other foot in the air as if dancing, perhaps to a tune played on the pipes she holds. It is a delightfully decorative piece by an accomplished sculptor.

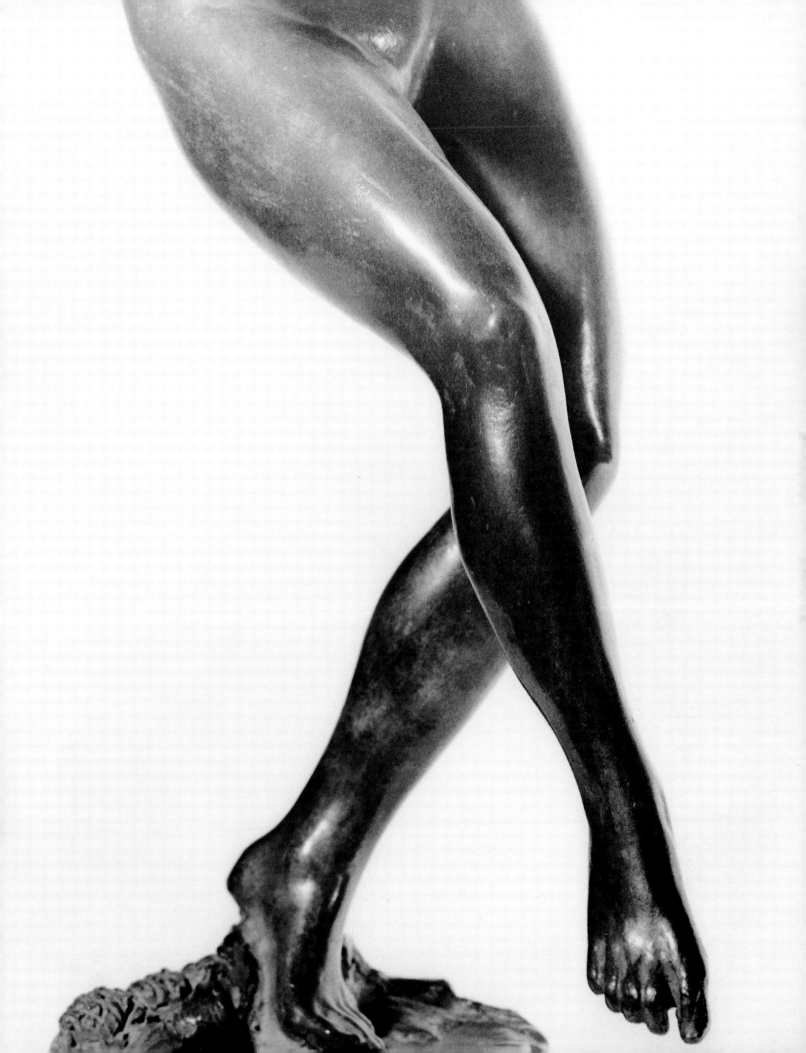

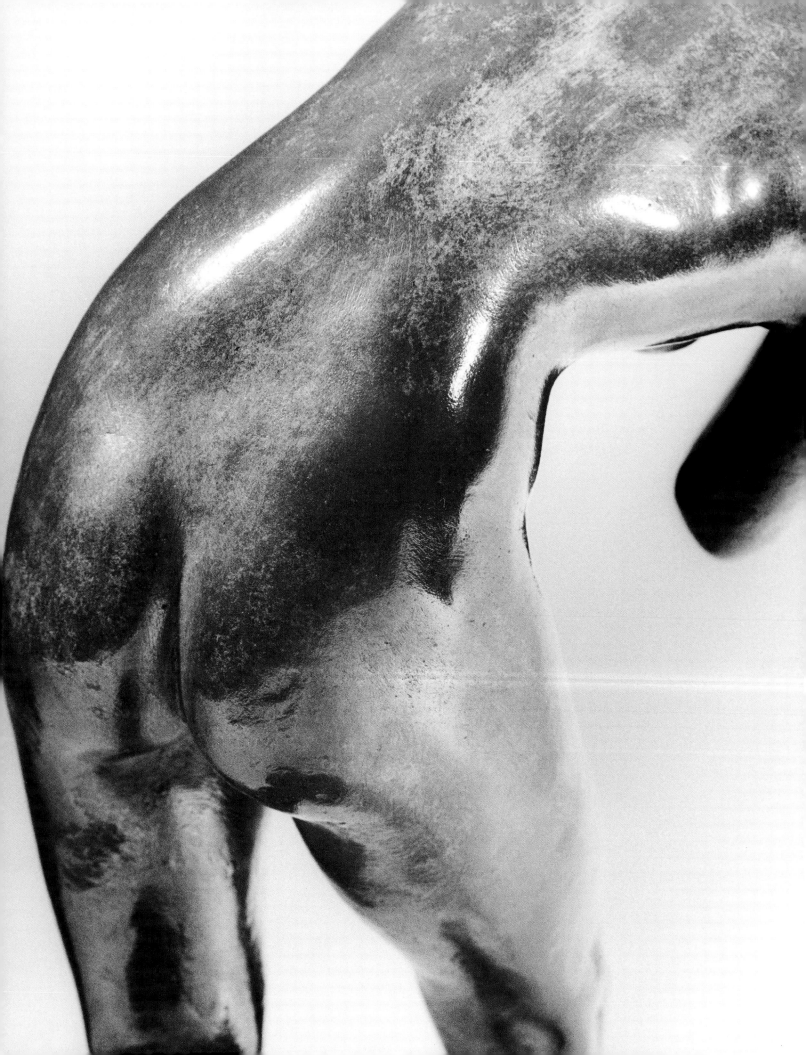

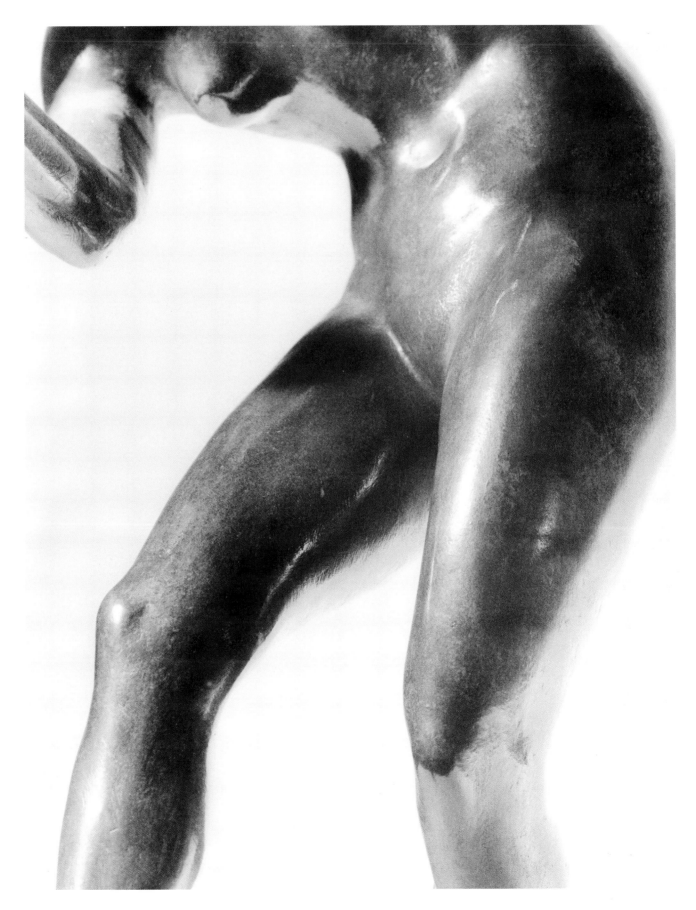

# Harriet Whitney Frishmuth

[1880–1979]

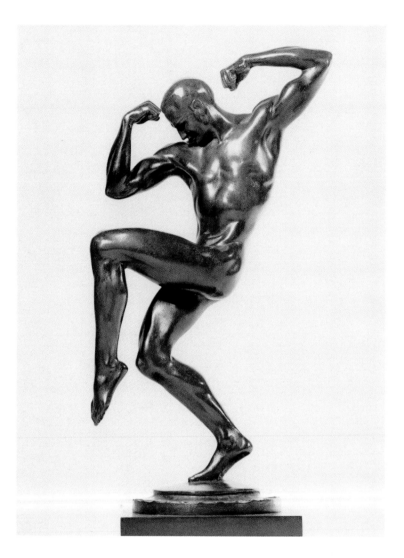

50. *Slavonic Dancer*, n.d.
Bronze
12½ x 2¾ x 7¼ in.
Gift of Mrs. William H.
Hill, 52.22
ABOVE AND OPPOSITE

ALTHOUGH BORN IN Philadelphia, Harriet Whitney Frishmuth lived with her mother and two older sisters in Paris from an early age. When she was nineteen she studied sculpture in a class visited regularly by Auguste Rodin. She subsequently moved to Berlin, where she continued her studies. Eventually she returned to the U.S. and took classes at the Art Students League in New York under the tutelage of Gutzon Borglum and other leading sculptors of the day. Like many young artists of her generation, Frishmuth tried her hand at making decorative, functional objects such as ashtrays, bookends, letter openers, and paperweights to help support herself. Later, she concentrated on garden and fountain sculptures,

and then, in the 1920s, under the spell of the romance and legendary personalities of modern and classical dance, she created sculptures of nude male and female dancers. "Most of my figures express motion,"[14] Frishmuth once said, and she worked with models who could hold difficult poses, mostly of an uninhibited and sensual nature. She lived to be almost one hundred years old and never married. The Corcoran's *Slavonic Dancer* (Fig. 50) is a virile male nude figure with tensed arms and legs, head bent low, standing on one toe. The figure's bulging muscles are well-formed, and there is an impressive rhythm to the sculpture as a whole. The acclaimed dancer Leon Barté is said to have posed for this work.[15]

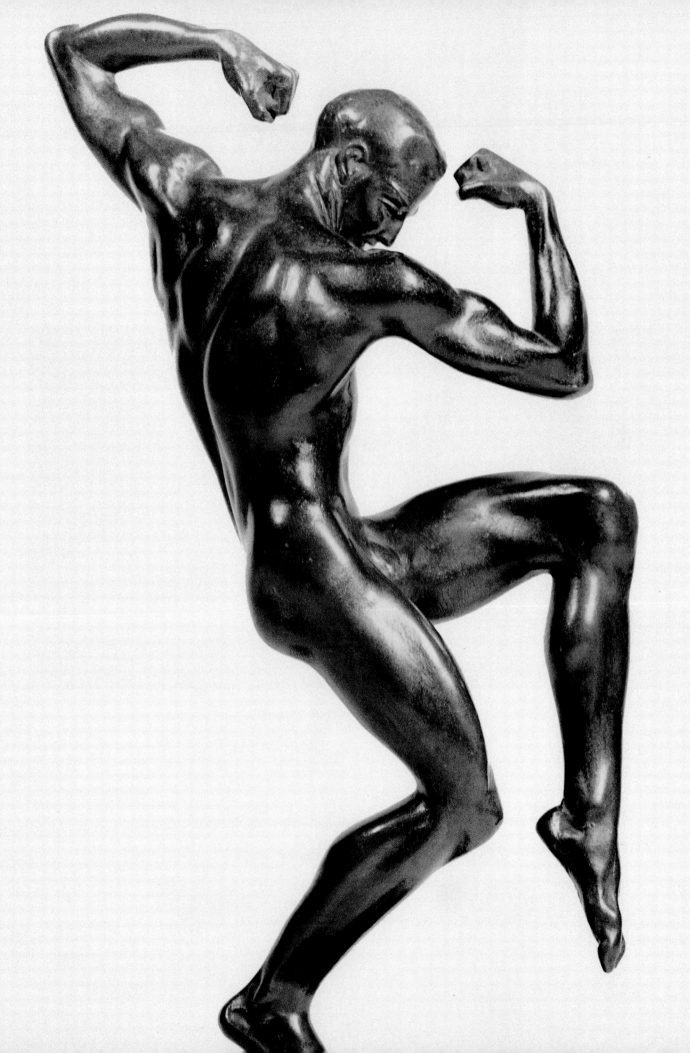

# Grace Turnbull

[1880–1976]

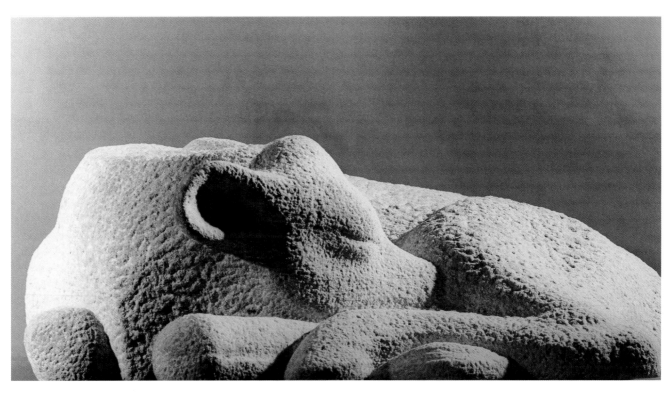

51. *Sleeping Calf,* 1944
Kingwood sandstone
9¾ x 26⅝ x 20¾ in.
Museum purchase and anonymous gift, 49.6

THERE IS VERY LITTLE available information on the long-lived sculptor Grace Turnbull. Her sandstone figure *Sleeping Calf* (Fig. 51) is an intimate and well-composed rendering of this young animal. With head nestled comfortably on bent legs, it is a lovely composition; an image of peaceful rest.

In the way she modeled the head, with gently closed eyes, relaxed ears and slightly mottled skin, Turnbull took advantage of the unusual texture of the sandstone; she also gives us the impression of a genuine love for animals.

# Elie Nadelman

[1882–1946]

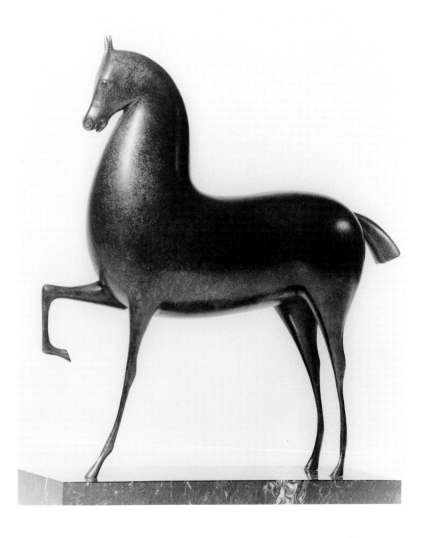

52. *Horse,* c. 1914
Bronze
11¾ x 12 x 4 in.
Museum purchase, Gallery Fund, Anna
E. Clark Fund, and William A. Clark
Fund, 61.19
ABOVE AND FOLLOWING

A LEADING FIGURE in twentieth-century American sculpture, Elie Nadelman was born in Warsaw when it was part of Russia. He studied at the Warsaw Art Academy, then immigrated to Paris in 1904 and to the U.S. in 1914, at age thrity-two. While he was in Paris, he was part of Gertrude Stein's avant-garde circle and created sculptures with simplified geometric forms. In New York, Alfred Steiglitz gave him his first American one-person exhibition, which led to a number of portrait commissions from wealthy collectors. Nadelman married a New York socialite, Viola Spiess Flannery, and they lived in a Manhattan townhouse and owned an estate in the Riverdale section of the city. They became collectors of American folk art and displayed their acquisitions at the Riverdale site. For Nadelman, folk-art objects served two purposes: they represented some of the finest examples of the genre, and they served as an important inspiration for his own work.

The two Nadelman animals in the Corcoran collection are superb examples of sheer elegance. The bronze *Horse* (Fig. 52), with its small head, amply rounded body, and spindly legs, features a wonderful combination of delicate lines and solid forms, which, when integrated into a single form, seem to float in the air. *Fawn* (Fig. 53) is even more impressive. It also has delicate legs, but here one of them is gracefully raised to meet the equally gracefully lowered head of the animal, forming a lovely composition. Both sculptures are extraordinary from every point of view.

Unfortunately, Nadelman lost most of his wealth in the 1929 stock market crash, and after that refused to exhibit, take commissions, or even sell his work. He was then virtually forgotten and "rediscovered" only after his death.

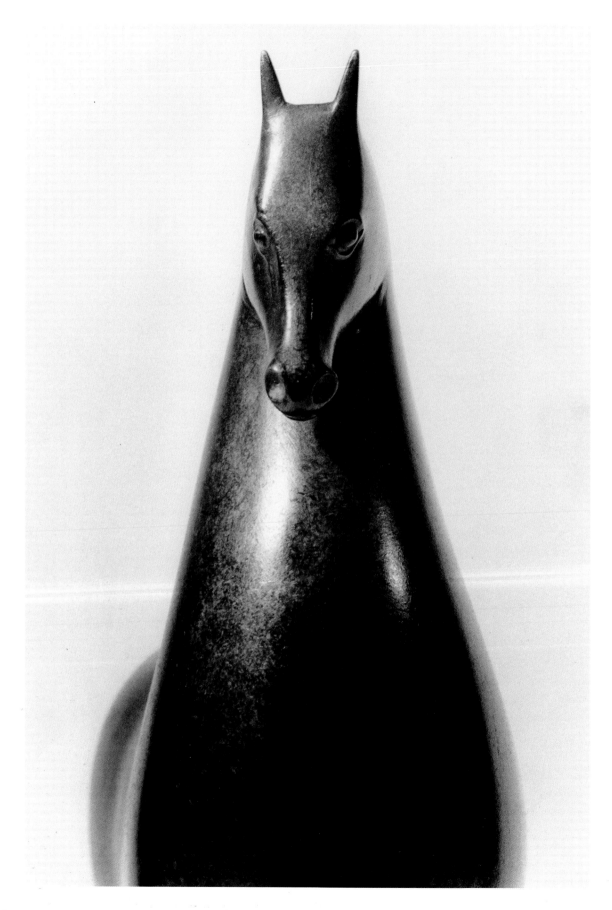

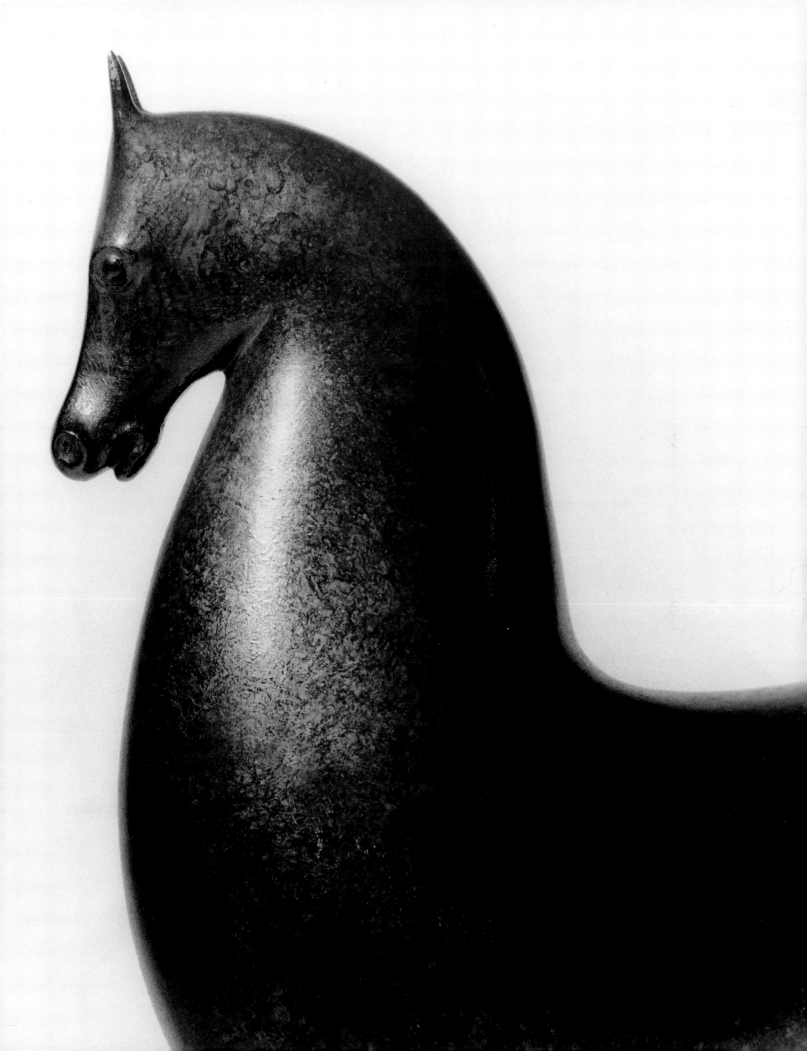

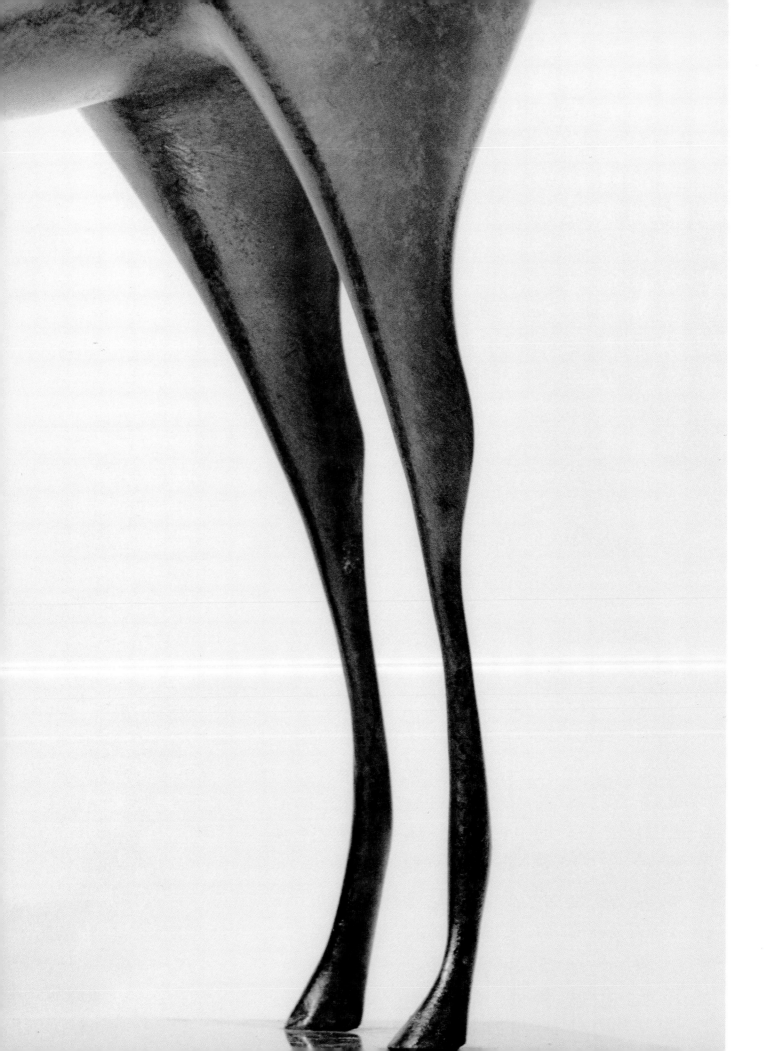

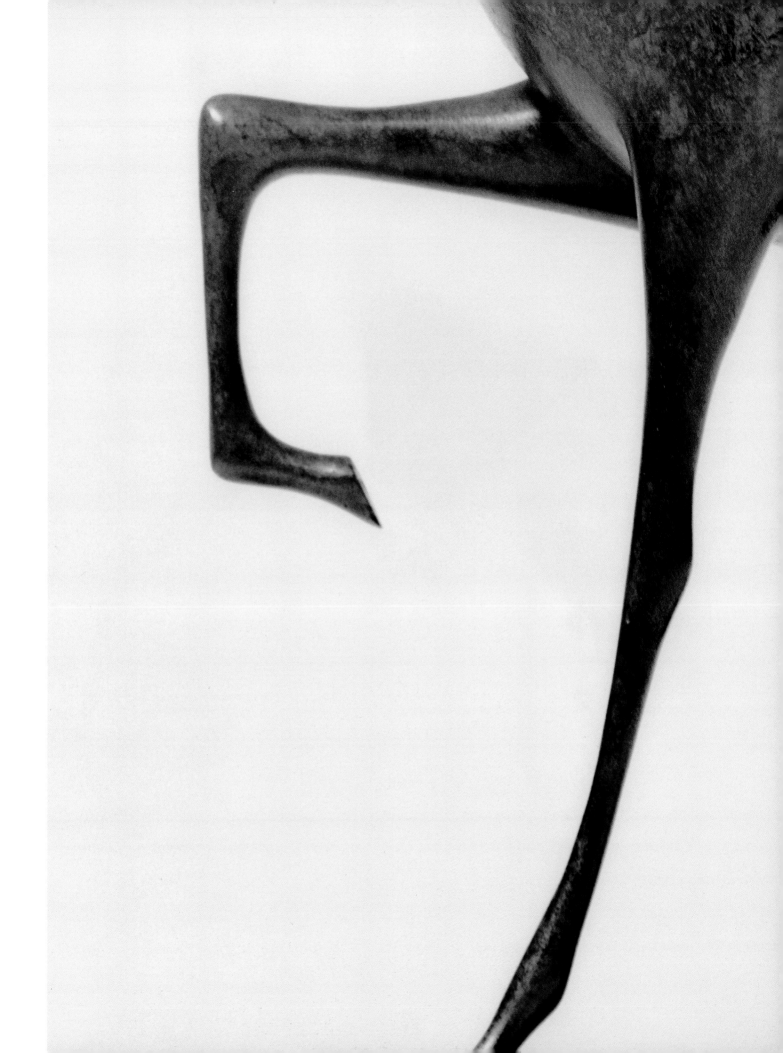

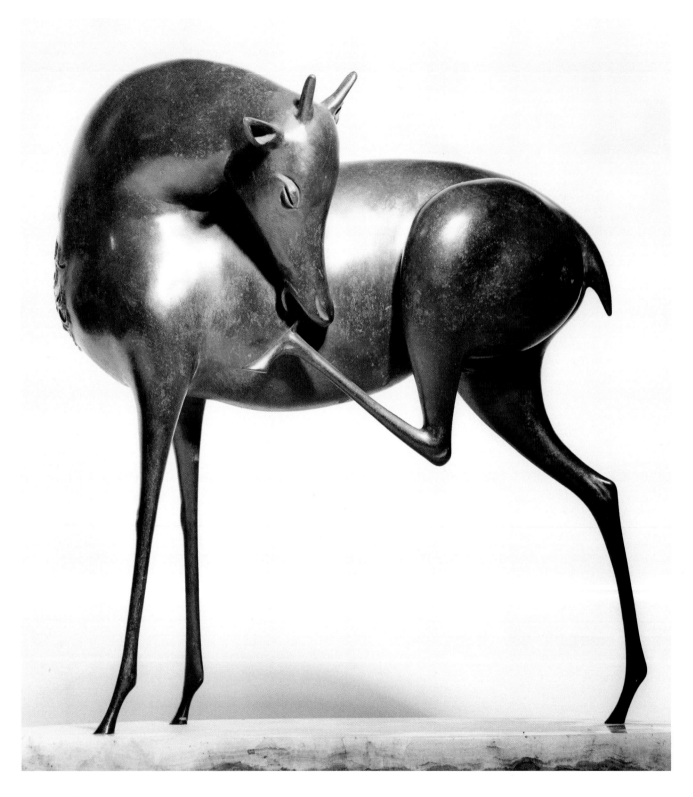

53. *Fawn*, n.d.
Bronze
18½ x 17 x 9½ in.
Gift of Mildred (Mrs. John B.) Hayward, 65.26
LEFT, OPPOSITE AND FOLLOWING

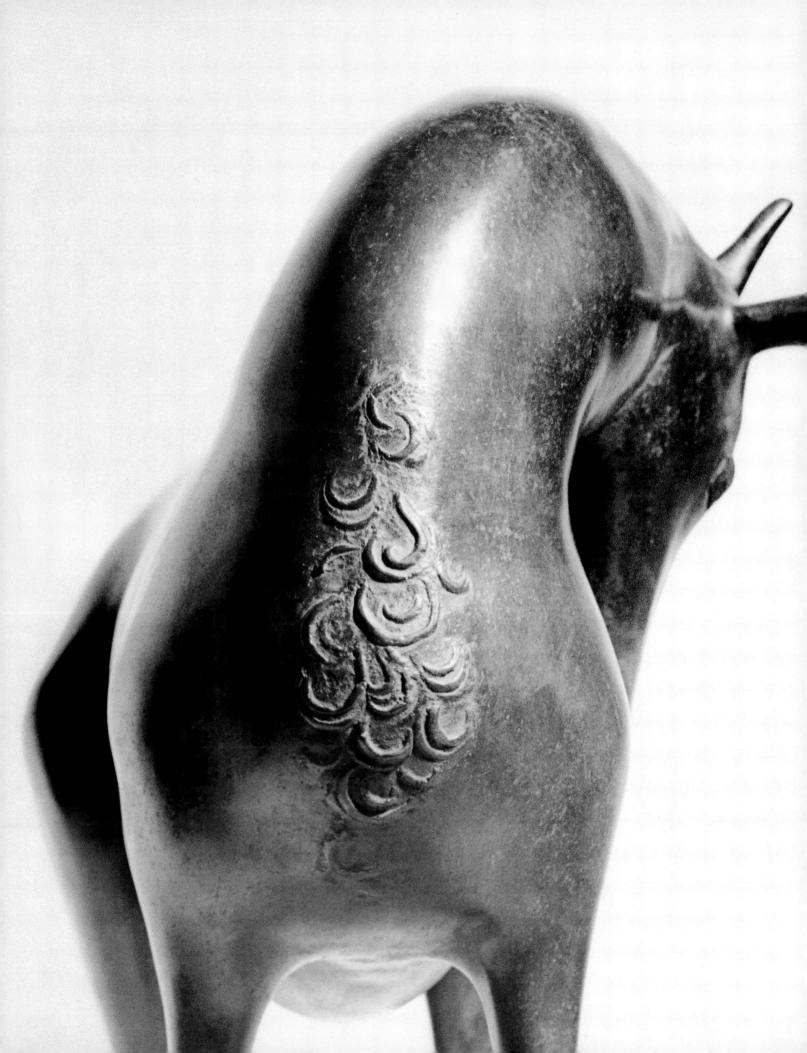

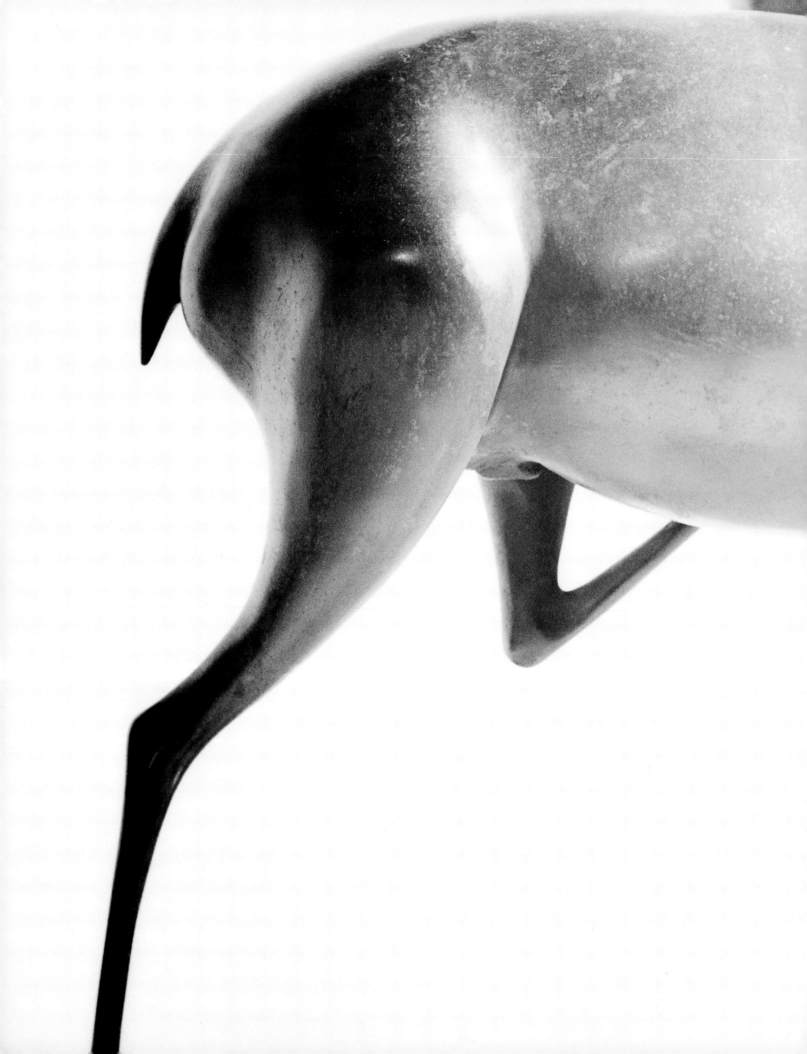

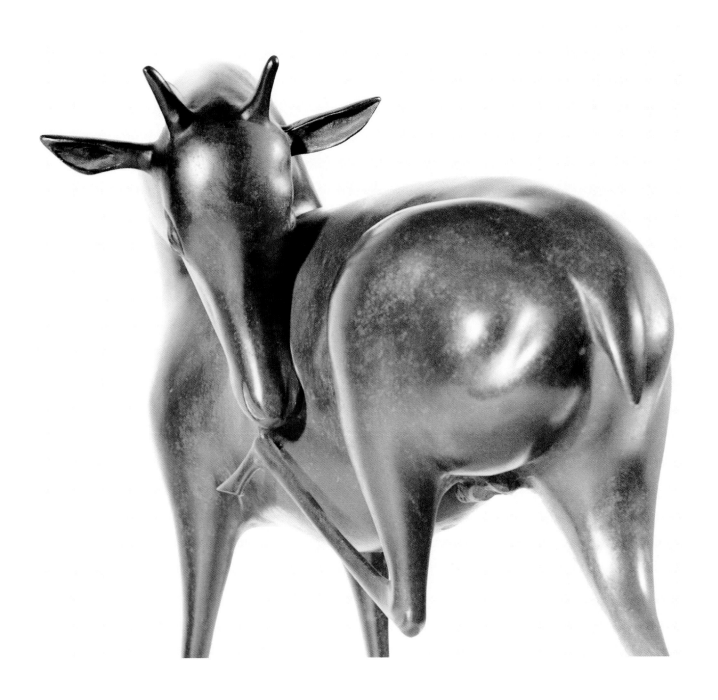

# William Edmondson

[1882–1951]

54. *Schoolteacher,* 1935
Limestone
14½ x 4 x 7¾ in.
Gift of Mr. and Mrs. David McKee,
1982.55

OF ALL THE SCULPTURES I photographed at the Corcoran, the one that seemed most like folk art was *Schoolteacher* (Fig. 54) by William Edmondson. Born to a former slave, Edmondson worked at various jobs, including that of janitor and orderly in a hospital in Nashville, Tennessee. In 1932, during a period of unemployment, he believed he had a religious vision that told him to carve tombstones, and at the age of fifty began creating figures out of limestone from demolished buildings, using self-made tools. The sculptor came to the attention of Alfred Barr, then director of the Museum of Modern Art in New York, who considered his work an outstanding example of primitivism, and in 1937 the museum gave him a solo exhibition. Edmondson subsequently received commissions from the federal government's Works Progress Administration (WPA), but in time arthritis prevented him from continuing his work. The Corcoran's stone carving is a small sculpture, interesting to me more for the message it communicates than for its form. It is a simple female figure staring expressionless at the viewer, with a book under her right arm, and a prim bow on the front of her dress. The figure seems to evoke the calm authority of an old-time schoolmistress.

# Gaston Lachaise

[1882–1935]

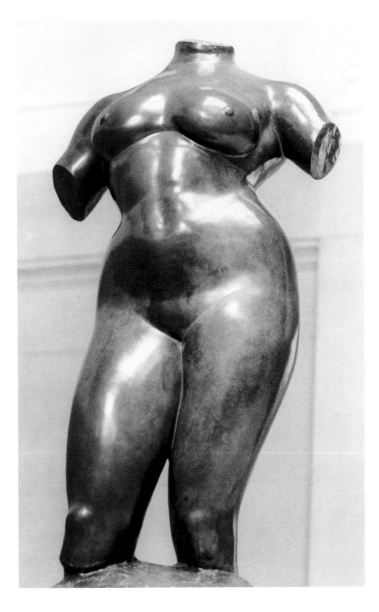

55. Torso of *Standing Woman
(Elevation),* modeled
1912–1918, cast 1966
Bronze
45½ x 23 x 12 in.
Museum Purchase, 66.28
LEFT AND FOLLOWING

GASTON LACHAISE has long been one of my favorite twentieth-century sculptors, and I was privileged to photograph his work in museums and private collections around the country for a 1993 book.[16] At that time, I met John B. Pierce, Jr., the devoted President of the Lachaise Foundation in Boston, who in large measure is responsible for the increasing recognition given to the sculptor's work during the last half century.

Lachaise's personal story is fascinating. He was a student at the École des Beaux-Arts in Paris when he met and fell in love with an older, married American woman, Isabelle Dutaud Nagle. His lifelong passion for her, which brought him to America, was the inspiration for virtually his entire life's work. Woman was his subject—and it was the sexual aspect of woman's nature that he portrayed in his remarkable sculptures. Breasts, hips, buttocks, vaginas were all erotically depicted. It was not the sexual act that was the subject of his work, but the very essence of woman, expressed in her sexual desires and manifested in her sexual life, which fixated him. For a number of years he was a studio assistant to Paul Manship, who was three years his junior but already a successful sculptor. Lachaise had his first exhibition at the Bourgeois Gallery in New York in 1931, and the critic Henry McBride wrote a rave review, in which he stated:

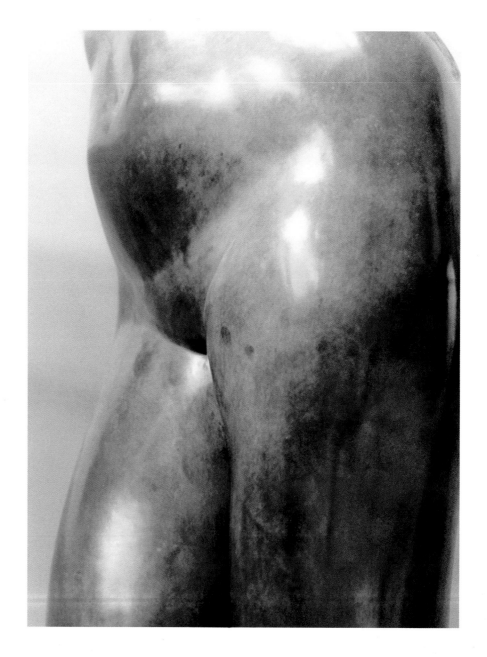

To eyes that had grown somewhat habituated to the platitudinous carvings of the day, the Lachaise 'Woman' was so different that at first she seemed a priestess from another planet than this. She must have been at least early Egyptian, early Arabian, or at least pre-Greek! But that was only at first. In a minute or two the strangeness disappeared, the authoritative satisfaction of the sculptor in his work made itself felt, and a mere critic could see a beauty that though new, was dateless and therefore as contemporary as it was 'early.'[17]

The exhibition made such an impact that four years later, in 1935, Lachaise became the first sculptor to have a one-man show at the Museum of Modern Art. Among his works in the Corcoran collection is a 1966 bronze cast after Lachaise's first life-size figure, *Standing Woman (Elevation)* now in the collection of the Albright-Knox Art Gallery, Buffalo, New York. The torso (Fig. 55) is a magnificent work. A voluptuous image of a woman's body, it was conceived before Lachaise developed the exaggerated anatomy of his later sculptures. Its power is in the energy that Lachaise projected into the figure—the way the breasts rest on the upper body, the way the hips roll, the way the navel accents the curved belly, the way the heavy thighs touch. This is not just any nude figure; it is Lachaise's prototypical image of the woman who was the passion—the obsession—of his life.

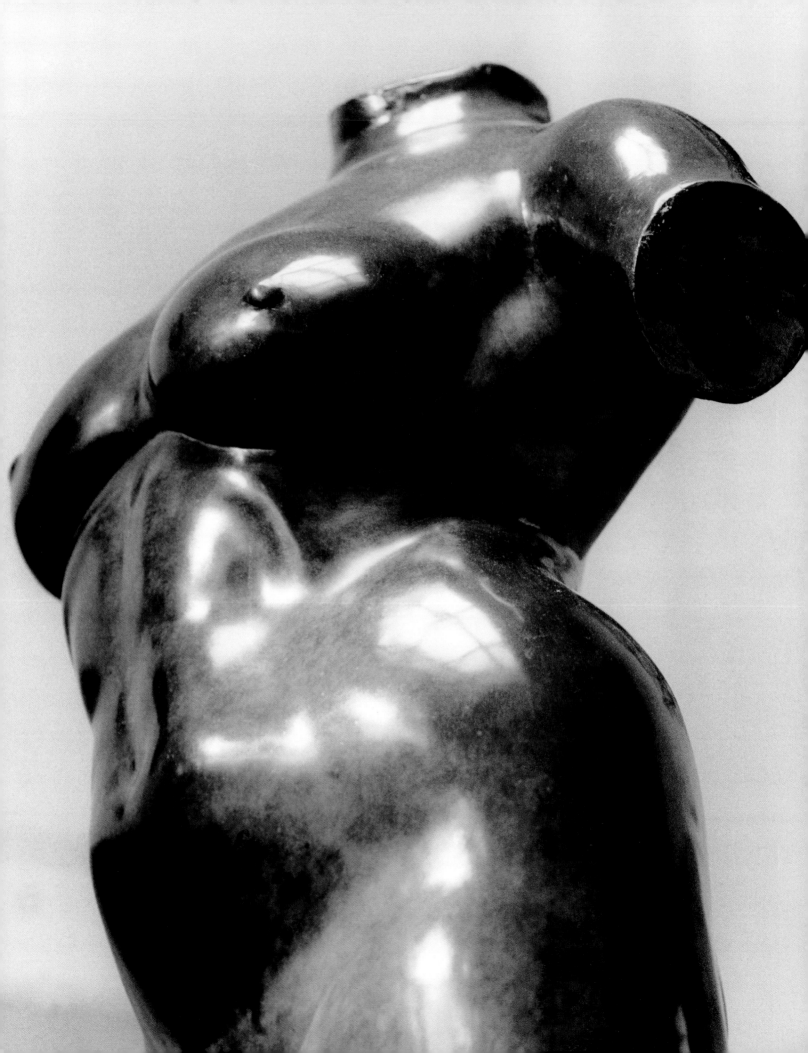

# Jo Davidson

[1883–1952]

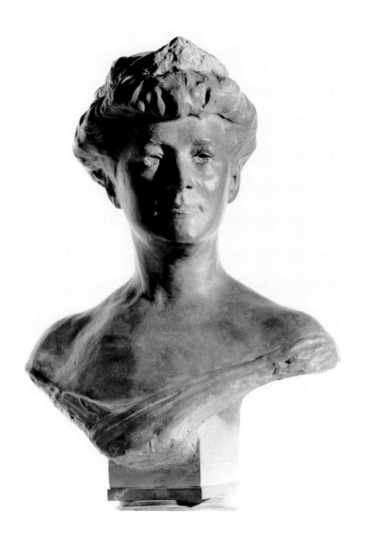

56. *Rose Chatfield-Taylor,* n.d.
Bronze
26 x 18 x 10 in.
Gift of Rose Chatfield-Taylor McMurray, 68.34

JO DAVIDSON was America's master portrait sculptor. Born in New York City, his family wanted him to study medicine, but by the time he was twenty he knew he wanted to be a sculptor. He met Gertrude Vanderbilt Whitney in Paris, and she became his patron. He returned to New York in 1910 where he had his first one-person show. In the following years he was increasingly recognized for his portraits of famous subjects, including Gertrude Stein, John D. Rockefeller, James Joyce, Aldous Huxley, D.H. Lawrence, Dwight D. Eisenhower, David Ben-Gurion, Golda Meir, André Gide, Helen Keller, Frank Sinatra, Franklin D. Roosevelt, Will Rogers, Mahatma Gandhi, and Carl Sandburg. He also sculpted nudes, but they did not produce as much income as his portraits. His first wife was a French actress, Yvonne de Kerstrat, and some years after her death he married Florence Lucius, a fellow sculptor. During his life he was involved in many liberal activities, including the Loyalist cause in Spain. The Corcoran owns a classic bronze bust of *Rose Chatfield-Taylor* (Fig. 56), which is typical of the portrait sculptures for which Davidson was famous.

# Paul Manship

[1885-1966]

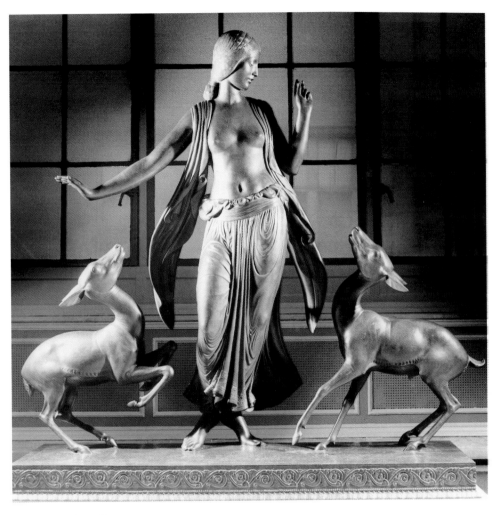

57. *Dancer and Gazelles,* 1916
Bronze
69¾ x 73 x 19 in.
Museum Purchase, 20.1
ABOVE AND FOLLOWING

A HIGHLY SUCCESSFUL sculptor in the early twentieth century, Paul Manship was best known for his decorative, neo-classical style. He was born in St. Paul, Minnesota, and showed an interest in drawing at an early age. Initially, his ambition was to be a painter, but when he discovered that he was color blind he switched his focus to sculpture, attending the Art Students League in New York, the Pennsylvania Academy of the Fine Arts in Philadelphia, and the American Academy in Rome. In his formative years he traveled widely—in Spain, France, Greece, Germany, Egypt, and Turkey—studying the sculpture of many different cultures. At age twenty-eight, he married Isabel McIlwaine, and in the same year he hired sculptor Gaston Lachaise as a studio assistant. Commissions, exhibitions, and honors followed at an increasingly fast pace, and by 1927 Manship was able to buy four tenement houses on Manhattan's East Seventy-second Street, two of which he converted into a spacious home and studio. At the height of his success he had homes in Paris and New York. In 1934, his most familiar work, the gilt-bronze *Prometheus Fountain*, was installed at Rockefeller Center in New York City.

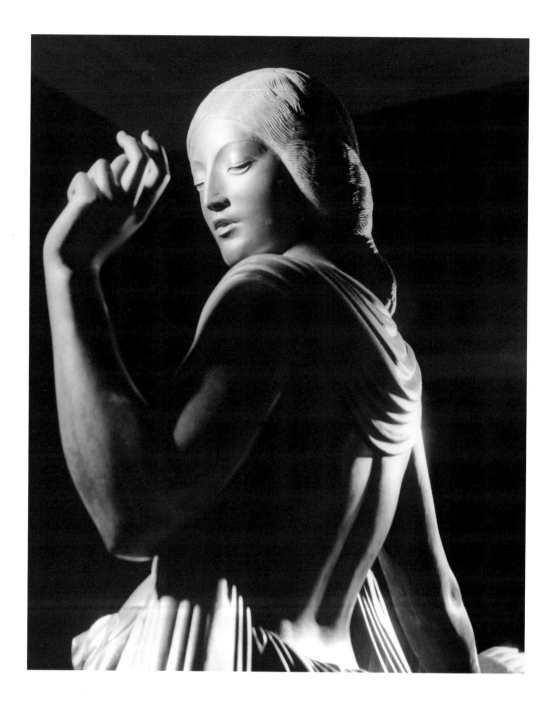

The largest and most impressive of the nine Manship sculptures at the Corcoran is *Dancer and Gazelles* (Fig. 57), completed in 1916 when he was thirty-one. Here, Manship's early style is fully developed, and reflects his study of Chinese and East Indian art, with the flowing lines of arms, legs, skirt, and scarf creating a rhythmic composition. The faces of Manship's sculptures have been called cold and impersonal, but when photographing this dancer from various angles I found her face, as well as her naked upper body, to be sensitively formed. The folds of the scarf and skirt are well designed, and the gazelles, although somewhat decorative, add to the energy of the overall work. *Flight of Night* (Fig. 58) was completed around the same time, in a similar style. As in *Dancer and Gazelles,* Manship created a sense of floating movement, mounting his crescent-shaped figure on a small globe. Once again, the gestures of the figure's arms and legs create a dazzling composition while the long flowing skirt beautifully evokes the fading of darkness as day approaches. *Indian Running with Dog* (Fig. 59), a later sculpture, also proved to be very popular, but to my camera eye it seems less finely executed than the earlier works.

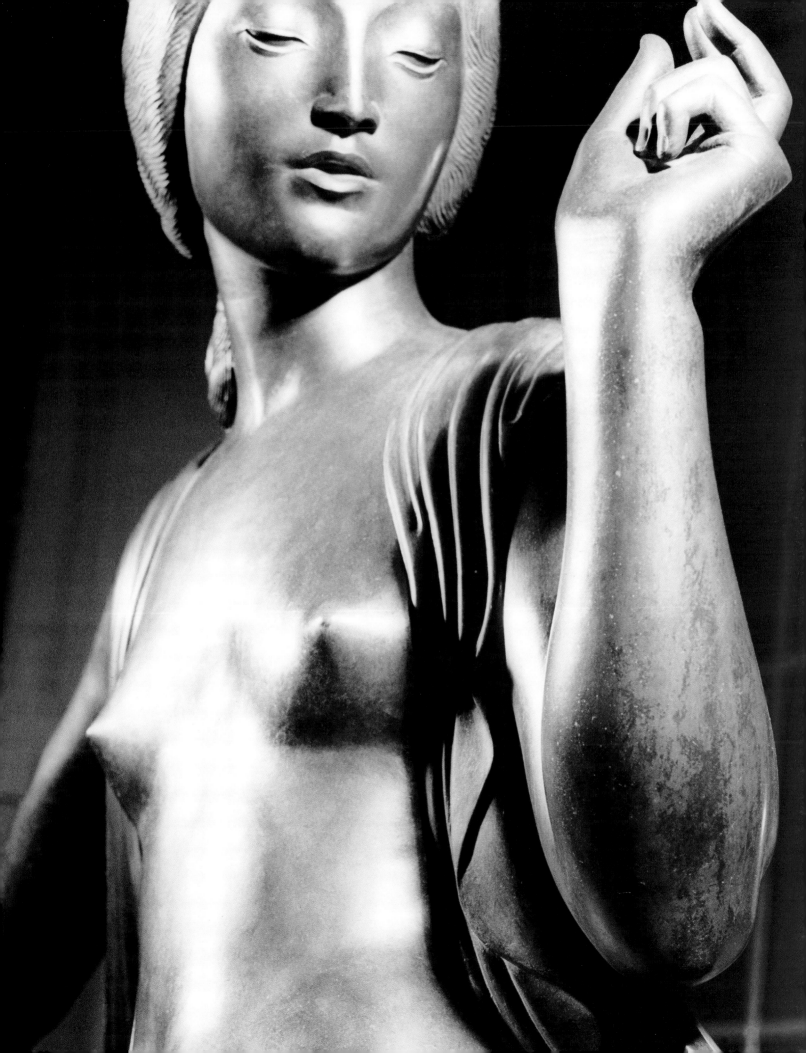

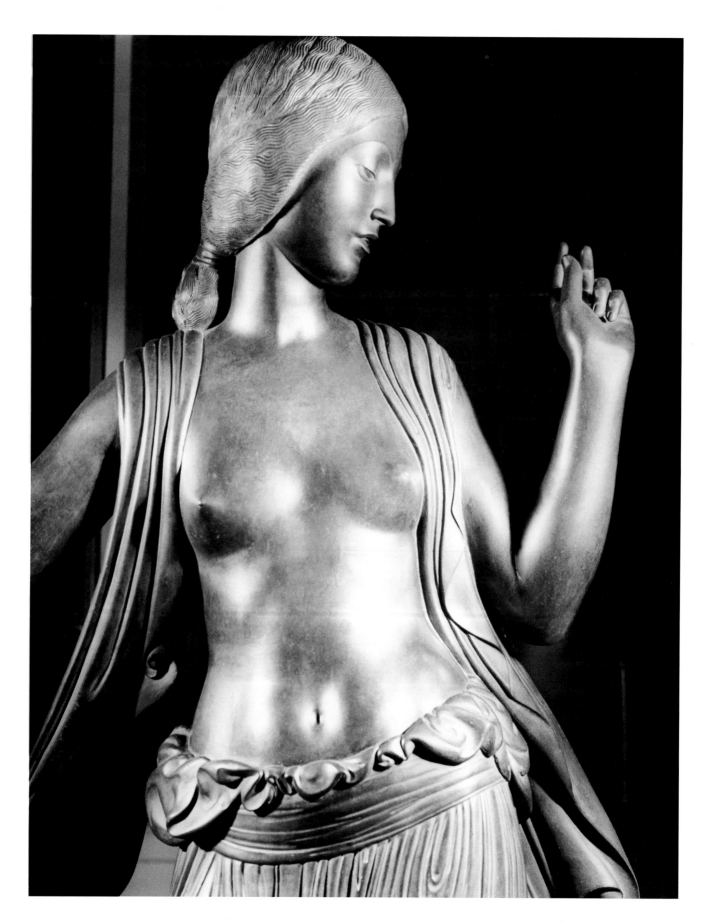

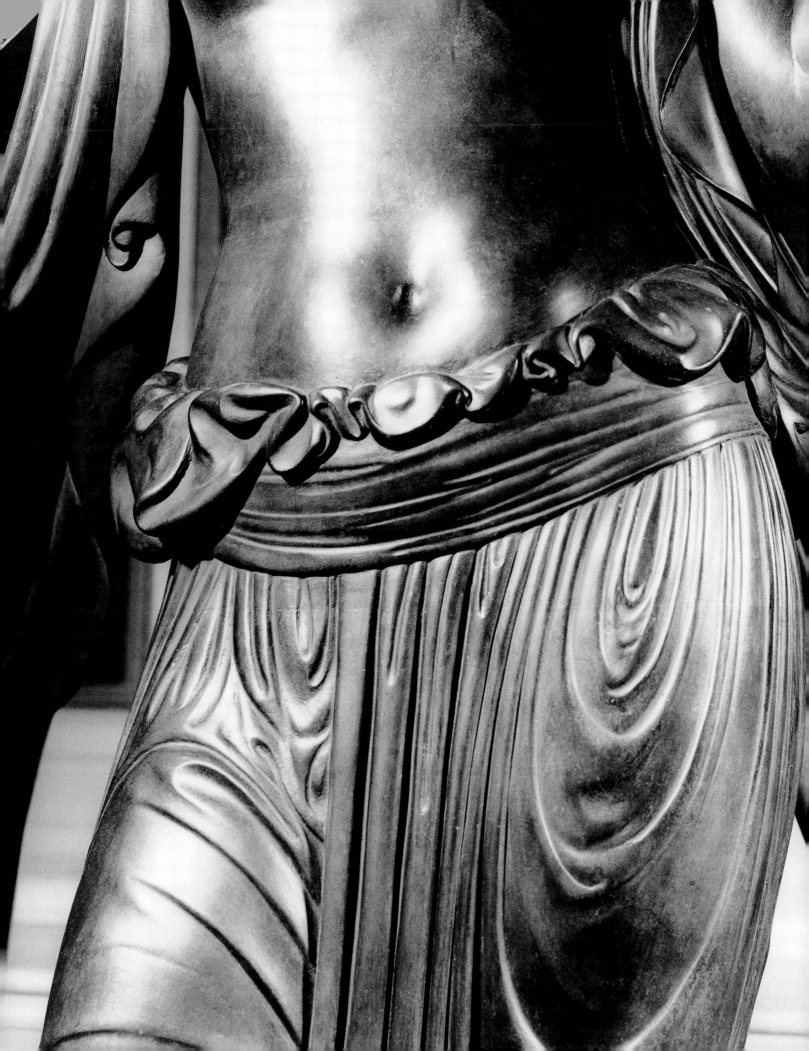

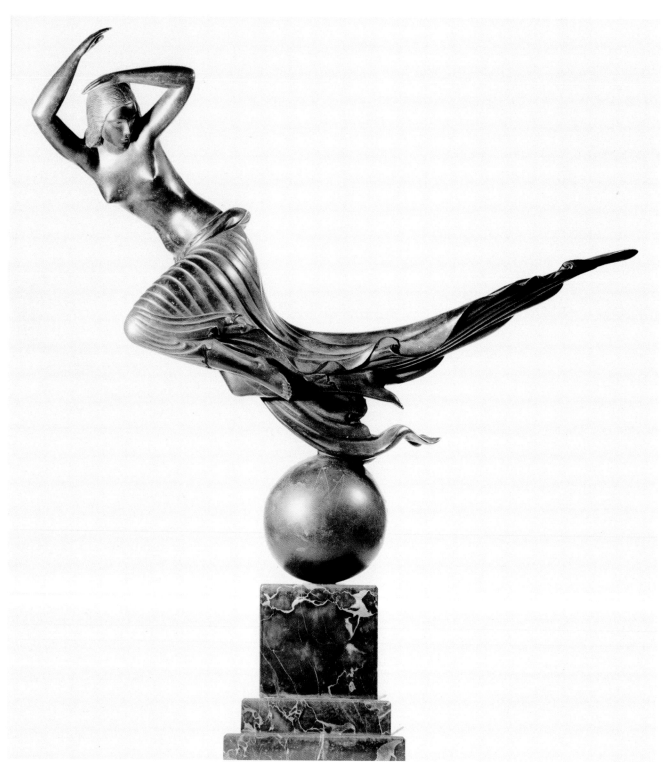

58. *Flight of Night*, 1918
Bronze
26¼ x 25¾ x 5⅛ in.
Bequest of James Parmelee, 41.73
ABOVE AND OPPOSITE

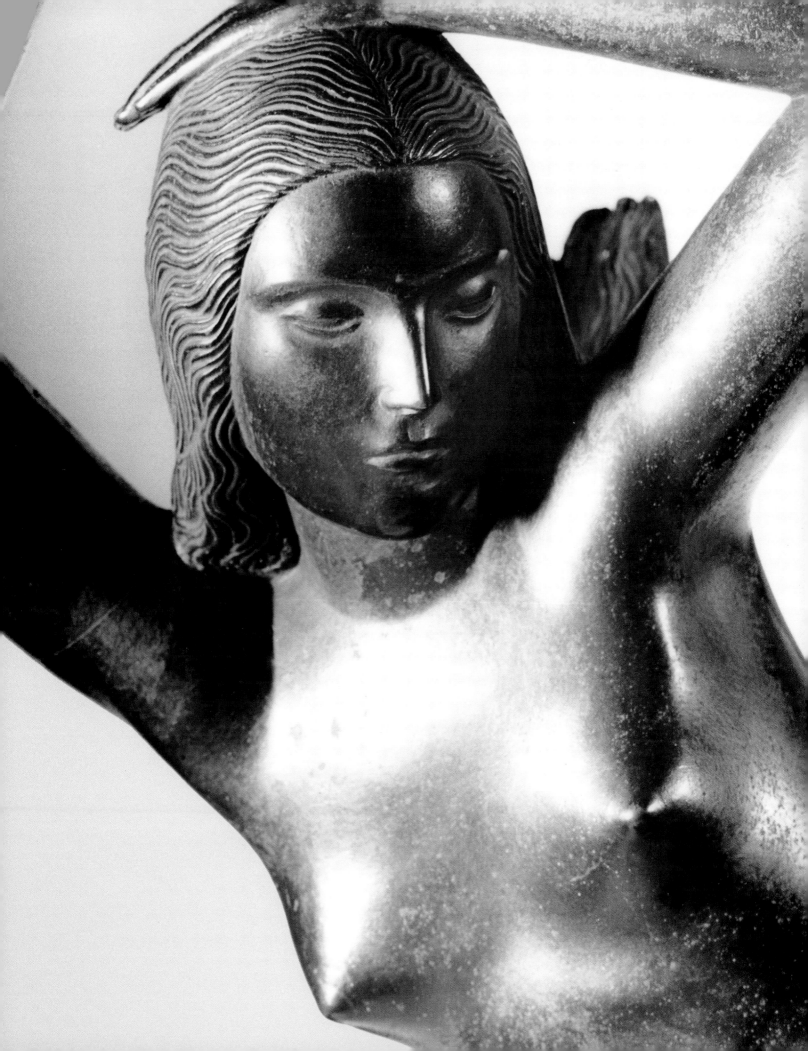

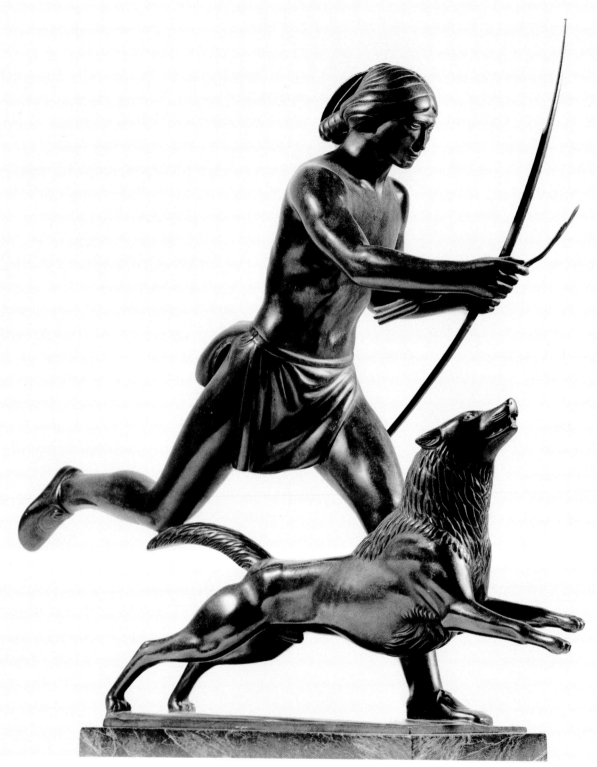

*59. Indian Running with Dog*, 1922
Bronze
23 x 23 x 8¼ in.
Bequest of James Parmelee, 41.74
ABOVE, OPPOSITE AND FOLLOWING

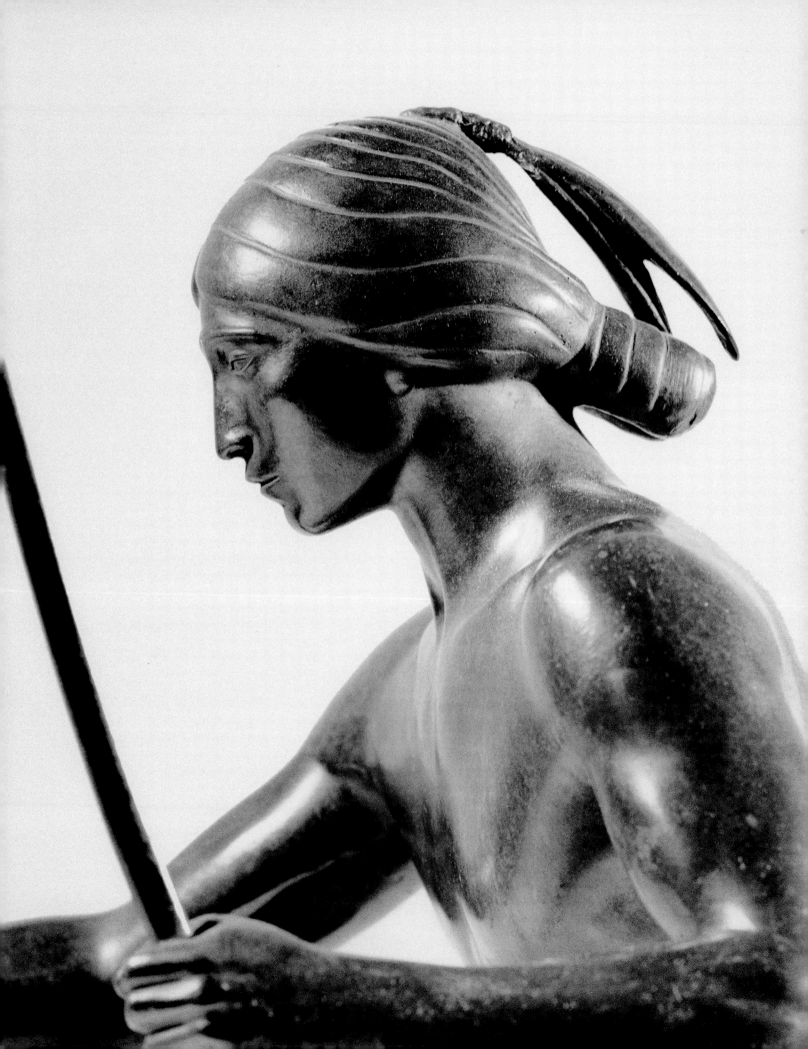

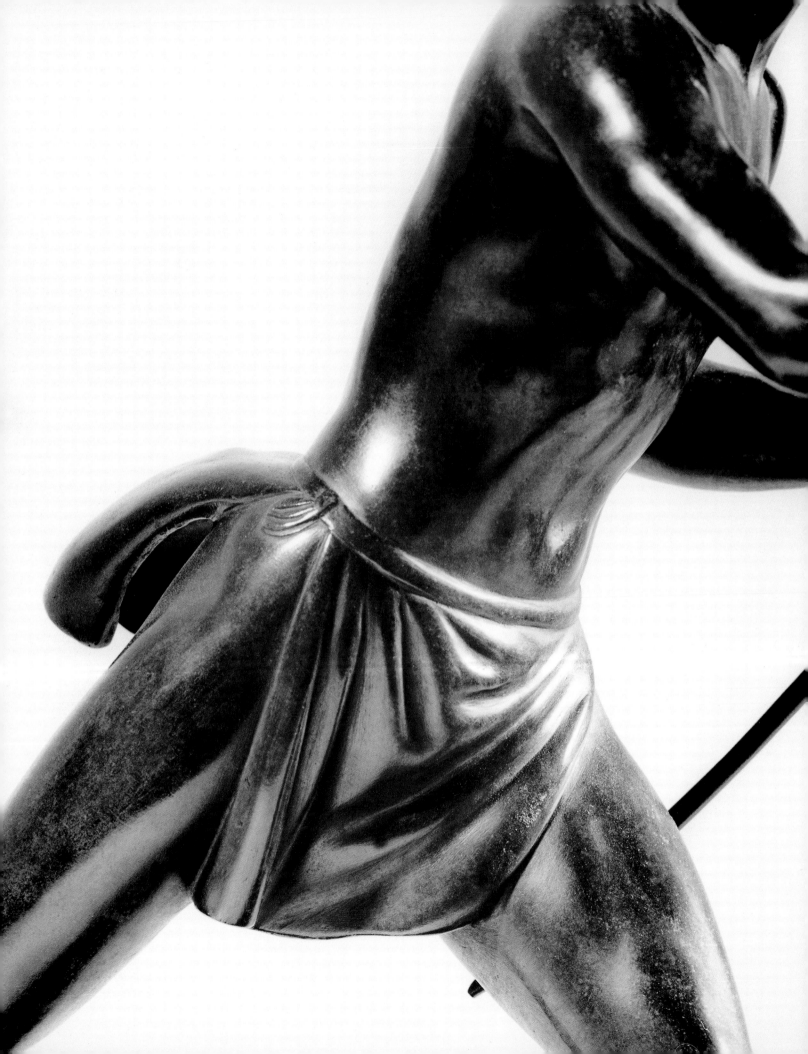

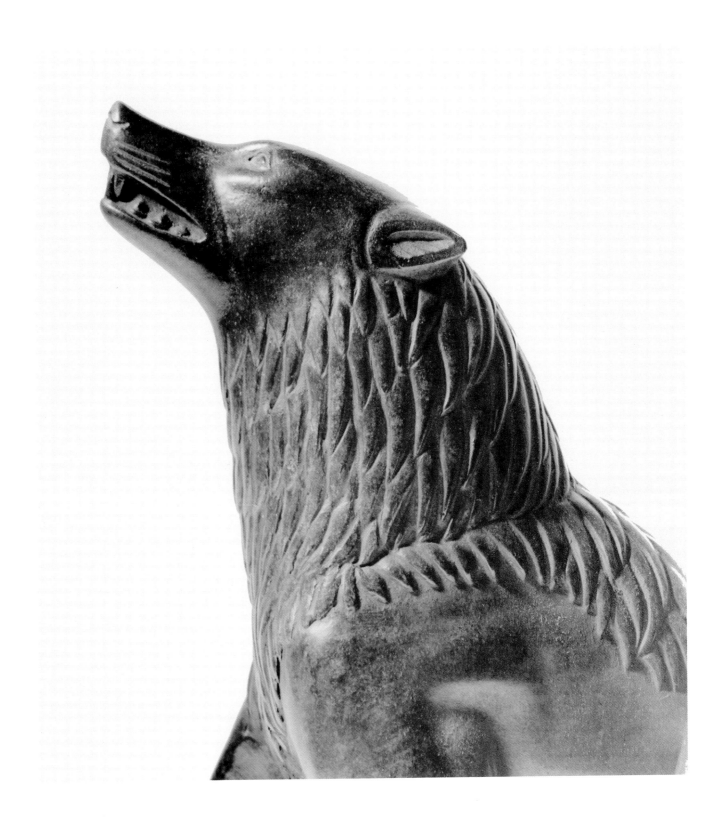

# Malvina Hoffman

[1887–1966]

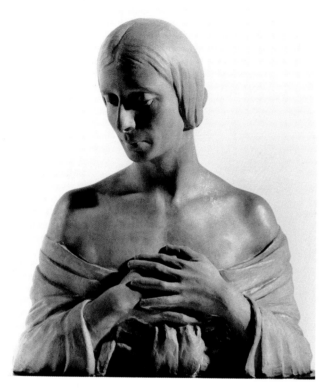 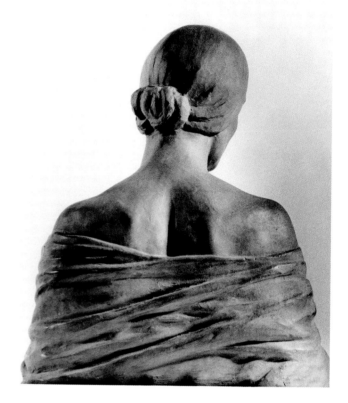

60. *Pavlova*, 1926
Terracotta
10½ x 9 x 4¾ in.
Bequest of James Parmelee, 41.68
ABOVE AND OPPOSITE

MALVINA HOFFMAN was a student of Rodin, and a friend of the famous Russian dancer Anna Pavlova, depicted here. Hoffman was fascinated with ballet, which was the inspiration for much of her early work. She also attended anatomy classes at the Cornell University College of Physicians and Surgeons, where she practiced dissection. When she was thirty-eight, she married a musician, Sam Grimson, but their marriage ended in divorce. Her most famous body of work is a series of more than one hundred bronze figures representing the races of man for the Hall of Man in Chicago's Field Museum of Natural History. In connection with that commission, Hoffman traveled through the South Pacific, Japan, the Dutch East Indies, the Malay Peninsula, and India. The works were so successful that they were shown in many museums around the country in a traveling exhibition. The sculptor wrote a book about her travels, *Heads and Tales*, and another about her life, *Sculpture Inside and Out*. In her later years, her studio became a salon visited by such friends as Andrés Segovia, Georgia O'Keeffe, Helen Keller, Clifton Fadiman, and Pierre Teilhard de Chardin. *Pavlova* (Fig. 60), one of three sculptures by Hoffman in the collection of the Corcoran Gallery of Art, is a remarkably sensitive terracotta portrait. Pavlova's head tilts forward, eyes down-turned, lips tightly shut, hair cleanly drawn back, robe dropped below her shoulders, and hands clasped in front. The renowned dancer was forty-three years old when Hoffman completed the work in 1926.

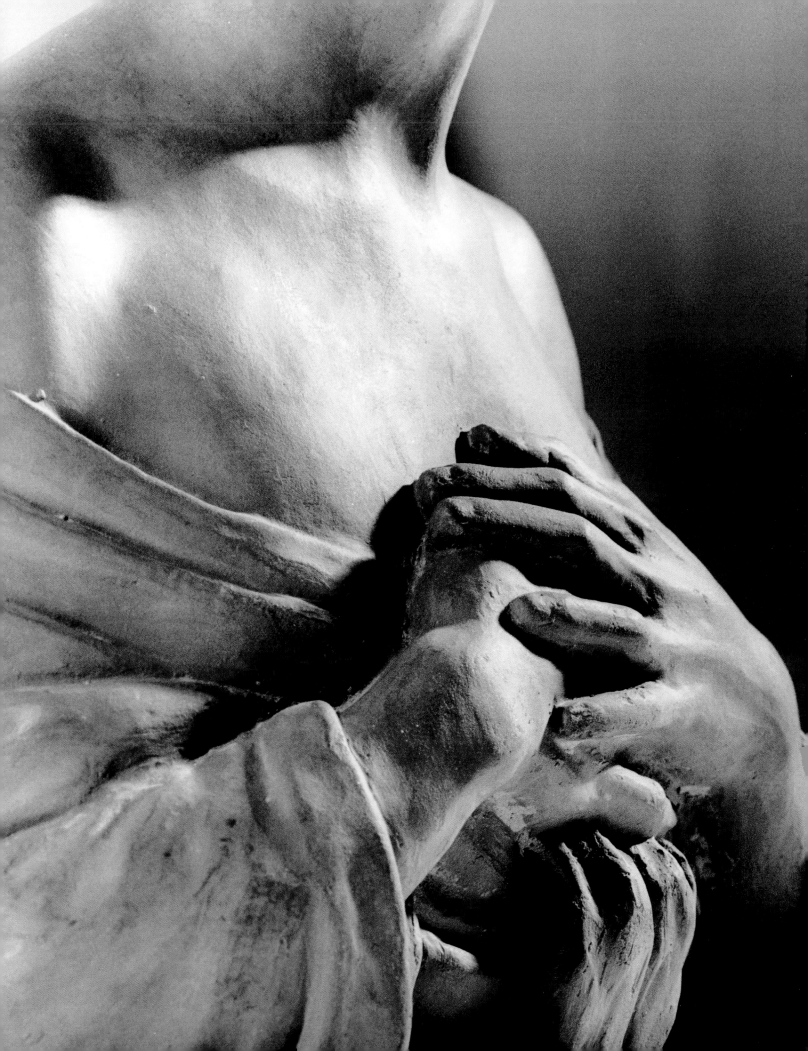

# John Storrs

[1885–1956]

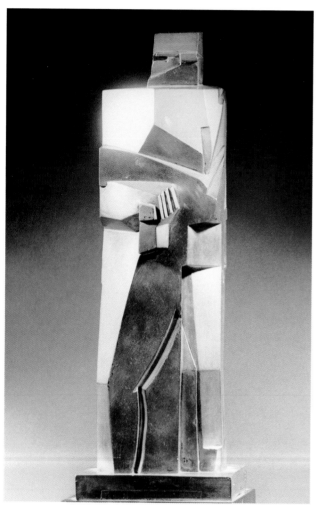
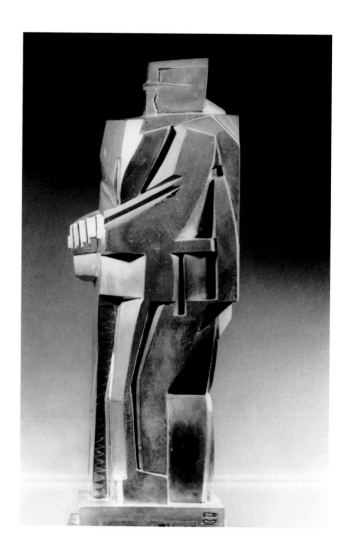

61. *Le Sergent de Ville,* c. 1920
Bronze with silver gilt
13¼ x 5¼ x 5¼ in.
Museum Purchase, William A. Clark Fund, 1969.43
ABOVE, OPPOSITE AND FOLLOWING

JOHN STORRS, son of a wealthy Chicago real estate developer, studied in various art schools in Chicago, Boston, Philadelphia, Paris, and Berlin. Initially, his work was traditional, influenced by Rodin, a good friend and mentor. But in 1918 he became intrigued with the British vorticist movement, and he began to model and carve cubist figures and nonobjective works based on architecture. The terms of his father's will required that the younger Storrs not establish permanent residence outside the U.S. and that he spend a minimum of six months there each year. However, Storrs ignored his father's wishes and settled down with his French wife in Paris, where he exhibited regularly and received major commissions. During World War II,

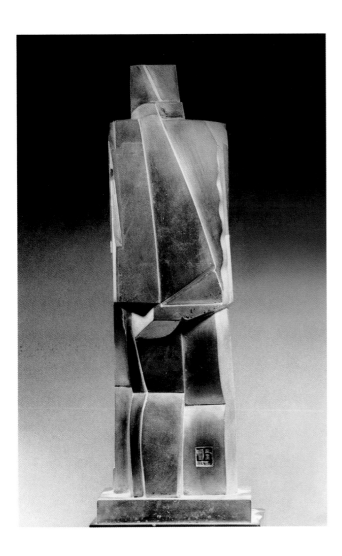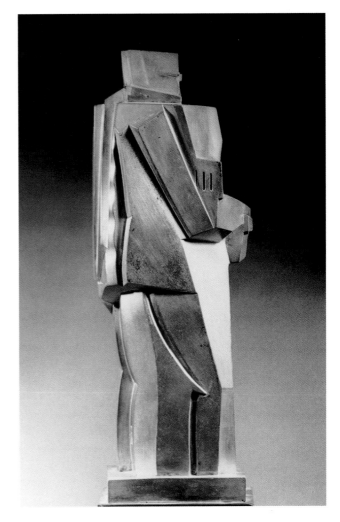

he was captured and imprisoned by the Nazis. His production after the war was limited, and he died in France in 1956.

The Corcoran has two of Storrs' works. One, *Le Sergent de Ville* (Fig. 61), is a cubist work with well-composed planes, curves, and lines. The sculpture is an endless source of striking compositions; I had a delightful time looking at the work from different angles and discovering its many details. The same was true when I photographed *Horses' Heads* (Fig. 62). The animals' heads are particularly intriguing, with their many abstract planes. The whole sculpture is well-designed, even from the back, where the place, date (Paris 1917 to 19), and the artist's name are cast within a small cartouche.

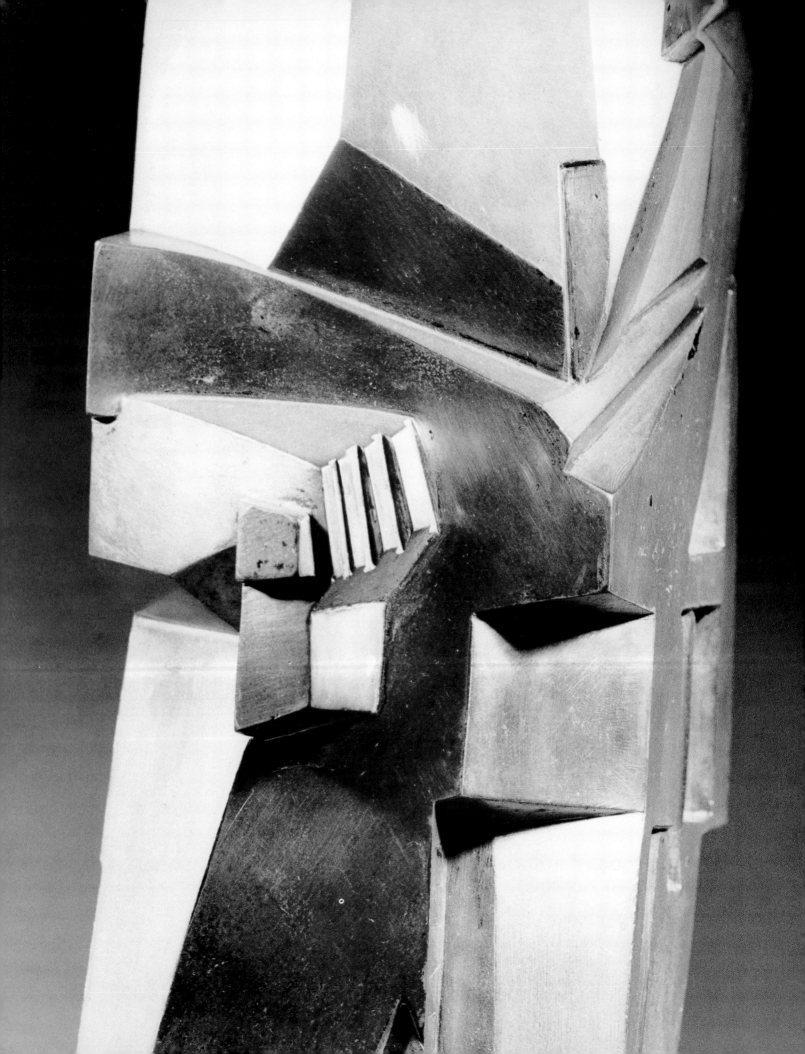

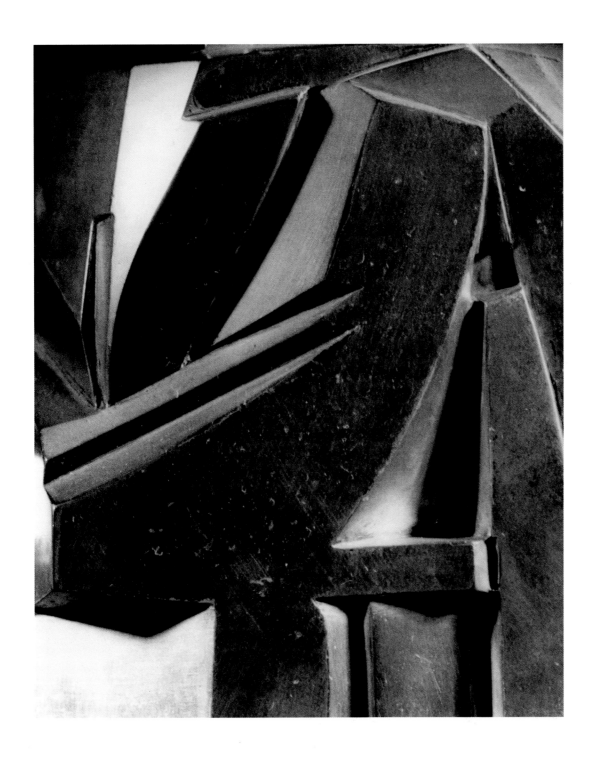

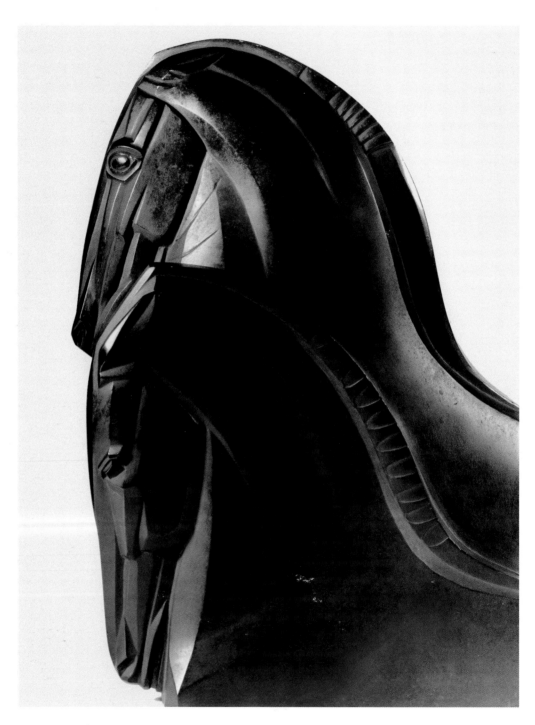

62. *Horses' Heads*, 1917–19
Bronze
14¼ x 4¾ x 8½ in.
Bequest of George Biddle, 1974.12
ABOVE AND OPPOSITE

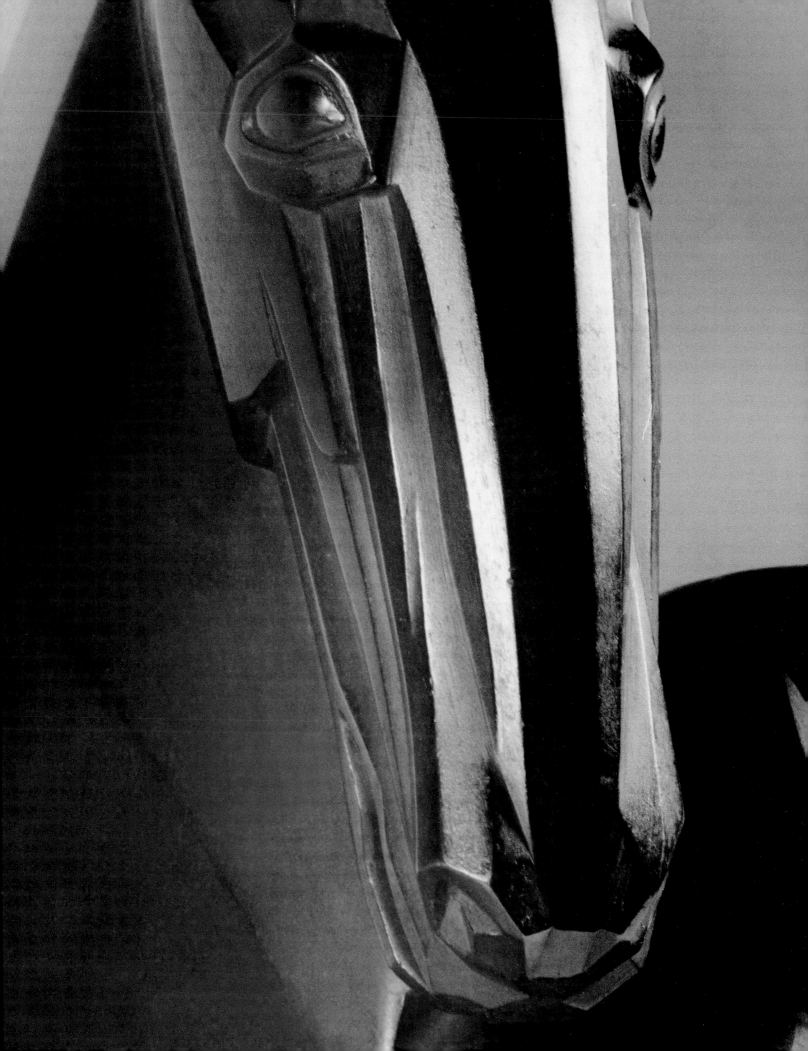

# Jacques Lipchitz

## [1891–1973]

JACQUES LIPCHITZ was one of the great figures of twentieth-century sculpture. Born in Druskininkai, Russia (now Lithuania), he went to school in Bialystok and later in Vilna. His father wanted him to study engineering, but his mother encouraged his interest in sculpture. At seventeen, the young man went to Paris and studied at the École des Beaux-Arts, the Académie Julian, and the Académie Calarossi. He befriended other young artists, including Diego Rivera, Juan Gris, Pablo Picasso, Chaim Soutine, and Amadeo Modigliani (who drew and painted Jacques Lipchitz and his wife, Bertha).

At an early age, Lipchitz began to collect African and Oceanic art as well as works from other cultures, and his passion for collecting influenced the character of his work. He began exhibiting in 1911 with a group of Russian artists in Paris, and over the next few years became increasingly involved with the cubist movement. Later in life he modified his style, going beyond cubism to develop his own approach to creating monumental forms, often of mythical figures. In 1941, Lipchitz and his wife emigrated to the U.S., where his work was exhibited by Curt Valentin at the Buchholz Gallery in New York. In one of his essays about his work, Lipchitz described his approach to sculpture as *encounters*:

I have always been fascinated by encounters, the encounters of materials, the encounters of ideas, the encounters between myself and things not-myself, and the encounters of various sides of myself. Sometimes these encounters are between similarities and likes; sometimes between opposites or wildly different things. But encounters are unpredictable, and through them the fabulous may take shape. From the encounter in the mind comes something entirely different from any of the ingredients, and sometimes that is unpredictable until then. So I welcome the encounters wherever I go or whatever I do.[18]

I met Lipchitz in the 1960s at the home of mutual friends and was thrilled to spend several hours talking to him about his work. I was also excited about photographing his bronze *Guitar Player* (Fig. 63), one of his most monumental early cubist works. There is immense strength in the way the abstract forms of this piece interact, and I discovered an almost endless number of compositions within as I photographed it from various vantage points. Almost every conceivable geometric form is incorporated into it—squares, rectangles, curves, angles; the guitar player's hands and abstract eye provide accents that make the sculpture seem to be a living being.

63. *Guitar Player,* 1918
Bronze
30 x 13½ x 13½ in.
Bequest of June Provines Carey, 1984.7.1
OPPOSITE AND FOLLOWING

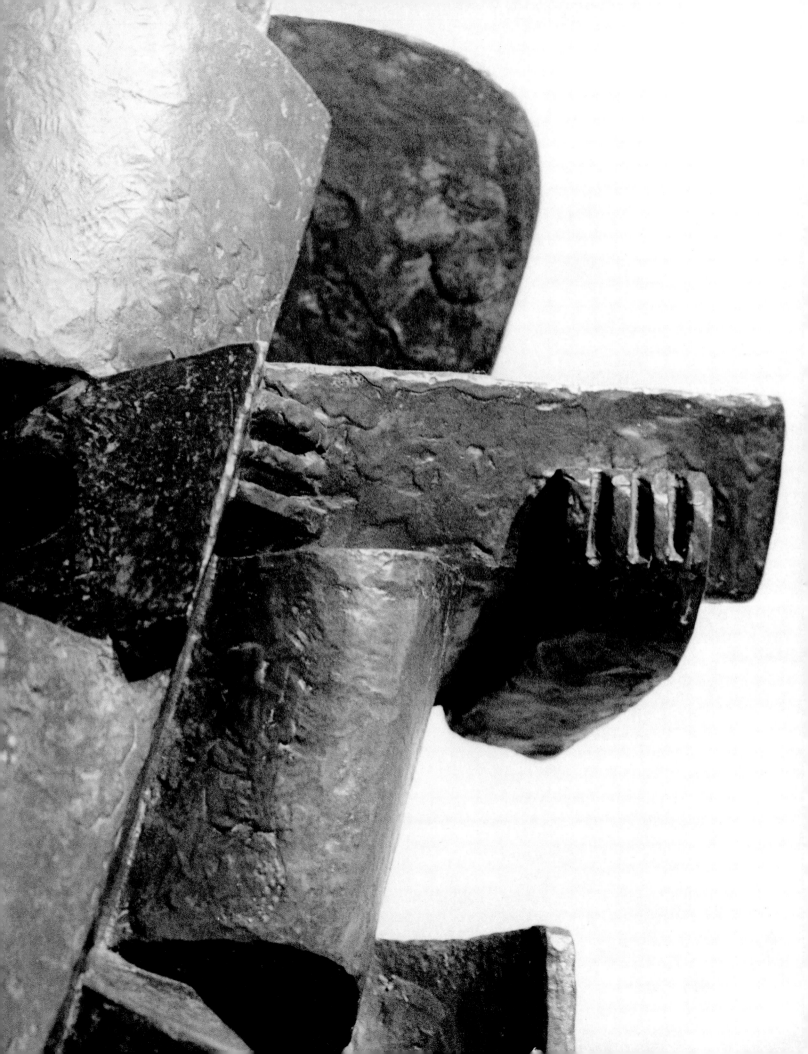

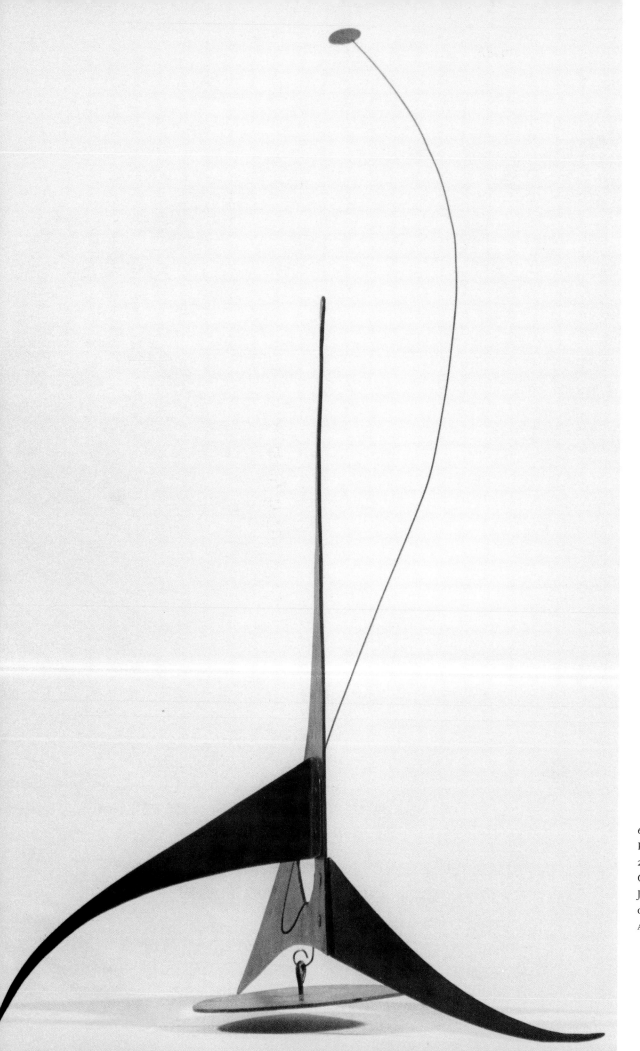

64. *Calderberry*, n.d.
Painted metal
22¼ x 12½ in.
Gift of Mrs. and Mrs.
James S. Schramm, 61.46
OPPOSITE, RIGHT
AND FOLLOWING

# Alexander Calder

[1898–1976]

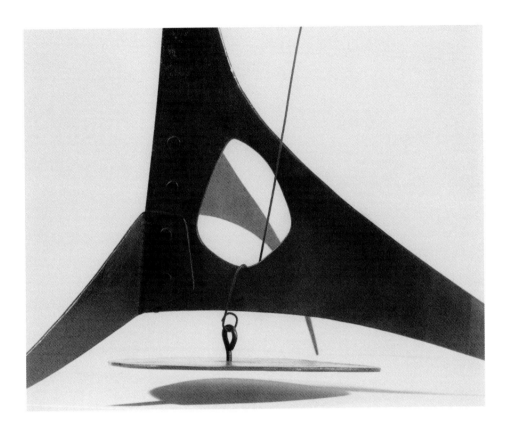

THERE IS NO twentieth-century artist with whom the work of Alexander Calder can be compared. I once asked Henry Moore what he thought of Calder's sculpture and he laughed. "Sandy is not a sculptor," he said. "He's just a great artist." For Moore, sculpture meant solid forms and framed spaces, but Calder's work is different. It combines the movement of dance with architectural forms of his own invention. Both his mobiles and stabiles have a unique grace. Others who have tried to imitate his technique inevitably fail to produce a work that has the balance and harmony that is characteristic of Calder's creations. He studied engineering at the Stevens Institute of Technology in Hoboken, New Jersey, but afterward attended the Art Students League in New York and the Académie de la Grande Chaumière in Paris. His early work consisted of wire sculptures and his *Circus*, in the collection of the Whitney Museum of American Art, which fascinates visi-

tors. Some of his first mobiles were activated by motors, but most were designed to float in the air suspended by wires.

The stabiles that followed seem to have the same airy quality as Calder's mobiles, even though they do not move. And then there were the combinations—mobile/stabiles. The Corcoran's *Calderberry* (Fig. 64) is technically a stabile, since nothing moves either by motor or air, and yet the delicate wire attached to the floating round form at the base of the sculpture resembles elements found in Calder's mobiles. Delicate and inventive, the sweeping legs of the piece come to graceful points as they rest on the ground. The surprising hole in the center creates a window into the work, and the long upright vertical form becomes a neck topped by a tiny head. The extraordinarily graceful wire reaching upward in a brilliant curve and crowned by a tiny disk is balanced like a dancer holding a graceful position for an instant in time.

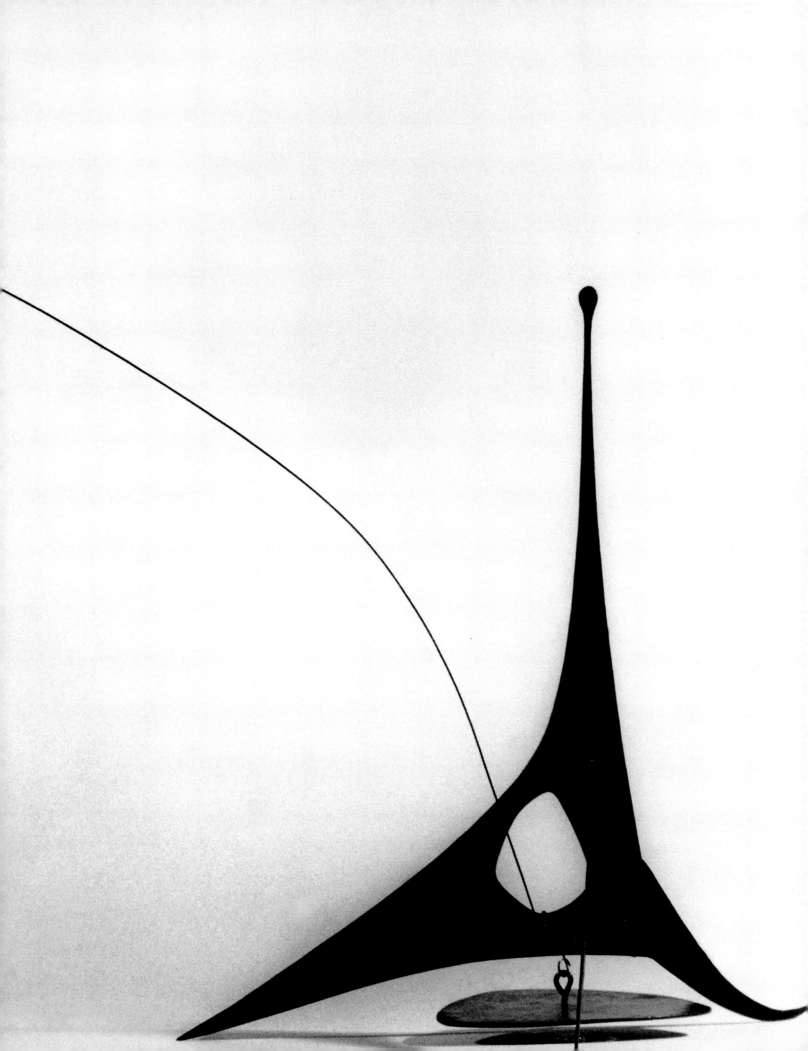

# Louise Nevelson

## [1899–1988]

65. *Ancient Secrets,* 1964
Wood
70⅝ x 62½ x 15 in.
Gift of the friends of the Corcoran Gallery of Art, 68.41
ABOVE, OPPOSITE AND FOLLOWING

BORN IN KIEV, RUSSIA, Louise Nevelson came to the U.S. with her family when she was five years old. Her father was a contractor and lumber merchant in Rockland, Maine, and it may have been in his lumberyard that her love for the shape and texture of wood developed. She studied with the painter Hans Hofmann at the Art Students League in New York, and subsequently traveled to Germany, where she became interested in acting and dancing. Later she traveled to Mexico and South America and began working in terracotta. She made her first works in wood in the 1950s, and won recognition for *Black Majesty,* which was exhibited at the Whitney Museum of American Art in 1955. In 1967, she had a retrospective exhibition at the Whitney that established her as a major twentieth century artist.

Most of Nevelson's sculptures are painted black—although some are white or gold—and consist of a miscellany of forms, including pieces of wood, wheels, knobs, and other objects. They are, for the most part, relief sculptures that resemble walls, sometimes with shelves framing sections of the work. Although the objects seem to be chosen at random, they are in fact carefully composed and convey a commanding sense of order. The Corcoran work, *Ancient Secrets* (Fig. 65), is a less common composition for Nevelson, in that it is made of four hinged sections that can be adjusted into various configurations. The textures and grains of the different pieces of wood, as well as the way they are arranged, contribute to the creative tension of the work.

# Dorothy Dehner

[1901–1994]

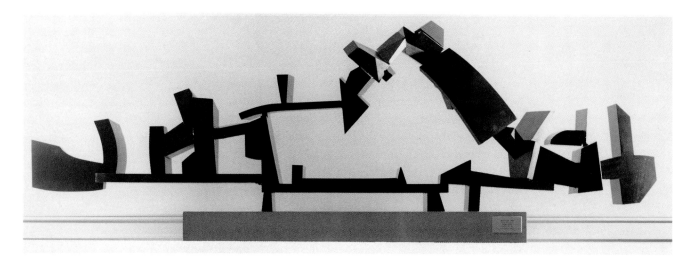

66. *Breakwater,* 1990
Fabricated steel, black paint
55 x 148 x 30 in.
Gift of the Artist, 1993.8.2
ABOVE, OPPOSITE AND FOLLOWING

I FIRST BECAME familiar with the work of Dorothy Dehner more than fifty years ago when I was a salesman for the American Artists Group line of Christmas cards. Her paintings were among the most popular in the company's catalogue, and I became an admirer of her work. It was, therefore, a special pleasure for me to come across her monumental steel sculpture *Breakwater* (Fig. 66) in the Corcoran collection. In her early years, Dehner wrote poetry and studied modern dance, theater, and piano. It was only after traveling to Europe that she became interested in the visual arts and began studies at the Art Students League in New York. After she married sculptor David Smith, rather than risk competing with him, she opted to produce few works during their twenty-three-year union. However, following their separation, she began to make large abstract sculptures and won recognition as a major figure in her own right. *Breakwater* is a large, intricate composition of forms that could be a metaphor for a giant wave mounting to a crest, dashing against a shore, and then receding. Through my camera eye, I was impressed by the variety of geometric forms comprising this intriguing work. It is an ingenious amalgam of shapes and spaces with a special rhythm; I felt like an explorer searching for hidden meanings as I focused on its many different details.

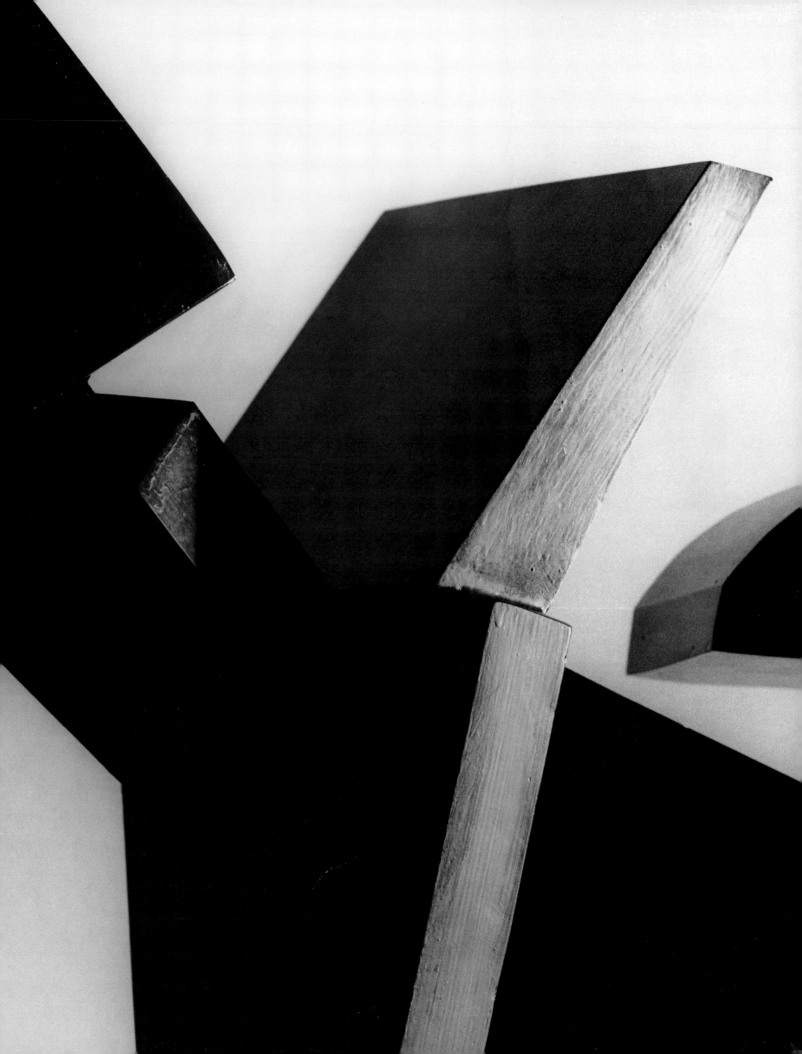

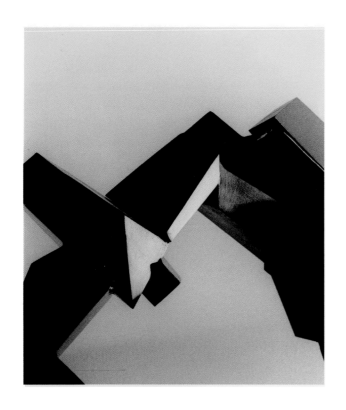

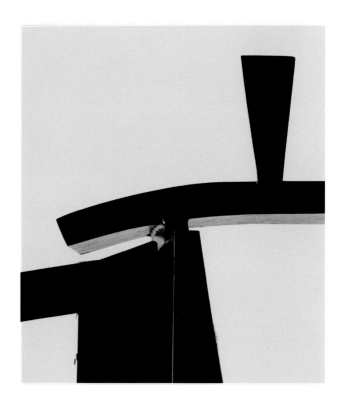

# Joseph Cornell

[1903–1972]

67. *Caravaggio Prince, Medici Slot Machine
    Variant,* c. 1950
Box construction and collage
15½ x 9½ x 4½ in.
Gift of the friends of the Corcoran
Gallery of Art, 1978.10
LEFT AND OPPOSITE

A CREATOR OF STRANGE but fascinating assemblages that are like stage settings, Joseph Cornell was born in Nyack, New York, and spent his early years working at a textile firm. In the 1920s, when surrealist art emerged as a major movement, he began to collect old books, engravings, and miscellaneous objects, putting them together in collages. In 1931, the Julien Levy Gallery in New York exhibited some of his creations in an exhibition of surrealist works, and the following year gave him a one-person show. He soon invented what would become recognized as his special art form: handmade wooden boxes with glass fronts, containing an amazing array of objects combined in an orderly fashion. The elements are put together with remarkable creativity to stimulate the eye and inspire the imagination, rather than to convey a specific message. Indeed, the absence of a message in a composition made up of objects from the real world is part of the impact of the work. The objects included are wide-ranging—thimbles, marbles, old photographs, maps, pipes, painted eggs, and dolls' heads.

Cornell's works also encompassed a number of recurring themes, such as the innocence of childhood, the passage of time, the romance of Europe, the adventure of travel, and the relationships among science, mathematics, and architecture. He also created constructions in homage to famous ballerinas and opera singers, and drew from art history. In the 1940s and 1950s, he created the *Medici Slot Machine* series, all of which contained reproductions of paintings by European masters such as Bronzino, Anguisciola, and Caravaggio. The Corcoran work, *Caravaggio Prince, Medici Slot Machine Variant* (Fig. 67) (a variation on *The Medici Slot Machine,* 1942, private collection, New York City), is one of these. It is an unusually simple but extremely effective collage, and an excellent example of Cornell's genius. The box contains a reproduction of a portrait that may be of Lorenzo de'Medici, by a follower of Caravaggio. There is a large image of a face with vertical and horizontal lines forming a cross painted on the glass in front of it; in addition, the tears and crackles in the canvas in the photograph (intentionally distressed by Cornell) form a random pattern of age lines across the surface. It is framed on each side by filmlike strips of six smaller versions of the same image, and below the main image appear the floor plans of a Venetian building. The frame is adorned with an elaborate, beaded decoration. It is a typical Cornell work, a delight to look at, subtle in its carefully assembled details, and hauntingly evocative.

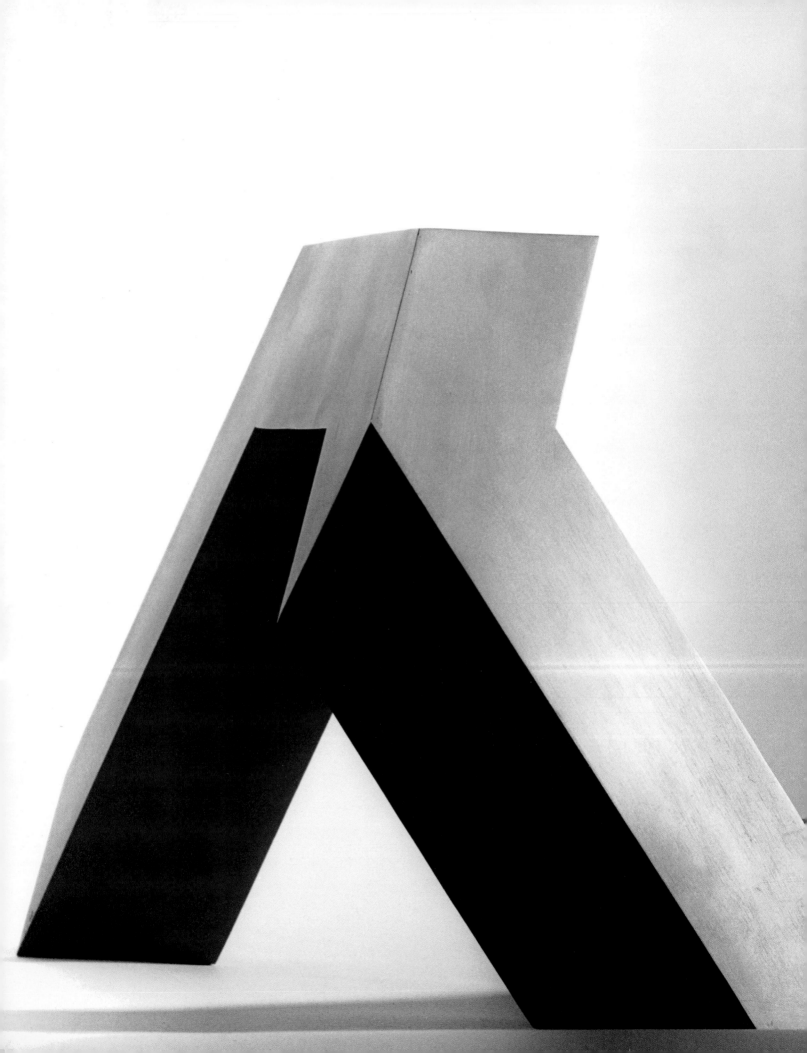

# Tony Smith

[1912–1980]

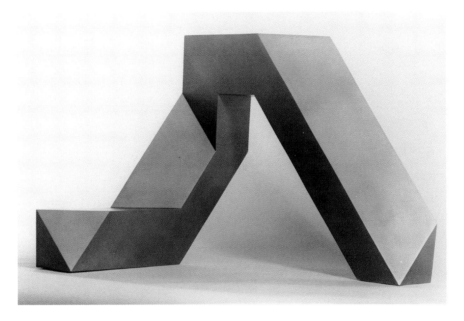

68. *Cigarette,* 1967
Mild steel, vapor-blasted surface
15¾ x 14⅞ x 14¾ in.
Museum Purchase, William A. Clark Fund, 68.24
ABOVE, OPPOSITE AND FOLLOWING

An architect, painter, sculptor, teacher, and a man with spiritual leanings, Tony Smith was a minimalist who was a member of the Abstract Expressionist generation. Widely recognized as a leading figure in the world of sculpture, he was featured in a *Time* magazine cover story in 1967 during his participation in an exhibition entitled "Scale as Content," held at the Corcoran Gallery. However, his major one-man show at the Museum of Modern Art did not take place until 1999, eighteen years after his death. Catholicism and Jesuit schooling were part of his background, as was an interest in the mystical writer George Ivanovitch Gurdjieff. A self-educated man, Smith was once described by as "a walking encyclopedia of Jung, shamanism, magic in general, ritual, the unconscious."[19] He said about his own work, "I got the principle from God. I got the form from Christ. I got the function from the Spirit."[20] In the 1950s he accompanied his wife, an opera singer, to Germany where he produced a series of paintings influenced by his architectural interests. These played a significant role in the development of his unique approach to form and space. In an *Art in America* review of the 1999 Museum of Modern Art exhibition, Richard Kalina observed:

Smith created sculptural space by architectural means, forging a new amalgam of the modeled and constructed form. His sculptures are elusive and allusive, yet basically simple, uncluttered and purposeful. Architecture provided him with a structural methodology, a vocabulary of technique and vision. Smith was after a humanist geometry, but one that was tough-minded and practical. In this he was very much a man of his time, a mid-century American artist, balancing know-how and the habits of realistic appraisal conditioned by the Depression with utopianism and the liberating, rootless ethos of bohemia.[21]

The Corcoran work, *Cigarette* (Fig. 68), is an example of Smith's skill in creating original geometric forms. It is amazing to realize how many different planes exist in the sculpture as it twists and turns. He combines triangles with rectangles with squares,—creating a unique space both within and around the sculpture. The images revealed by the camera are startlingly different as one moves around the form, yet clearly they are all part of the same structure.

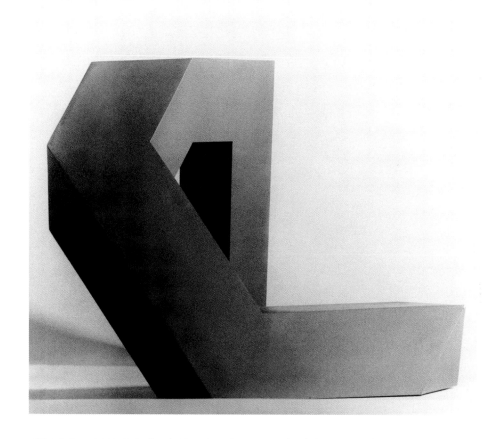

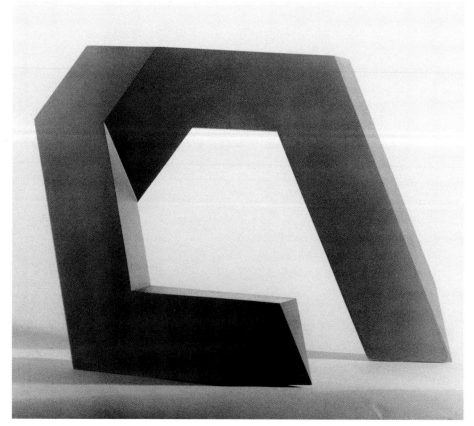

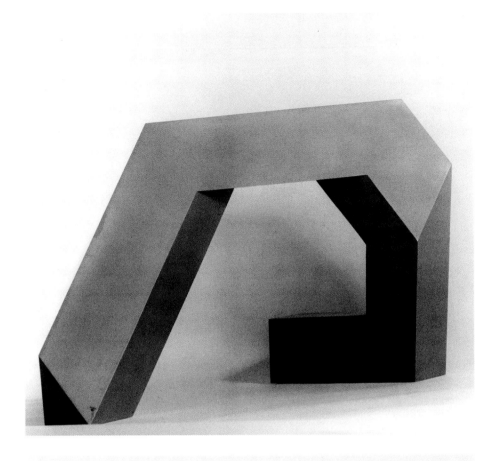

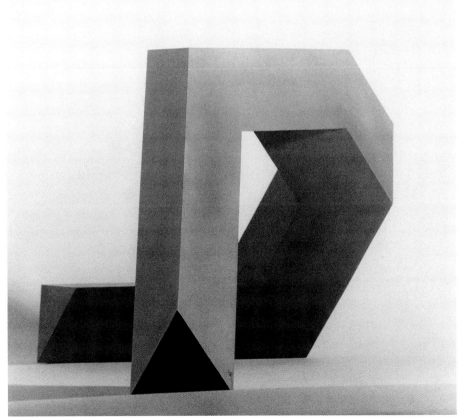

# Marisol Escobar

[B. 1930]

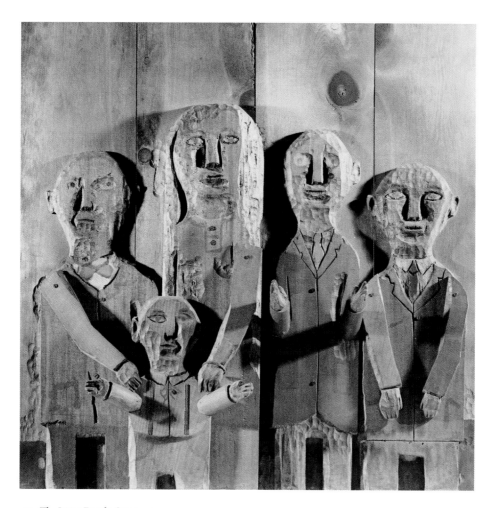

69. *The Large Family Group,* 1957
Painted wood
37 x 38 x 6½ in.
Gift of Mr. and Mrs. C.M. Lewis, 1973.20
ABOVE AND OPPOSITE

MARISOL ESCOBAR, known simply as Marisol, was born in Paris of Venezuelan parents. She studied at the École des Beaux-Arts and the Académie Julian in Paris, as well as at the Hans Hofmann School in Provincetown, Massachusetts and the Art Students League in New York. Her special approach, almost from the beginning of her career, was the construction of figurative sculptures in wood that have a distinctly primitive character. In the 1960s and 1970s Marisol became a major figure in the pop art movement, with one-woman exhibitions at the Leo Castelli Gallery in New York and the Hanover Gallery in London, and her work was included in group shows in vari-

ous museums. *The Large Family Group* (Fig. 69) is a striking relief, with carved figures of painted wood that are almost caricatures. Although the faces and figures are formed in similar patterns, each has its own personality. The mother, with her long straight hair, is confident and proud as she rests one hand on the shoulder of her youngest child; the father, also touching his child, is shorter, balding, a bit sad; the two big-eared boys beside them appear to be posing at the artist's request; and the baby, with outstretched hands, is simply pleased to be included in the picture.

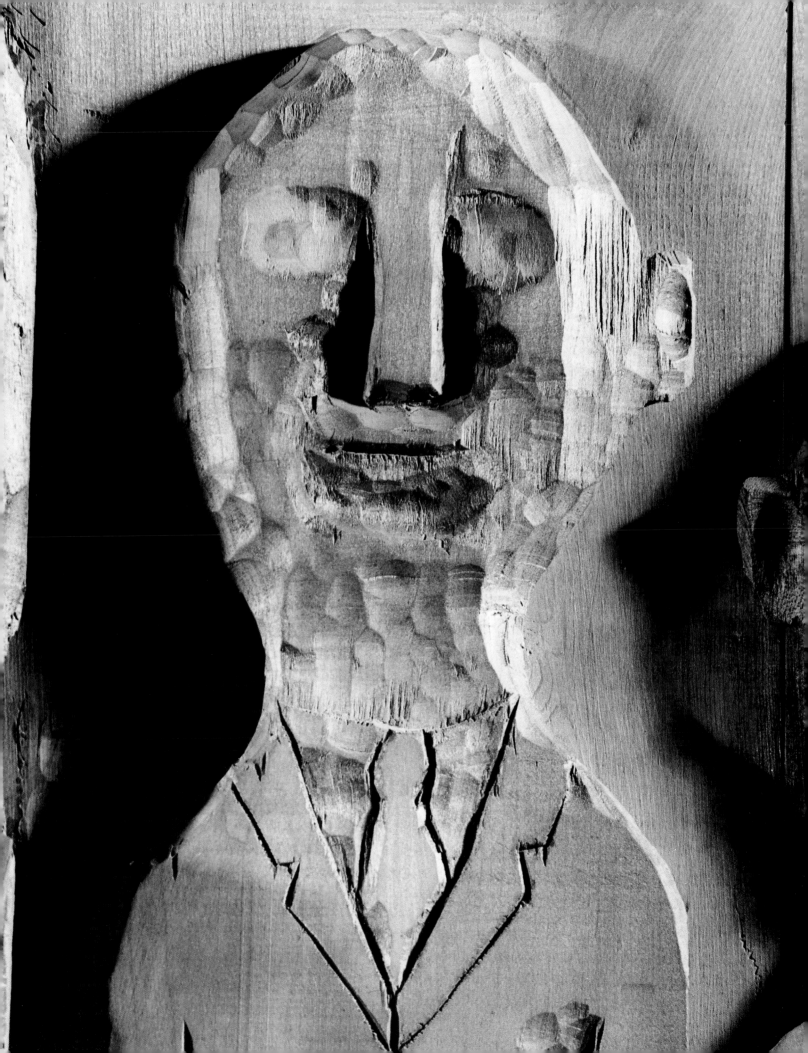

# Joel Shapiro

[B. 1941]

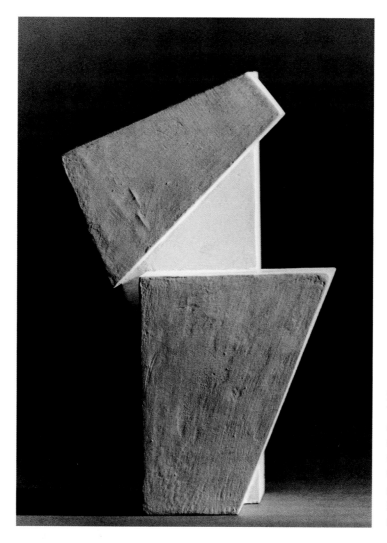

70. *Untitled*, 1979
Wood
6½ x 3¾ x 4⅛ in.
Gift of the Women's
Committee of the Corcoran
Gallery of Art with the aid
of funds from the National
Endowment for the Arts,
1988.1.2

A POST-MINIMALIST artist whose work is both representational and abstract, Joel Shapiro grew up in a scientific environment; his father was an internist and his mother, a microbiologist. He received both a B.A. and an M.F.A. from New York University; in between earning those degrees, he spent two years in the Peace Corps in India. His early sculptures were assemblages of materials that seemed to have been arranged haphazardly, but by the mid-1970s he began to put together simple block forms representing familiar objects like houses, chairs, and tables. By the 1980s, his main subject had become the human figure constructed in block forms that sometimes resembled puppets. Often they are represented with limbs flying in different directions and in positions that seem to defy gravity. *Untitled* (Fig. 70) is a purely abstract work: a small wood sculpture made of brilliantly arranged forms. Although it is unlike some of his later works, including the sculpture in the outdoor plaza of the United States Holocaust Memorial Museum in Washington, D.C., which seem to convey humanistic messages, this is nonetheless a little gem, and a fine example of the artist's inventiveness.

# Dale Chihuly
## [B. 1941]

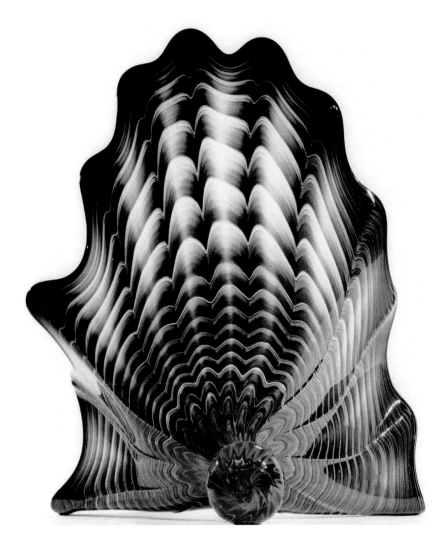

71. *Teal Persian Single with Maroon Lip Wrap,* 1993
Glass
28 x 21½ x 13½ in.
Anonymous gift in honor
of Elmerina and
Paul Parkman, 1996.25
LEFT AND FOLLOWING

DALE CHIHULY was born in Tacoma, Washington, studied interior design at the University of Washington, and later enrolled in glass programs at the University of Wisconsin and the Rhode Island School of Design. He was awarded a Fulbright fellowship to work at the Venini factory in Venice, where he mastered the technique of blowing glass. Later, he introduced his studio to the Italian "team" approach to creating in glass. Subsequently he cofounded the Pilchuck Glass School in Stanwood, Washington, which has become an international center for glass-blowing as a studio art. Chihuly's work, which has involved collaborative glass-blowing at factories in Finland, Ireland, and Mexico, has been exhibited in museums around the world, including in spectacular installations in Venice, Jerusalem, and London. Chihuly is well-known for his large architectural installations and also for his many series, including those he called Baskets, Seaforms, and Persians. I was delighted to have an opportunity to photograph one of his works, *Teal Persian Single with Maroon Lip Wrap* (Fig. 71), a breathtaking, shell-like form with brilliant colors and designs. The composition of the glass structure is extraordinary, and it is especially dazzling to focus the camera on the lights and lines mysteriously contained within the form. The movement of lines is like music – a brilliant display unlike anything one might see in any other medium.

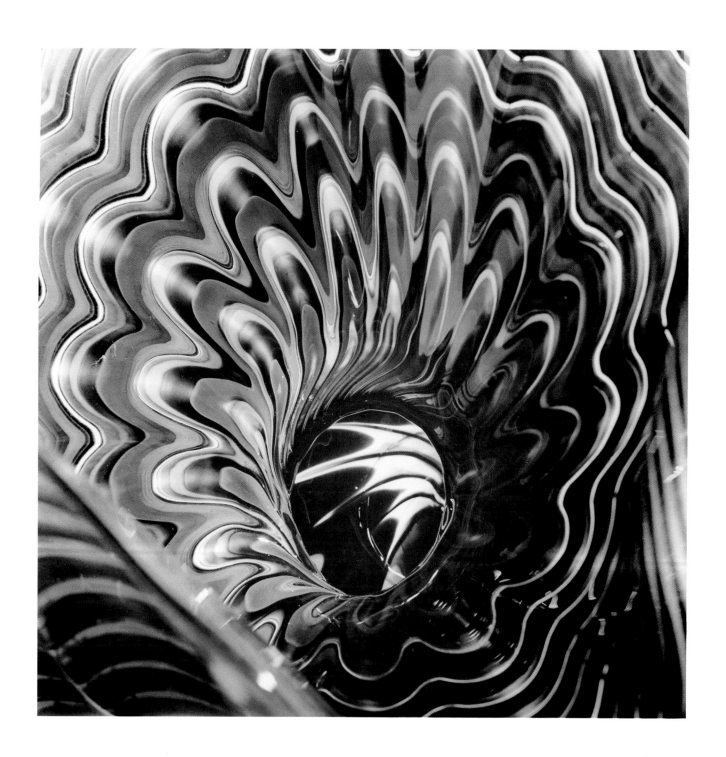

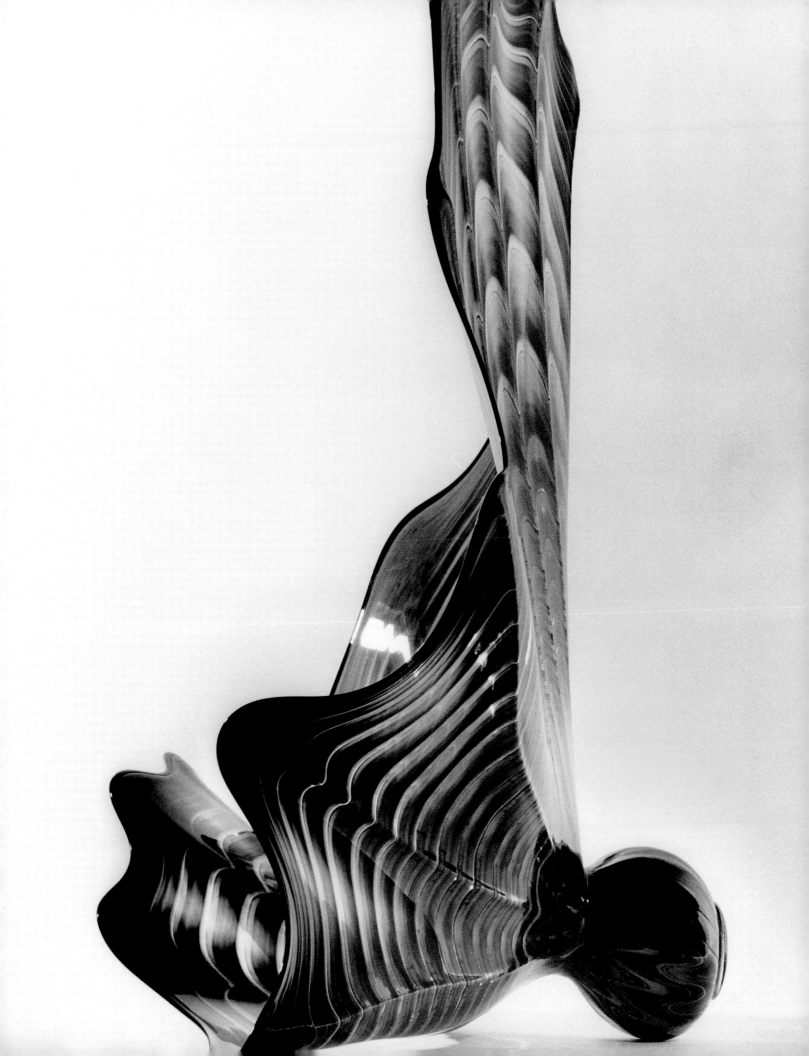

# Kiki Smith

[B. 1954]

THE LAST SCULPTURE I photographed is by Kiki Smith, the youngest sculptor whose work is included in this book. A highly expressive conceptual artist, Smith was born in Nuremberg, Germany, where her father, the sculptor Tony Smith, and her mother, an opera singer, had been living. As a teenager, Smith made figures for a traveling puppet theater; when she moved to New York in 1976, she worked as a hospital emergency medical technician and made drawings of images inspired by *Gray's Anatomy.* She also began to work in glass at the New York Experimental Glass Workshop, and subsequently added other materials to her repertoire, including fabric, wax, plaster, resin, papier-mâché, ceramic, and bronze.

Smith's subject has always been the human body—both as a whole and as fragmented parts, each serving a specific function in the complex biological processes that take place in organic systems. Her sculptures have depicted flowing menstrual blood, fetuses, placentas, and various organs. Smith's first solo exhibition was held at the Fawbush Gallery in New York in 1988, and since then her work has been seen in major museums in the U.S. and Europe. Smith's sculpture challenges viewers to think beyond what they see before them, which makes photographing her work an intensely personal experi-ence. A groundbreaking exhibition at New York's Museum of Modern Art consisted of neatly labeled antiseptic glass jars that contained actual body fluids. The visual excitement of these singular pieces was further enhanced by the viewer's understanding that these were the different elements that make up the human body.

When a Corcoran staff member placed *Breast Jar* (Fig. 72) on a table and then filled the glass jar halfway with water, I looked with amazement at the object I was about to photograph. As I examined it more closely through my camera lens, I discovered that there was an arched cavity at the bottom of the jar, and in that space was an upturned woman's breast formed of glass. I was intrigued to find so much meaning in such a pure and simple form. Sometimes a photograph can do little more than record what the artist has put forth, as in Marcel Duchamp's *Fountain* (1917, original lost; 1964, numbered refabrication, San Francisco Museum of Moden Art). And some conceptual works cannot be photographed at all. Fortunately, *Breast Jar* provided something provocative in the way the forms and substances related to each other, and I was glad that I was able to take some photographs that reflected the nature of this unusual work.

72. *Breast Jar,* 1990
Blown glass
9½ x 7½ x 7½ in.
Museum Purchase, with funds provided by
Deane and Paul Shatz, 1990.21.a-b

# Index

Aitken, Robert  118

Barye, Antoine-Louis  41

Borglum, John Gutzon  106

Bousseau, Jacques  25

Calder, Alexander  163

Canova, Antonio  33

Chihuly, Dale  183

Cornell, Joseph  174

Crawford. Thomas  64

Croff, Giuseppe  39

Daumier, Honoré  60

Davidson, Jo  138

Dehner, Dorothy  170

Eakins, Thomas  84

Edmondson, William  134

French, Daniel Chester  92

Frishmuth, Harriet  122

Galt, Alexander  74

Hoffman, Malvina  150

Houdon, Jean-Antoine  28

Huntington, Anna Hyatt  116

Ives, Chauncey  63

Lachaise, Gaston  135

Lipchitz, Jacques  158

Mac Monnies, Frederick  102

Maillol, Aristede  97

Maiolica Inkstand  23

Manship, Paul  139

Marisol, Escobar  180

Nadelman, Elie  125

Nevelson, Louise  166

Powers, Hiram  51

Remington, Frederic  100

Renaud, Charles-Alexander  32

Rimmer, William  69

Rinehart, William Henry  71

Rodin, Auguste  77

Rush, William  31

Saint-Gaudens, Augustus  86

Shapiro, Joel  182

Smith, Kiki  188

Smith, Tony  177

Storrs, John  152

Terracotta Figures  13

Turnbull, Grace  124

Vonnoh, Bessie Potter  110

ENDNOTES

1.   Fred Licht, *Canova*, Abbeville Press, New York, 1983.
2.   Etienne-Jean Delécluze, *Journal des Débats*, quoted in William T. Walters, *Antoine-Louis Barye from the French of Various Critics*, Baltimore, 1885, p. 16.
3.   Stephen Tailton, and the University of Virginia, Institute for Advanced Technology in the Humanities, *Uncle Tom's Cabin & American Culture*, Electronic Text Center, Charlottesville, Virginia, (Accessed October 9, 2002), <http://www.iath.virginia.edu/utc/sentiment/sexilehp.html.
4.   Stephen Tailton, ibid. The following four reviews may be found online at: <http://www.iath.virginia.edu/utc/sentiment/sexilehp.html.
5.   Anonymous, *The Literary World*, New York, 18 September 1847, quoted in web site, see note 4.
6.   "R.S.C.," *The Knickerbocker Magazine*, New York, October 1847, quoted in web site, see note 4.
7.   Mary Irving, *The Independent*, New York, 11 September 1851, quoted in web site, see note 4.
8.   Henry T. Tuckerman, *New York Daily Tribune*, 9 September 1847, quoted in web site, see note 4.
9.   Thomas Moore, *Lalla Rookh, An Oriental Romance*, Buffalo, Geo. H. Derby and Co., 1850, p. 112.
10.  Truman H. Bartlett, *The Art Life of William Rimmer*, Kennedy Graphics Inc./Da Capo Press, New York, 1970, p. VII.
11.  Eleanor Heartney with Corcoran Curators and Contributors, *A Capital Collection: Masterworks from the Corcoran Gallery of Art*, Corcoran Gallery of Art, Washington D.C., 2002, p. 204.
12.  Janis Connor and Joel Rosenkranz, *Rediscoveries in American Sculpture*, University of Texas Press, 1989, p. 165.
13.  Roayl Cortissoz, "Recent Works by Two American Sculptors," *New York Tribune*, 1 February 1914, sec. V, p. 6.
14.  Conner and Rosenkranz, ibid., p. 38.
15.  Conner and Rosenkranz, ibid., p. 40.
16.  Sam Hunter, *Lachaise*, Abbeville Press, New York, 1993, p. 25.
17.  Henry McBride, *Lachaise*, Brummer Gallery, New York,1928, quoted in Nordland, Gerald, *Gaston Lachaise: The Man and His Work*, George Braziller, New York, 1974, pp. 21-22.
18.  A. M. Hammacher, *Jacques Lipchitz, His Sculpture*, Harry N. Abrams, 1960, New York, p. 9.
19.  Fritz Bultman, quoted in Jackson Rushing, "Ritual and Myth: Native American Culture and Abstract Expressionism," in *The Spiritual in Art: Abstract Painting 1890-1985*, Los Angeles County Museum of Art, 1986, p. 283.
20.  Richard Kalina, "Building Form," *Art in America*, March 1999.
21.  Richard Kalina, ibid.